Botanical **Painting**

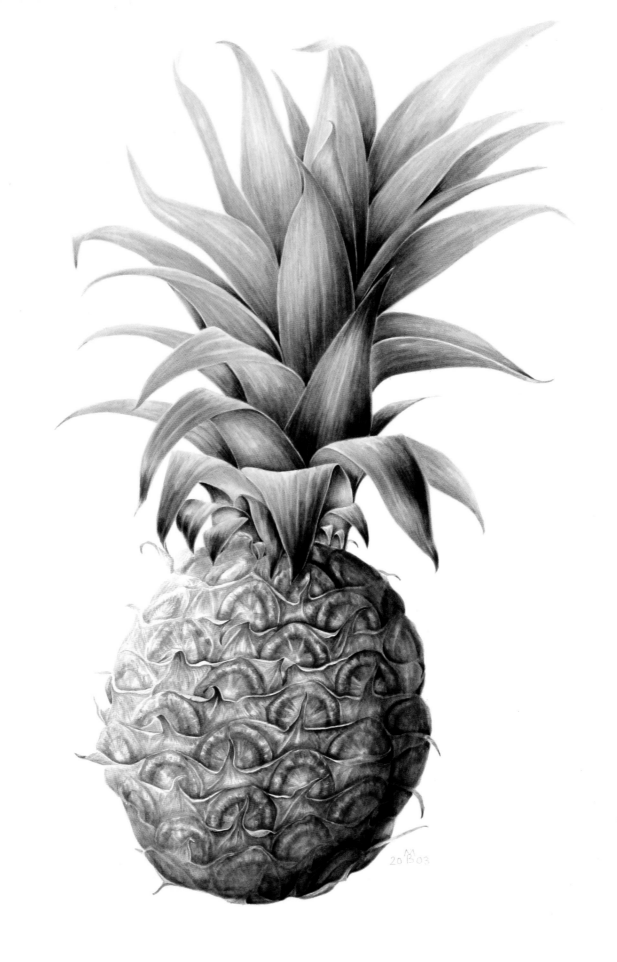

Botanical **Painting**

Mariella Baldwin

THE CROWOOD PRESS

First published in 2011 by
The Crowood Press Ltd
Ramsbury, Marlborough
Wiltshire SN8 2HR

www.crowood.com

This impression 2012

British Library Cataloguing-in-Publication Data
A catalogue record for this book is available from the British Library.

ISBN 978 1 84797 277 4

Dedication
This book is dedicated to my dearest children, Sam, Hettie and Alfie, with love.

Typeset by Servis Filmsetting Ltd, Stockport, Cheshire
Printed and bound in India by Replika Press Pvt. Ltd.

CONTENTS

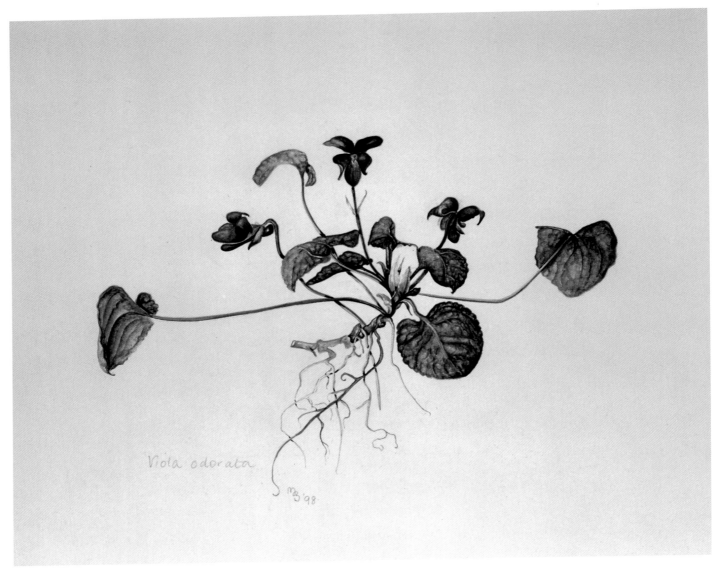

Viola odorata

Violet.

PREFACE

My formative years were spent in what could be described as a rural idyll, surrounded by the natural world. I would spend hours collecting and painting flowers. At school the nature table was the highlight of my day and left to my own devices I would have ventured no further.

Fortunately I was forced to receive a wider education and my eyes were further opened to the wonders of botany through the inspiration of my Polish biology teacher Madame Bashka. One afternoon in my late teens I found myself in an apartment overlooking the Chelsea Physic Garden, which at that time in its history operated as a 'closed order' and the public were not admitted. I was mesmerized but could only dream of being a part of that garden. Unable to pursue a career in art or study botany further, it was only later in life that I was able to return to my passion. My children were all at school and I was thinking about a return to work. I realized that the world of technology had marched on at an alarming pace so I set about looking for courses. Miraculously I was distracted by a brochure, from the English Gardening School, and my dream began to become a reality.

As soon as I walked through the gates of the Chelsea Physic Garden where the English Gardening School was based, I knew this was where I belonged; when I met Anne-Marie Evans, the course director of Botanical Illustration, it was confirmed I was home. With the support of my family, I began the Diploma Course not knowing the possible outcome. Now I find myself in a position to pass on my knowledge and the passion I have for the natural world that surrounds us.

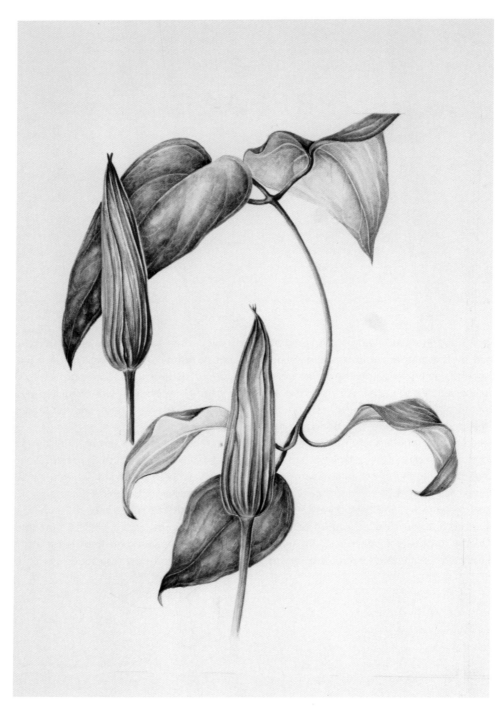

Clematis buds.

INTRODUCTION

The enthusiastic rediscovery of Botanical Painting in the latter part of the twentieth century was first thought to reflect the fashion of the time and would be just that; a passing fad, expected to phase out in the goodness of time. However, critics have been proved very wrong and interest in the subject at the beginning of the twenty-first century continues unabated. Despite access to digital photography and computer graphics this quiet, contemplative discipline still manages to command attention. Botanical Painting is not such a rigorous discipline as Botanical Illustration; nevertheless it manages to warrant a place in plant identification, even though its main focus is on the beauty of the subject and not necessarily the recording of plants for science. It is, by the nature of its beauty and inherent skill, a reward for both the artist and the viewer; focusing attention on the miracles of the natural world, the rich diversity of the plant kingdom and the life that surrounds us.

During the mid-part of the twentieth century Botanical Painting was maintained and enjoyed by a very few persistent stalwarts who disregarded the prophets of doom and it is down to them, together with those frustrated by the lack of available instruction on offer anywhere, that the momentum began and the appreciation of the art grew and burgeoned. Despite advances in photography which heralded a decline in the art, and although the camera threatened the very idea of Botanical Illustration as a means of describing plants and recording information, the camera falls down on a number of basic principles. It cannot as yet record everything in its sight in full focus, and its rendering of colour is variable, despite digital manipulation that the computer affords. The Botanical Artist, unlike the camera, can select and choose which parts of the plant need to be emphasized for correct identification, and can also match the colour accurately by comparison to the plant in front of them. Equally, through accurate measurement, he/she is able to convey the scale of the plant. In order to accurately read a photograph it is important to know how far the camera is from the subject if no indicator of scale is included. No such limitations are imposed by the drawing or painting if the depiction is accurate. Photographs of course can be beautiful, and provide equal enjoyment to botanical depiction; but photography is a different skill, no less valuable than painting, but different. For the Botanical Artist it is partly the time spent in contemplation, learning and honing a delicate craft that is the attraction of the subject.

The profile of the subject was raised by enthusiastic collectors such as Mr and Mrs Roy A. Hunt, who founded the Hunt Botanical Library in 1960, which forms a research department at the Carnergie Mellon University in Pittsburgh, USA and is now known as the Hunt Institute for Botanical Documentation. The heart of this collection originated from the works collected by Rachel McMasters Miller Hunt, and the collection continues to grow as new works by contemporary artists are acquired by the Institute. In the United Kingdom, Botanical Artists have benefited from the generosity and enthusiasm of the collector Shirley Sherwood. Through her expertise and knowledge she has acquired an impressive collection of contemporary Botanical Art, which has travelled the world in numerous exhibitions. In 2008 Shirley Sherwood created and donated a gallery devoted to Botanical Painting in Kew Gardens, London. The long-awaited specialist gallery bears testament to the interest and popularity of the subject.

As a tutor of the subject, Anne-Marie Evans is renowned throughout the world. Her enthusiasm and knowledge of the subject has proved to be infectious. The success of her pupils must surely be unrivalled and their work can be seen

WHAT MAKES A GOOD BOTANICAL PAINTING?

What constitutes a good Botanical Painting can be very subjective, but from a personal perspective the key elements that go some way towards reaching common agreement are as follows:

1. It looks like the plant being depicted, capturing the nature and character of the plant.
2. The plant is accurately observed, having the right number of petals and sexual parts – in the right place. Everything should seem to join at the correct point in a convincing manner.
3. It features a thoughtful composition and layout, which makes good use of the paper giving corresponding space to the plant depicted, with a sense of balance and proportion.
4. It has a good feeling of form. This means the painting looks and feels three-dimensional. It will have a minimum of three tones, and in all probability have many more. The greater the variety of tones the greater the vitality. A good contrast of dark and light tones should be displayed.
5. It displays a thoughtful and pleasing use of colour, accurately matched to the plant and at the same time giving the feeling of a harmonious whole, with no sudden jumps in tone or colour.
6. It has impact, vitality and strength. The painting can be powerful or peaceful, architectural or graceful. It can be small and a gem, or enormous and a statement. It is a very difficult quality to define, but you certainly know it when you see it!

in numerous public and private collections. In the United Kingdom various Florilegia have been set up as ongoing projects to record and document plants in gardens such as The Chelsea Physic Garden Florilegium Society, The Eden Project Florilegium Society and The Hampton Court Palace Florilegium, to name but a few. The Society of Botanical Artists is a group of artists all dedicated to the depiction of the plant world, and it continues to grow and prosper. The exhibition they hold each year shows the broad diversity of styles and interest that the subject holds. The American Society of Botanical Artists based at Brooklyn Botanical Gardens in New York is a similar organization, with a close affiliation to the Chelsea Physic Garden in London.

People are often puzzled by the difference between Botanical Illustration, Botanical Painting and Flower Painting and while opinions frequently can and do differ the following offers an attempt at clarification.

Botanical Illustration is essentially a form of describing plants, which can be used by science for correct identification. A rigorous attention to accurate detail is essential and the beauty of it is purely incidental. Botanical Painting *can* have these elements, but does not necessarily display all the vegetative features of a plant; it may focus on one or two particular features, and attention to the aesthetic beauty of the plant is usually the primary concern of the artist. Flower Painting is a looser term and can encompass all and everything concerning the vegetable kingdom and has at its heart the artist's personal response to the subject matter, so capturing the essence of the subject as opposed to searching for verisimilitude. Each and every specialism is a matter of personal choice and can appear quite subjective. Nevertheless the objective seems to be universal; that is to contemplate, capture and hold something of the beauty that surrounds us.

This book, which is directed towards Botanical Painting rather than Botanical Illustration or Flower Painting, aims to convey the ideas that enable the budding Botanical Artist to get the most out of their painting; however the information contained could be useful to anyone interested in drawing and painting from nature. It seeks to help the beginner who wants to learn more about the subject, yet equally aims to help the more experienced artist who wishes to develop and enhance his/her skills. Due to the very nature of the subject a rudimentary knowledge of Botany can be useful but, as this book will hopefully demonstrate, not essential. Don't let a lack of knowledge of Botany be a deterrent, and don't be put off by complicated Latin names. The more the subject of Botanical Painting is studied, the more addictive it is likely to become, and the pursuit of knowledge of the subject of Botany can become an imperative. Let the knowledge come slowly and gently according to need. Seek out Botanists and specialist books on the subject, if this is of interest. There are a number of books available on the subject for artists and these will always be useful to refer to for information and clarification. Or you can just enjoy the painting purely for the sake of it.

Botanical Painting can almost become a form of meditation as the cares of the world dissolve into the observation of simple, yet paradoxically complicated, nature. Equally, it can prove to be a most frustrating business as perfection is sought. This book sets out to demonstrate that through simple, methodical exercises a firm basis can be put into place. Successfully mastered, these exercises can be translated into painting from nature to obtain a satisfactory result. Once confidence is obtained through control of the materials, progress and success can be limitless. Try to banish angst and enjoy every successful step, no matter how small. Possibly the most important consideration to hold in mind is that Botanical Painting ultimately should bring joy.

Equal attention will be given to drawing as to painting, as drawing forms the basis of accurate depiction. From a strong foundation everything can be built. Historically, art colleges would train artists in observation by using plaster casts of fruit, vegetables and leaves which they would diligently copy using continual tone in pencil. These plaster casts were symbolically destroyed when the teaching of drawing was abandoned by art schools towards the end of the 1960s. The desire to be able to draw, however, goes beyond any ideological dogma; it is a strong human impulse. Drawing, *per se*, has never really had to fight its corner, as it has been continuing quietly within sketch-books, but now it has begun to assert itself on its own terms, not as a second to any other art form but in and for itself. Drawing is at the heart of Botanical Painting and it can be a thing of beauty in its own right, but also it has the ability to assist the painting process. The art of drawing is neither a mystery nor is it difficult. However, it does have two requisites: that is, an interest in the subject and the determination to achieve through practice. A significant key can be confidence. Confidence can be mastered and once a confident drawing has been achieved, the painting should follow. This book aims to guide those who wish to learn the art of Botanical Painting to achieve their goal.

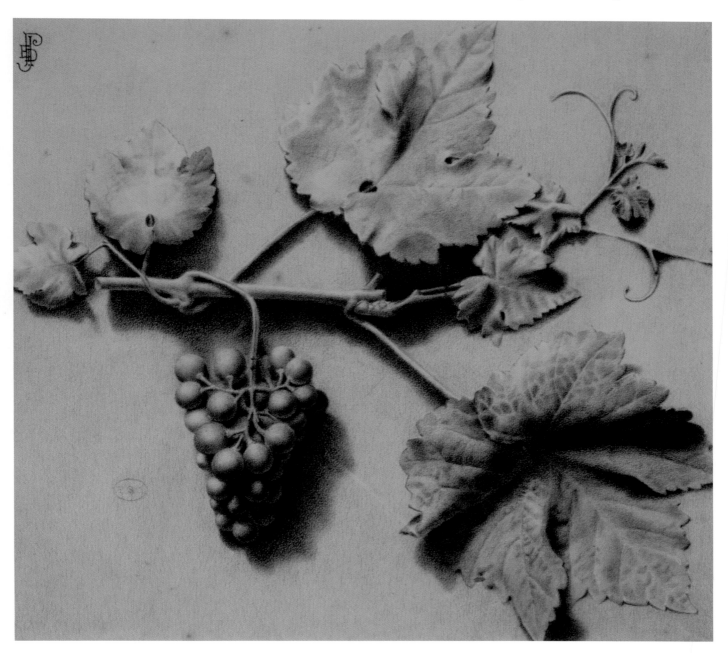

Victorian ACT Certificate drawing, James Proudfoot, 1891.

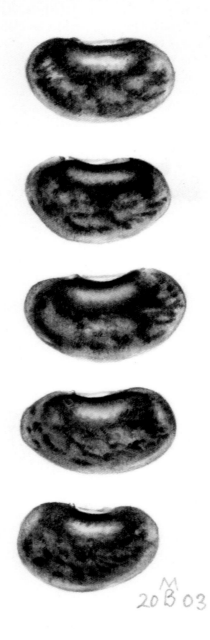

Five runner bean seeds.

MATERIALS

Each artistic discipline has specific materials to make the work easier and Botanical Painting is no exception. Painting and drawing can be hard enough without doing battle with unsuitable equipment. The materials described include the available equipment traditionally used for Botanical Painting. However, it is all a matter of personal choice; not each and every artist will use the same materials, and there are no hard and fast rules. It would be a dull old world if that were the case. The information given here is merely to help the Botanical Painter make informed choices.

HOT-PRESSED WATERCOLOUR PAPER

Hot-pressed paper is exactly that. During its manufacture the paper is passed through heated steel rollers, which create the characteristic very smooth surface. This surface not only enables the artist to draw a very crisp outline, but it also allows watercolour to be built up in successive layers. It is the layering of colours that creates the richness and luminosity that is so specific to Botanical Painting. The papers more usually associated with watercolour painting are cold-pressed or Not, or Rough. These papers are useful in letting the paint flow easily over the paper, which allows the paint to be manipulated before drying. They do not permit such a precise line as is required for Botanical Painting, nor do they take layers of paint so receptively. There are a number of hot-pressed papers on the market which are available by the sheet, or in a block, although some are only available in block form and others only by the sheet. Paper needs to be stretched if the paint is used very wet, and espe-

cially if the paper is of a light weight (under 300gsm/140lb). 300gsm/140lb is a useful weight and shouldn't need stretching.

The predominant method described in this book involves the paint being applied either in even washes or very small strokes, which tend to be dryer than methods typically associated with the use of watercolour. Working wet-in-wet, when used, is usually done in a relatively controlled manner and certainly not sopping wet. If hot-pressed paper gets too wet, the size on the paper surface can become diluted which in turn can affect the appearance of the paint on the paper, and that can ultimately affect the painting. If a stretched paper is necessary it is worth considering the use of paper in a block, as this helps the paper remain taut while the painting is in progress and therefore helps to minimize the possibility of the paper cockling. The sheet of paper is removed from the block once the painting is completed and the paint is completely dry. The hot-pressed paper made by the French paper mill Arches is considered the 'Rolls Royce' of papers. It is very tough and it is also receptive to paint on both sides. The painting side of the paper is the one on which the watermark can be read the correct way round. However, some artists prefer the opposite side for painting; there are no rules that must be slavishly adhered to and many artists deliberately choose to work on the reverse side of the paper. Each side of the paper gives a slightly different effect and it is a matter of personal choice as to which one is used. The Italian paper mill Fabriano produce an excellent hot-pressed paper too, which is slightly softer and therefore handles differently, but nevertheless it is an excellent paper.

There are numerous other hot-pressed papers on the market and it is good to experiment with as many different papers as possible to find the one that gives the desired effect. However, as each has individual characteristics, once a favourite has been

Arches and Fabriano hot-pressed watercolour blocks.

found it is useful to stick with it. Most sheets of watercolour paper are approximately A1, and therefore will often need cutting down to an appropriate size. Blocks are an expensive way of buying paper, but have the advantage of being available in convenient sizes, and as they are rigid can protect the painting and at the same time provide a board on which to work. This is particularly useful when travelling or on the move.

- When using a single sheet of watercolour paper, cut it to size and mark each corner with a small pencil cross so you know which side is the right side.
- If using a block of paper it is worth marking the top sheet with a small pencil cross too, just in case the block becomes detached from the backing board.

The choice of loose sheets or watercolour pad will be personal and most probably chosen according to the project. As mentioned earlier, both have their merits and drawbacks. The loose sheet allows the artist to select the size of their painting from the outset. If transferring drawings from a sketch using a light-box, the paper does not have to be removed from the pad. The position of the hand is more comfortable for painting as there is less bulk. Transporting a large sheet from the shop to the workplace increases the possibility of damage, although many art shops and mail order companies offer to cut the paper to the required size, making this less of a problem. Dealing with a rolled-up sheet of paper is always awkward. When storing paper try to keep it flat if possible and make sure it is protected. The surface of the paper can be very easily damaged, even by simply moving it in and out of a drawer. If a plan chest is not an option the space under a bed is a useful storage area. Make sure the paper is protected, either in a portfolio, or placed in a plastic sleeve and then protected with stiff cardboard.

The use of a pad means that the paper is permanently stretched while working, reducing the possibility of cockling. The painting is kept rigid by the pad and therefore less prone to damage. The pad is easily transportable and protects the painting in transit. The downside is that the sizes of blocks are set and while, of course, the sheet can be cut down, this could lead to unnecessary waste. The paper in a block is more expensive and the initial investment is greater.

THE PENCIL

A whole chapter could be dedicated to the pencil alone. From the variety available the three most important choices for Botanical Painting are the 2H pencil for drawing and shading, the HB for sketching, drawing and shading and a soft pencil such as a 6B for taking leaf rubbings. The 2H pencil, which may sound alarmingly hard, however allows for the drawing of very fine detail and it also gives a much cleaner line as it produces less loose graphite, which can smudge and therefore dirty the paper. A shaded drawing can be effectively undertaken using a 2H pencil only, from the darkest dark to the lightest light. The secret is to keep a very sharp point to build up the tones, rather than exerting greater pressure. Part of the advantage of using a harder pencil is the control, even though it will be slower than using a softer pencil. While this is definitely a much slower process, a harder pencil allows for a more detailed rendition of the subject. Depth of tone is not achieved by pressure, but by successive layers of graphite. If pressure is exerted on the shading there is a danger that the graphite becomes burnished (that is brilliantly shiny) and no amount of shading will allow the tone to become darker. However, if the pencil shading should become burnished use a putty rubber, dabbing it on the drawing to lift off a bit of the shading and begin again, remembering to reduce the pressure. Keep the shoulders down and relax.

Very beautiful paintings and drawings have been created with strong pencil lines still visible, and watercolour combined with the graphite of a softer pencil can be attractive, certainly for the field sketchbook. A softer pencil can be a practical option when speed is needed to capture the essence of a plant. HB pencils are also useful; they are slightly softer than the 2H and therefore excellent for sketching, general drawing and tracing. If the option of the 2H pencil seems too daunting the HB pencil can be adequately substituted, but do watch out for smudged lines. If they occur the paper can be cleaned by the gentle use of a putty rubber.

To keep the point, which is needed for fine detail, a good

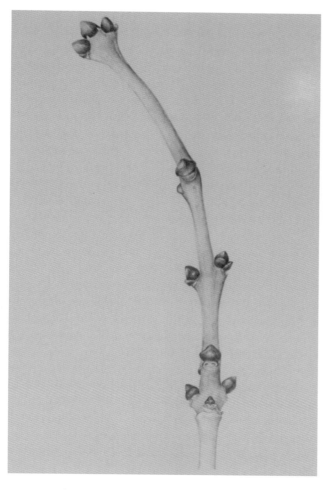

Tonal drawing of an ash twig using a 2H pencil.

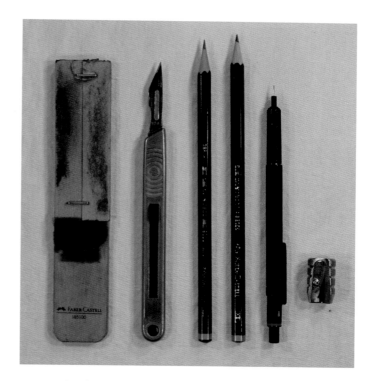

Sandpaper block, blade, pencils and sharpener.

sharpener with a sharp blade or a craft knife will be required. Sharpening the pencil can be a bothersome process and some prefer to use a mechanical pencil or a clutch pencil. The clutch pencil will still need to be sharpened and there are specific sharpeners for the purpose, or fine-grade sandpaper can be used to help maintain a good point. Equally a craft knife can be used. A mechanical pencil does not need to be sharpened as the very fine lead is fed down automatically and sharpens itself during use; the trick is to constantly rotate the pencil so as to keep the sharpest point of the lead in contact with the paper.

- Use a piece of very fine sandpaper to keep the tip of the pencil sharp and to reduce the number of times a pencil sharpener is needed.
- Use a mechanical pencil with a lead of 0.3mm, which produces a very fine line without the need to sharpen.
- If using a pencil sharpener, be prepared to change the blade from time to time as these become blunt after extensive use.

- Use a swan or goose feather, or a large soft goat-hair brush to remove erasure dust. This helps prevent the hand smudging the work, or transferring natural skin oils to the page.

Mechanical pencils use graphite leads which come in various grades: 0.7mm, 0.5mm and 0.3mm are the most common. They also come in a choice of hardness. For the purpose of botanical painting where fine detail is required, 0.3mm is an excellent choice. If using both HB and 2H leads it would be recommended to have two different pencils for different leads. The disadvantage of these pencils is that the mechanisms of some brands can be complicated and can cause some bother, but once one is accustomed to their idiosyncrasies and how they work, they can become invaluable.

Sharpening pencils can be a therapeutic exercise and can be done at the close of the day's work or at the beginning of the new day in preparation for the work ahead.

ARTISTS' QUALITY WATERCOLOURS

This book is directed to the use of watercolours, but it is acknowledged that some artists do use gouache and acrylic paints very successfully and achieve exceptionally beautiful results. Gouache and acrylic are opaque paints which means

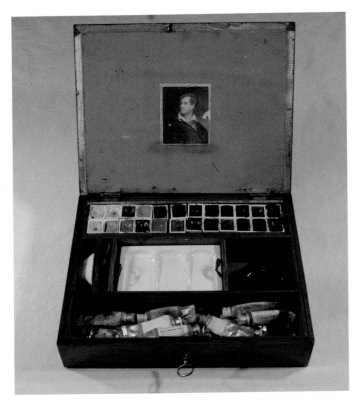

Treasured nineteenth century mahogany watercolour box.

they do not have the translucent quality that watercolour affords. Watercolour, when it is applied built up in thin layers, allows each layer to shine through. It is this layering that gives the depth of colour associated with Botanical Painting. White Gouache, sometimes referred to as bodycolour, is occasionally used when a special effect is called for, such as the 'bloom' on fruit, or conspicuous hairs on leaves or stems.

When it comes to paint it is a false economy to buy student quality watercolours and the use of artists' quality paints is to be recommended. While artists' quality paints are more expensive, they are on the whole very much superior. It is not necessary for the beginner to purchase a great number of paints as this book will demonstrate. It is possible to achieve a magnificent range of colours with just one of each of the three primary colours; that is yellow, red and blue. As a starting point, French Ultramarine, Permanent Rose and Aureolin would make an excellent choice. There are a number of different makes of watercolour paint, some better than others. The most consistent in quality and most readily available are Winsor and Newton and Schminke in the United Kingdom; or in North America, M. Graham Co. and Daniel Smith have well-deserved reputations. Other brands are available and it is always worth trying them out. Especially with Botanical Painting when a specific colour can be called for, it is so much easier to dip into the right colour for the job, rather than spending hours trying to mix it. Different brands have different colour charts and mixing and matching is no bad thing – for example Sennelier, Blockx, and Holbein also have excellent ranges. There are several informative books on the subject of paints and their properties, which are worth consulting as they provide sound and informative advice.

It is a matter of personal choice as to whether one uses half-pans or tubes. Half-pans are well suited to Botanical Painting for many reasons. First and foremost they fit into a watercolour paintbox, which is easily transportable. With Botanical Painting speed is of the essence in most cases as the subjects have a frailty and are frequently short-lived. By having half-pans it is easy to quickly select the relevant colour needed for matching and mixing is easy. Tubes are fiddly to use and can be very wasteful. It is almost impossible to use the last drop of paint without having to cut open the tubes, which is messy and means that the colour can easily get onto fingers and onto the painting sometimes with disastrous results. It is also tricky to squeeze out just the right amount of colour needed. If too much tube colour remains unused, the excess can be left on

Tube, whole pan and half-pan watercolour.

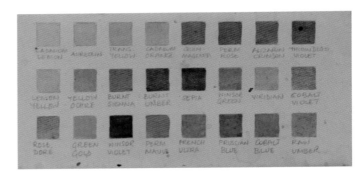

The author's personal chart of watercolours, labelled as they are arranged in the box.

a mixing palette indefinitely. Just make sure the colour is protected from the elements, and in particular dust, by covering the palette with cling film. Tube paints are excellent for large projects and landscapes and they certainly have their place, but for the majority of Botanical Painting projects that only require minute additions of colour they can be just a bit awkward. Giving consideration to the above and for the purpose of Botanical Painting the half-pan seems to be more economical; however there can be no common agreement regarding this as it will be down to choice.

Half-pan or tube, it is useful to make a personal chart of the colours and to label them with their names at the outset. This is useful for quick reference. Winsor and Newton produce a hand-coloured watercolour chart which is an excellent reference tool for learning the colours, to view the colours available, and to see what they look like when applied to paper. Schminke also produce a watercolour chart, with the colour applied mechanically, which has a different appearance but is no less useful. These should not be confused with printed colour charts, which are available free from art stores. Hand-coloured paint charts usually have to be asked for specifically, as they tend to be kept separately from the free handouts in order to avoid confusion.

■ Make a watercolour chart and label the colours with their names.

■ Invest in a hand-painted colour chart from the paint manufacturer, especially if the idea of hand painting a chart doesn't appeal. The manufacturer's chart gives all the information that is needed regarding transparency and opacity, the composition of the paint and its durability. This all helps to make informed choices.

■ Tube colour can be squeezed into empty pans and used as half-pans, which avoids wasting valuable paint. Tube colours can be squeezed onto a palette and at the end of a painting day, rather than being washed away, the palette can be covered with a piece of cling film so the paint can be used at a later date. It is important to cover the paint when not in use so that dust and fibres don't get onto it. This equally applies to half-pans in boxes.

■ If using tubes make sure the top of the tube is spotlessly clean when the cap is put back to prevent the paint from leaking out and also to avoid sticking. Also be particularly careful in checking fingers and hands before beginning, as it is very easy to get tube colour everywhere without much effort, and it seems to have the ability to multiply and spread with little or no encouragement, often with disastrous results.

■ If tube caps become stuck or difficult to open, dip the cap end of the tube in hot water to soften the paint.

CHINA MIXING PALETTE

A china palette is preferable to a plastic one. A plastic palette, while being light and easy to transport, does not allow watercolour paint to adhere to the palette so well. This means that when picking up paint with the brush, almost all the paint will be transferred to the brush, which can mean that the colour has to be re-mixed constantly. While a white enamelled palette is preferable to a plastic one, if weight is a concern, it is perfectly possible to use a very simple small palette and there are some good ones on the market. Not everyone experiences problems with plastic palettes and many get along quite happily with them. It is all down to the individual. An old white china tea saucer, plate or dish can be just as effective as an artists' palette, but do stick to white, so the colours can be seen clearly.

Winsor & Newton colour chart – hand-coloured.

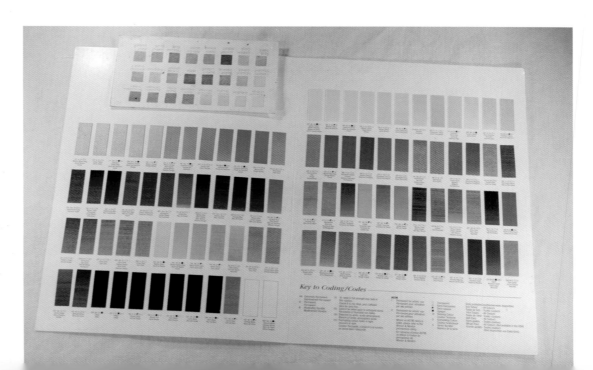

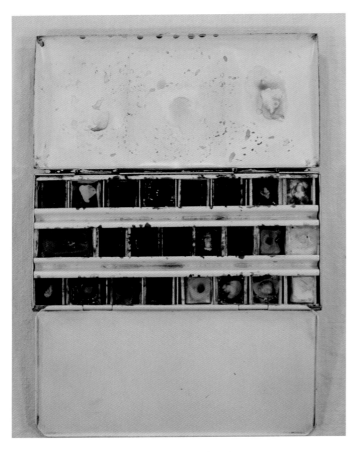

Enamelled watercolour box.

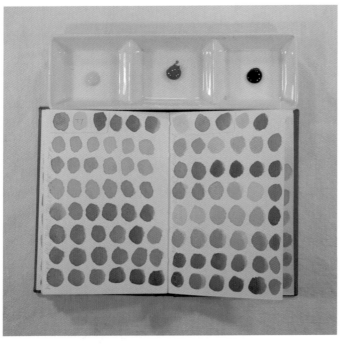

China mixing palette and colour notebook.

Kitchen shops often sell white china dishes with compartments, designed with food in mind, which can also be used for watercolour mixing.

WATER POT

Almost too obvious to mention, but a clean jam jar provides a perfect water vessel. Always make sure the rim of the jar is clean before beginning work to prevent disasters. However, it may not be so obvious that it can be useful to have two jars of water on the go. Use one for washing the paintbrush, and one for taking up clean water for painting. This does help keep colours clean, and also provides a good supply of dirty water when needed for delicate shadows. If using only one pot of water, do consider changing the water regularly during the day, if it should become too dirty.

BRUSHES

Miniature Sable Watercolour Brushes

The term 'miniature' does not mean the brushes are very small, but that they are specifically designed for miniature painting and happen to be very good for Botanical Painting. These brushes have short hairs, which come to an excellent point. This means they can hold a lot of water to enable a good flow of paint, and at the same time provide good control. The most popular watercolour brush has long hairs and great flexibility

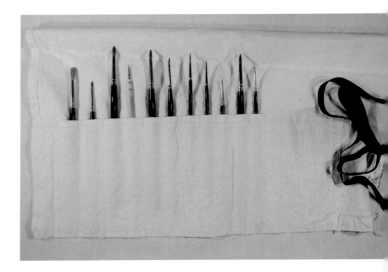

Cotton compartmented brush roll to protect brushes.

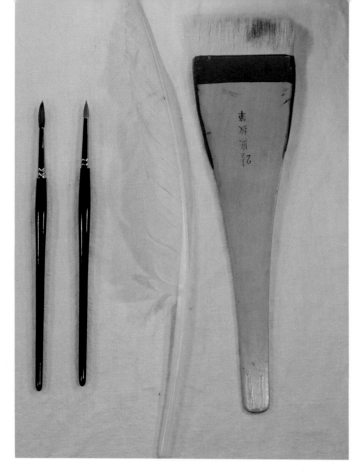

A traditional watercolour brush and a miniature watercolour brush. Goose feather and Goat Hake used for brushing away eraser dust.

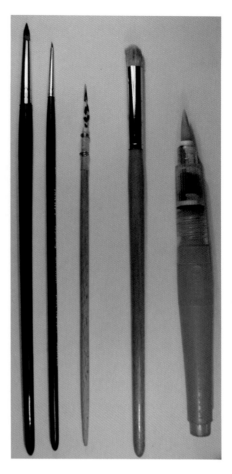

A selection of brushes from left to right: miniature watercolour brush, No.5, watercolour brush No. 1, woodcock pinfeather brush, bristle stippling brush, Japanese wash brush.

allowing for loose sweeping brush strokes, which is the opposite of that required for Botanical Painting. Great advances have been made with the development of synthetic brushes and these can be used, but nothing quite beats the quality of a sable brush.

The best and the most expensive watercolour brush is the Kolinsky sable. If investing in the time to paint, it makes sense to invest in the best materials even if it is only possible to buy just one. The prices do vary according to the manufacturer but there are a number of excellent makes widely available: Da Vinci and Winsor and Newton are generally easy to find; Isabey make brushes too. Some art suppliers produce their own brands and these are in no way inferior, and can be less expensive. There are a number of smaller manufacturers of brushes and these should not be dismissed. One of the most important things is to be able to get a good point on the brush. The advantage of purchasing a brush from one of the professional art shops is that it is possible to check the point on the brush, as they can and do differ.

Sable brushes are very precious and need to be treated with care. Always wash the brushes thoroughly at the end of the day. Accumulations of paint will dramatically reduce the life of the paintbrush, and can be a cause of the brush failing to retain its point. It is advisable to use an old brush for taking colour from the watercolour paintbox to mixing on the palette, in order to preserve the condition of the painting brush.

Each series of brush is numbered according to its size and they can vary from 00000 to 8 and beyond. Three useful sizes for Botanical Painting are, No. 0, No. 3 and No. 6, and these are suitable for most projects. No. 6 will be excellent for washes, No. 3 for the smaller areas, and No. 0 for the detail. The balance of fluidity is of vital importance. If the paint is too fluid the brush will not be able to retain its point, and the colour may 'pool', which will leave uneven and unsightly bands. If the brush is insufficiently loaded and therefore too dry, the colour will not flow from the brush, and again uneven washes will result. A few exercises are worth undertaking before beginning to paint a plant subject if this method of painting is new.

If the brush ever separates or splits, thus spoiling the tip, boil a kettle and put a small amount of hot water in an egg-cup. Immerse the tip of the brush in the water for a few seconds, taking care not to cover the ferrule (the metal band holding the hairs of the brush in place). Remove the brush and gently roll it

between the thumb and forefinger, twisting to achieve a point. Leave the brush to dry before using. Frequently this first-aid measure works a treat.

Other Brushes

A useful brush for applying even washes on large subjects is a Japanese wash brush. The handles of these brushes are made of plastic with a chamber for water and they have a synthetic brush with a very good tip. The brush is used like a traditional paintbrush. As the paint is applied the water flows from the chamber in a controlled way, which allows for the preliminary wash of colour to be laid down evenly. This will only work for the first couple of layers, after that the brush will pick up more paint than it puts down.

A small hog brush with short bristles is useful for stippling paint, especially dry gouache on top of paintings to produce

Putty rubber and moulded putty rubber to pick out errors, plastic rubber (cut to give a chisel edge to get into difficult corners) and a craft knife.

the effect of 'bloom' when required. If you are lucky enough to find the pinfeather of a Woodcock, these are superb for painting very fine detail. They were highly prized by the Victorian watercolourist. An old or cheap brush for mixing paints is invaluable.

DRAWING PAPER

The smoother the paper the better, as it gives a sharp line to the drawing. Bristol Board is an excellent smooth paper. Traditionally it is used for precise line drawings associated with Botanical Illustration and it also provides a superb surface for detailed pen and ink work. The surface of the paper prevents the pen nib from picking up fibres of paper, which would eventually block the nib of the pen and prevent a good sharp outline being achieved. It is worth trying out different papers to find one that suits a personal drawing style. Some will be strong enough to take colour washes, useful for creating a study page; others will be thin and allow for a sharp outline. Copier paper used for printing from the computer can be a good drawing surface, although it will not take washes. The choice of paper will be determined by the purpose for which it is required.

TRACING PAPER

Tracing Paper has a number of uses. Primarily it can be used to transfer a drawing from the sketchbook or worksheet onto the watercolour paper. This can be very useful unless and until one can draw confidently with little use of the eraser. Hot-pressed watercolour paper is very smooth and it is best not to disturb or destroy the surface by excessive use of the eraser. By transferring a drawing using tracing paper, such disturbance is minimized. Tracing paper can also be used to check corrections before committing to the drawing itself. The tracing paper can be laid over the drawing and an alteration tested before adjusting the existing drawing. Tracing paper can also be used for making compositions. By tracing individual components, they can be positioned and repositioned to create a stronger composition. It is useful to cut a sheet of tracing paper into small pieces when doing this; a tracing taken of the preliminary drawing can be an insurance policy.

ERASERS

It is helpful to have both a putty rubber and a plastic eraser. A putty rubber is a soft eraser that is good for picking out small areas

that need correcting and for cleaning up excess graphite. Small pieces of the putty rubber can be pulled off for use; when softened in the hand the piece can be moulded to fit into awkward areas to pick out minute errors. It can also be used to clean the paper prior to painting. Having taken a piece off, roll it between the finger and thumb before using, or roll it in the hand to create a sausage shape that can then be rolled over the drawing which will collect any loose graphite. A plastic eraser is best for erasing larger areas and generally for removing pencil work, as and when needed. Try to remember not to use the hand to brush away the loose graphite and eraser dust. A feather or soft brush is best. A plastic rubber can be used to pick out detail or erase awkward to reach lines; cut off an edge of the eraser at an angle with a craft knife. This will create a sharp edge, perfect for the job.

Steel rules, proportional dividers and simple dividers on graph paper for measuring plants.

MEASURES

It is useful to have a small steel rule that can be used for measuring parts of plants for reference, as well as for ruling small lines. A larger plastic ruler for ruling longer lines, and preferably one with a steel edge for cutting paper, are useful too. Rulers can be held up against a plant subject when it is necessary to check the nature of growth, and how far it moves from the absolute vertical or horizontal, for example. Make sure the edge of the ruler is always clean before use, by running a piece of towel along the edges.

GRAPH PAPER

Graph paper is handy for checking simple measurements. The plant material can be laid on top of the graph paper and the measurements checked. It is also useful when it is necessary to make a simple magnification of plant detail. This is especially good for small subjects. For example, take a petal and lay it on a piece of graph paper. It is then possible to read the number of squares across the bottom of the petal. To multiply the drawing by two, simply draw the petal twice the size by doubling the number of squares for each measurement and a faithful magnification of x2 should be achieved.

DIVIDERS

Dividers are used for measuring the plant and for plotting distances, but are by no means essential. However, dividers are better than a ruler to check measurements in a complex plant

subject as they can be poked into the middle of a plant to take a measurement. Simply adjust the dividers to size and then plot the measurement taken on the drawing paper. Proportional dividers are precision tools and are expensive to purchase, but they are essential if accurate magnifications, or even reductions, are frequently required. These instruments are invaluable to the Botanical Illustrator.

CRAFT KNIFE

Not only is a craft knife an ideal tool for sharpening pencils, but also for cutting plant material and cutting paper. Change blades frequently to ensure they remain sharp. The type of knife with a retractable blade is safer and easier to transport. Before putting the knife away make sure the blade is both clean and dry, in order to prolong the life of the blade and equally to prevent plant material, graphite or even rust accidentally being transferred onto the drawing or painting paper the next time it is used. To prevent injury or damage to painting surfaces, as these blades are very sharp, it is advisable to use a pair of pliers to remove the old blade, holding the knife firmly and well away from the body.

HAND GUARD

It is advisable to get into the habit of having a hand guard to protect the work. The best choice is a piece of scrap watercolour

Watercolour paper hand guard to both protect work and test colours.

Painting in progress.

paper, which also allows for the colour and paint flow to be checked before it is applied to the painting. For a drawing, a piece of cartridge paper is useful, upon which the density of the graphite can be tested following each sharpening. At the same time this paper will help prevent grease, paint or graphite being accidentally transferred to the work in hand. Keep any offcuts of paper you may have for this purpose.

RAG

Keep to hand a scrap of cloth or a sheet of blotting paper to mop up excess water or paint. Kitchen towel is equally good, but do not be tempted to use facial tissues as these are too soft and release fibres easily, which can adhere to the paint, causing no end of trouble as they are very hard to remove.

OTHER USEFUL ITEMS

Drawing Board

Obviously the size of the board will depend upon the size of the paper. Make sure the paper sits comfortably on the board and doesn't hang over the edges. As a suggestion an A2 size is popular for beginners. Always try to have the board at an angle; this will help to prevent neck strain. The paper being worked on can be attached to the board using masking tape to stop it from slipping.

Table Lamp

An Anglepoise lamp is the most useful, or a lamp that can be easily adjusted. If possible, ensure it is fitted with either a day-light or a halogen bulb, as this will give a light as close to natural light as possible.

Masking Tape

This is a low-tack tape that is ideal for temporarily securing paper, and plant material too. It is designed to be easily removable and it will not mark the paper.

Magnifying Glass

Magnifying glasses come in all shapes and sizes, with and without lights. They are invaluable for observing detail and when it comes to painting very small areas. Opticians are a good source of magnifying glasses and it is worth looking thoroughly at the choices available. Linen testers, while made specifically for examining linen and checking thread counts in fabric, are useful for Botanical Painting. They stand on the table and have the advantage of a scale mark on them.

Magnifying Lens x10

This type of lens is very portable and can be used to examine minute detail and for accurate identification, especially in the field. They can, if desired, be worn around the neck in order

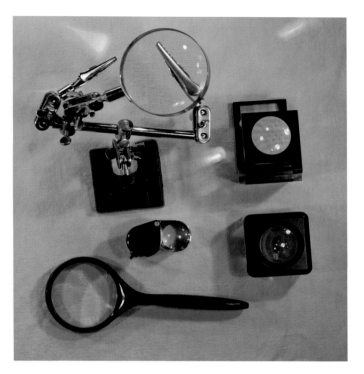

Clockwise from top: third-hand clamp with magnifier, linen tester, table loup, hand-held magnifying glass, x10 hand lens.

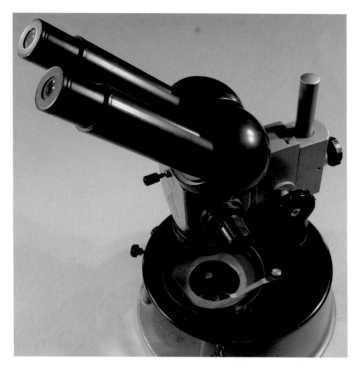

A binocular stereo microscope.

to seize any opportunity to look at a plant up close. These lenses are particularly useful if access to a microscope is not an option.

Microscope

A microscope is only necessary for the artist who wants to get very close up to the subject and is interested in minute detail. They are invaluable to the Botanical Illustrator and, even if minute detail isn't being depicted, the more knowledge acquired about the plant the better the painting probably will be. They provide a fascinating insight into the plant kingdom and can become addictive.

Lightbox

A lightbox is used to transfer a complex drawing onto watercolour paper, and for testing out compositions. There are numerous versions on the market from a lightweight tracer used for crafts, to the more robust and commercial varieties. If the purpose is only to trace images, it is possible to achieve the same results by using a window pane for tracing. However, it can be awkward to transfer as the drawing will need to be done vertically against the window, which can be tiring for the arms!

Whether using a lightbox or a window, the drawing needs to be on a fairly thin cartridge paper, layout paper or tracing paper. The initial drawing should be good and strong so as to be seen through the paper. Place the drawing on the lightbox or window and tape securely. The first step is to place the watercolour paper on top and secure that with masking tape. The light coming through the paper will allow the drawing to be seen on the paper above and it can then be traced. It is important to keep the pencil tracing as lightweight as possible as the light will bleach the intensity of the line and it will come out darker than it appears while tracing. The pencil needs to have a good sharp point and a 2H pencil is to be recommended here. When using the lightbox method of tracing and the drawing cannot be seen, place the lightbox in a darkened room which will assist in seeing the drawing through the paper more clearly. The lightbox can be used to work out the placement of an additional image to an existing composition by placing the painting with the additional drawing underneath on the lightbox. The new drawing can then be moved around to work out the best arrangement.

Layout Paper

This paper is a very thin but nevertheless very strong; it is good for both drawing and taking leaf rubbings.

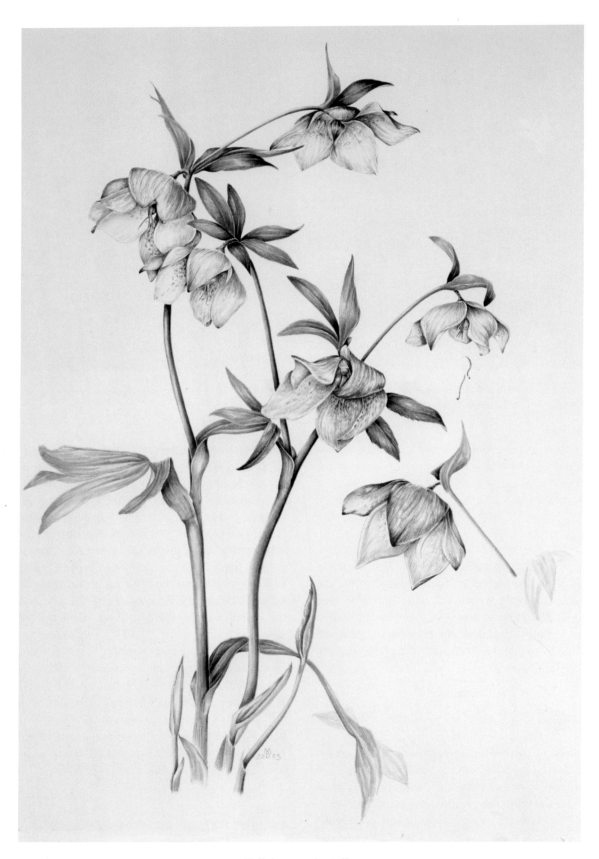

Helleborus orientalis.

DRAWING THE SUBJECT

PREPARING PLANT MATERIAL

Good preparation of the subject will always pay off and frequently this requires advance planning. Large subjects invariably need to be picked or cut to be manageable. If using cut plant material, it is useful to give them a good drink, preferably overnight. Immerse as much of the stem as possible. Most woody subjects can withstand complete immersion for a couple of hours, which will refresh them and help give them a bit of stamina to survive for a few days. The most obvious exceptions are the grey-leaved plants and fragile plant material so this method should always be exercised with caution. Always try to get plant material into water as soon as possible. Taking a bucket of water to the plant when cutting is a good idea, especially on a hot day. If it is impractical to take a bucket of water then take a plastic bag to put the plant material in. Seal the bag carefully and place it in a cool place (such as in the refrigerator) as soon as possible. The plant should be happy for a little while, before being conditioned by re-cutting the end of the stem and immersing in water for a good drink before drawing and painting it.

If the painting or drawing cannot be completed in one day, most temperate plants are happy to live in the refrigerator when not needed. This will help prolong their life. It is also useful to put a flower in the refrigerator to prevent it opening up too rapidly in the warmth of the house. The coolness of the refrigerator can also be used to good effect to hold back the opening of buds until the plant is ready to be drawn or painted. Do make sure the plant has had a good drink before starting work. A plant sprayer filled with water to refresh the specimen from time to time will help to keep it perky. If a stem is too long do not be afraid to cut it. Keep both parts of the stem and ensure the lower half is put in water too, and placed the right way up so the two halves can be united in the drawing, if needs be. It is essential that all equipment used for cutting is kept as sharp as possible and cleaned thoroughly after use, to avoid rust building up and spoiling a specimen. It also prevents the cut edges being frayed. If flowers have been purchased from a florist, do cut the stems before putting them into water.

If the intention is to paint a plant from the garden a good solution can be to place the subject in a pot before bringing

Shaded drawing in continual tone of a magnolia bud.

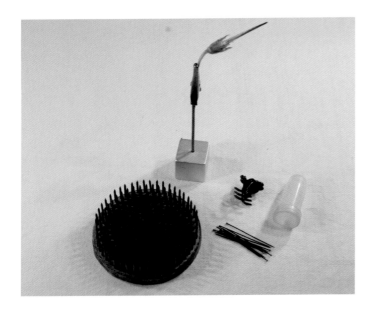

Clockwise from top: place name clamp, orchid stem clamp, orchid vial, entomological pins, flower pin holder.

it into the workroom. Make sure the plant pot has enough soil and is well watered. Place the pot on a dish to prevent any soil or water getting onto the paper. When painting is finished for the day, the plant can be returned outside or put on a window sill to get as much natural light as possible and remain at its ambient temperature.

Every plant will present its own problems and challenges. Some flowers collapse before the eyes within moments of picking and bringing indoors; this can be a particular problem with many wild flowers. Others twist and turn within the blink of an eye, such as the tulip. The crocus, for example, once in the warmth of a house, opens fully within a matter of minutes. Therefore time spent carefully examining the specimen and getting to know it really well before starting work will pay off. It is a good habit to get fully prepared before commencing. The more projects undertaken the more resourceful one becomes.

All sorts of unlikely equipment can be gathered and put to use in taming the botanical subject in preparation for drawing and subsequently, painting. Always have to hand a good supply of containers. Masking tape (or florists' tape, which is waterproof) can help hold plants in place. Florists' pins are useful for securing a plant in a vase. Barbecue sticks and garden twigs can be attached to plants and used to prop them up. Cotton thread or plant ties can be used for controlling wayward stems on to supports. Cotton thread can also be used to loosely tie opening flowers in place to prevent them from opening too swiftly, until they have been depicted. Putty rubbers, flower pins, orchid vials, bulldog clips and small clamps can all be useful in holding plant material in place, at a suitable viewpoint.

When preparing a specimen for drawing or painting, do pay adequate attention to its essential qualities and try to position the plant so that it relates to the way it grows in nature. Sometimes it is easier to draw a plant that is growing in a pot as it is already supported and, as long as it hasn't been neglected or forced into early growth, it should be a fairly typical specimen. Large subjects can be tricky and imaginative solutions have to be worked out. For example, it may be necessary to place the pot on the floor so the flower is at a good height to draw. If the flower has to be cut off from the main stem, remember to keep the measurements faithful to the specimen and ensure that the nature of growth has been accurately observed before chopping. Try to keep all pruned pieces just in case they are needed later on for the composition. Place them on a piece of dampened kitchen paper and put them in the refrigerator if appropriate until sure they can be either discarded or painted.

Take time to consider the positioning of the plant so that it can be shown off at its best. Turn the plant around a number of times before settling on the best arrangement. Sometimes the specimen chosen is just not attractive enough, so abandon it before wasting too much time trying to find a good position. Alternatively, consider choosing bits and pieces from several plants to achieve the best representative specimen.

THE LINE DRAWING

A strong line drawing will be the basis of most botanical paintings, although it must be admitted that there are artists who have the ability to paint in extraordinary detail with the minimum of drawing. There are even some artists who go straight to paint with an impressive confidence, with no drawing whatsoever. However, for many, the drawing is a very rewarding part of the process and at the same time the most challenging. There are many ways of achieving a fine drawing and so use anything and everything to assist the process. The correct equipment will be a great help to success.

First and foremost a very sharp precise point to the pencil is needed, and it will require regular sharpening. If using a wooden pencil, rather than a mechanical one, a piece of fine-grade sandpaper close to hand will make this less of a chore. Any loose graphite must be cleaned from the pencil each time, so that fine graphite powder is not picked up by the hand and accidentally transferred to the paper. Get into the habit of protecting the drawing with a sheet of scrap paper, which will prevent smudges being left on the drawing. Alternatively, prepare a mask to cover the work with a window to access the drawing. This can then be closed to keep the drawing and painting protected and clean.

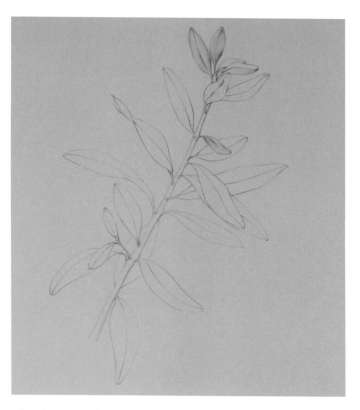

Line drawing of an olive branch varying the quality of the line.

TO CREATE A MASK

- Select a sheet of cartridge paper, or tracing paper, the same size as the piece of paper for the intended drawing, or larger.
- Measure the size of the drawing and draw a box to that size.
- If the drawing is particularly large a smaller box can be drawn, and the mask moved across the drawing, section by section.
- Using a ruler, draw a diagonal line from the top corner to the bottom corner.
- Repeat this to make a diagonal cross.
- With the ruler in place, cut along these two diagonal lines, then press back.
- The wings of the window can then be secured open or closed, as required, with masking tape.

Take time to become familiar with the possibilities of the pencil line. Practise drawing straight lines, curves and circles. Relax the shoulders, the elbow and the hand and hold the pencil as lightly as possible. To vary the weight of the line, begin with a faint line then increase the strength by gently increasing the pressure. Draw slow lines and fast lines, short and long lines, horizontal, vertical and diagonal lines. Such exercises can become part of a warm-up routine at the beginning of a painting day. It is most important to obtain a comfortable working position so as not to put too much strain on the body. Move around from time to time; every thirty minutes or so it is good to stand up, walk about and have a little stretch. Not only is it good for the body, but it means the work can be seen from another viewpoint before sitting down and returning to work. It is best to have the drawing board slightly tilted.

Observation and accuracy are two of the fundamentals when attempting to draw a life-like botanical composition. Before launching into a complicated drawing it is advisable to spend time in contemplation of the chosen specimen. Examine the plant from all angles and during this time of observation make assessments as to the best angle at which to attempt the drawing, which in most cases will be the plant's most attractive aspect. Once this has been established it will be necessary to position the specimen at the correct height in order to be able to draw it with ease.

Preparation is important. A few drawing exercises to loosen up will be invaluable. Make it part of a routine to do some loose sketches and doodles before beginning work. Get into the habit of using this time simply to draw, without using the eraser at all. These exercises are most definitely not about good or accurate drawing. There is no test, and nobody will ever need to see

Mask to protect drawing.

**A simple line drawing of a *Helleborus niger* suitable
for painting.**

***Helleborus niger* sketchbook page – an exercise to loosen up
and relax into drawing.**

them, so they are purely for personal benefit. Choose a section of a plant to focus on and discover how many different views can be shown. Just keep going and fill the page. Because this is just an exercise with no specific outcome there is no need to worry about composing a pleasing picture. It is surprising how much information can be acquired with such a simple exercise, and in turn it should help speed up the final drawing process because the plant will gradually become more familiar. While doing these sketches, mental notes will be made as to the way the parts of the plant are attached and how they relate to each other. Remember that the object of the exercise is not accuracy, but more about observation and relaxation. By slowly relaxing into the drawing some of the tension hopefully will be removed, allowing a more fluid and convincing final drawing. Just as with handwriting, it is nice to get a good flow to the line in drawing and this can be practised. Once relaxed and quite possibly bored by the exercise too, it's time to move on to accurate observational drawing.

A study page is invaluable and is a place to record all the information that may be needed to complete a painting. This can be as elaborate or as simple as required, but it is rarely time wasted. A photograph can serve as a reminder of the fresh specimen, as well as providing a record of the plant growing in its natural habitat or garden setting and confirming the position of the various parts of the plant in growth, as well as its nature. At this point it is a good idea to add some quick colour notes as

well. Accurate colour matching need not be undertaken at this stage necessarily. The colours can be just basic contrasts, such as dark green and light green for the vegetation, and a colour for the bud of the flower and another colour for the flower itself. Accurate colour matching can of course be done at this stage if wished, although this aspect will be covered later.

Very important: relax the shoulders and don't forget to breathe! Make sure everything needed is to hand, so that full concentration can be given to the drawing. Consider carefully the placement of the drawing on the paper, whether it is just a sketch, or is intended to be a plan transferred to watercolour paper later. Do make sure a generous margin is left around the drawing to help make it look more 'comfortable'. If a blank page looks daunting, a good idea is to draw a box slightly larger than the size of the plant. This will serve the dual purpose of giving a framework to the drawing, and also helping to keep the drawing in check so that it doesn't get too wayward.

Before attempting to make an accurate drawing measure

A lily study observation page.

the plant, especially if it is a plant not previously encountered. Providing there is enough plant material to spare, it is worth taking the plant to pieces purely to understand its construction. Using a sketch book, it is useful too to draw each element, as this will be a good reference aid for the future. When ready to begin the drawing itself, plot the main elements of the plant on the paper. Do this using a light touch of the pencil, so that it is just visible and easy to rub out. For example, a line indicating the length and nature of the stem will act as a central reference point. Mark loosely any leaf attachments, such as stems, stipules and bracts (if present), the direction of their growth and the arrangement on the stem. Look out for patterns and symmetry, as it will soon become obvious that nature tends to symmetry; discovering the patterns is part of the fascination of the subject.

Under examination, look for any basic geometric shapes which can act as a guide, such as the circle, triangle or rectangle, and lightly mark these. When drawing the leaves mark in the midrib first, then draw a simplified leaf margin, which can be done one half at a time. Once happy with the general outline the detail of the leaf margin can be added. Pay great attention to the veins – their size, direction of growth, the angles at which they emerge and most importantly, how they terminate. Generally the veins become finer towards the leaf margins and stop short of them. The characteristics of leaves will be covered more extensively in the chapter dedicated to them.

As a rule the stem holds the flower and the sexual parts, which are held in the centre of the flower. Therefore it is possible to draw an imaginary line from the stem through the sexual parts and these will be arranged around this line. Everything *has* to fit. Pay particular attention as to how the petals are arranged around the stem. Observe the shape of the overall flower, the petal unit known as the corolla, as well as the arrangement of the petals. Draw a faint line to mark the outline of the whole flower. Make a very faint centre guideline for each petal, and then draw one side of each petal followed by the other, as described for the leaves. Be aware that not all the petals will necessarily be symmetrical nor the same size as each other. Each time a new project is started it is worth taking a flower to pieces to examine each part and see just how it all fits together. To make this job easier it is best to start from the outside towards the middle. Make a note of each of the parts as you go along as this way you can identify everything with greater speed and efficiency when you come to draw and subsequently paint the flower. As you remove the parts it can be useful to use a pair of tweezers to handle the delicate components. These can then be laid on a sheet of graph paper, which will not only make measuring faster, but will also mean their shape can be swiftly assessed against a vertical and horizontal grid.

It is worth getting to grips with some simple Botany if this has never been studied, and there are some excellent books

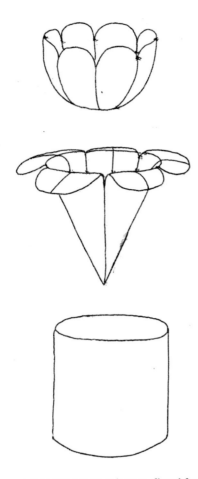

Geometrical shapes to relate to floral features.

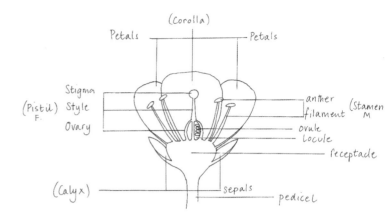

A simple diagram to show the floral features.

available. A little clarification is always useful. The *stamens* are the male parts of the plant and the *pistil* is the female part of the plant. A *stamen* is made up of the *filament*, or stalk, which bears an *anther* in which the pollen is produced. The *pistil* is made up from the *stigma*, which is held on a stalk known as the

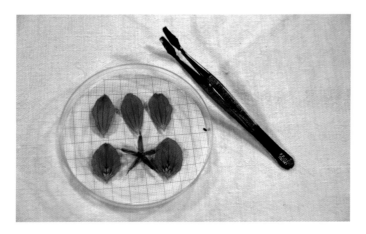

Geranium petals in a petri dish with graph paper for accurate measuring.

style, and the *ovary,* which is the seed box. The *locules* are the chambers within the seed box that hold the developing seeds, providing, of course, that fertilization has taken place. *Nectaries* are honey-secreting glands that are frequently found at the base of the petal. The flower is attached to the *pedicel (*the stem or stalk) and the *receptacle* is where the stem swells to house the flower. The company of petals that make up the flower head is known as the *corolla.* The petals in the *corolla* are protected by the *calyx,* which is made up of individual *sepals.*

These are merely a few of the basic and most simple terms that should prove of some use for many flower painting projects. Further reading on the subject is always useful, and nothing beats drawing plenty of plants to come to learn the prominent botanical features and variations. *Monographs* are books dedicated to one particular species of plant and written by experts; they can be an invaluable source of reference.

A check-list can be helpful to ensure everything is accounted for.

1. The caylx – how many sepals, if any: what shape, what size and what colour?
2. Sepals – shape and distribution?
3. The corolla – how many petals: what shape, what size and what colour?
4. Nectaries – visible or not: what shape, size, colour and how many?
5. Stamens – filament and anther: how many, what colour, what shape and size?
6. Pistil – stigma and style: what shape, what size and what colour?
7. Ovary – what shape, what colour, and what size?
8. Locules (chambers) – how many?
9. Seeds – how many?

Despite the great variety of flowering plants, the shape of the flowers fall into a fairly small number of possible combinations,

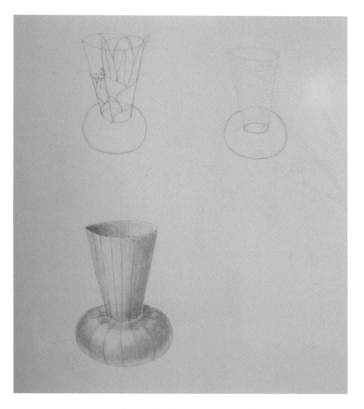

A crocus study – relating geometrical shapes to understand the form.

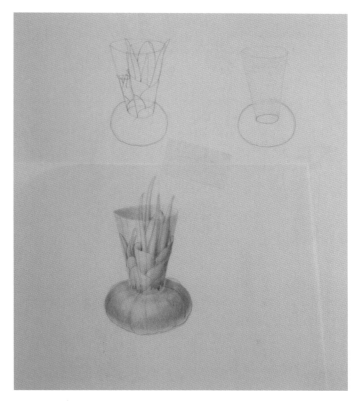

A crocus study – relating geometrical shapes to the botanical subject.

while the range of specific flower shapes is enormous. By taking a range of flowers and breaking them down into geometrical or simplified forms, they can be seen in relationship to the bowl, the saucer, the cone, the cylinder or combinations and inversions of these. Breaking the flowers down into simple shapes helps get the construction right, and from a simple beginning it is possible to develop the complexity of each flower relatively easily.

Do work from a fixed and comfortable position. When moving the head forward to see detail a little more clearly it is important to return to the initial position, otherwise distortion can occur. It is also a good idea to close one eye from time to time to check for accuracy. It can be useful to work from the general to the particular. The general refers to the most simple form observed: for example, drawing a simple geometric shape as a guide and then gradually adding the specific detail. The idea is to simplify the drawing, and then once a simple outline is achieved the precise detail can be added – such as leaf margins with the line getting progressively bolder as the corrections are made, or outlining the overall form of a plant and its arrangement before working in the detail.

No matter what the intention of the painting, an accurate drawing cannot fail to please both the artist and the viewer.

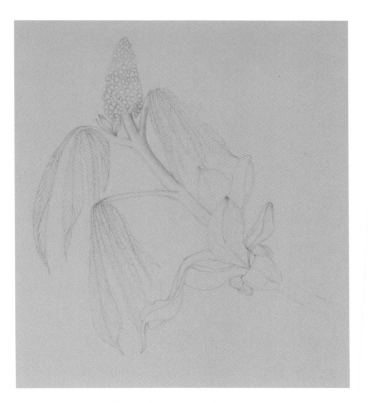

Horse chestnut study page.

It is a mark of achievement, with the eye, the mind and the hand working together in harmony. Accuracy, however, does not need to eradicate the artist's response to the subject since, by the very nature of human character, this will be imposed on the subject. What is important is to capture the essence of the subject described so that it can be recognized for what it is.

THE SHADED DRAWING

Shading Exercises

CONTINUAL TONE

Once a good outline has been drawn, it is useful to give the drawing form. It is through form that one is able to give the subject the impression of volume; that is, the impression of a three-dimensional object. To grasp this notion it is valuable to begin with a tone drawing using pencil shading. This type of exercise will be of great help when it comes to the painting process as they are directly related. A shaded drawing in pencil using continual tone will help to reveal the form, without the distraction of colour, pattern or markings on the subject. A black and white photocopy of a leaf can reveal the effective reduction to monotone. A little time playing around with the settings on the machine may be needed to get a sufficient range of tones.

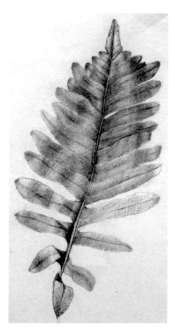

Shaded drawing of a fern developing tonal values in pencil.

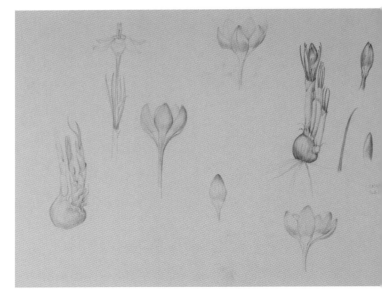

A crocus study page.

Continual tone is a means by which pencil is laid on the paper smoothly without any visible gestural marks. To begin with use a relatively hard pencil, such as the HB. After a few experiments it should be possible to achieve excellent results using a 2H pencil, remembering to keep the pencil pin-sharp. Unlike using a soft pencil, where the edges can be blurred by blending the tones with a finger, with a hard pencil such as a 2H the change in tone is purely down to the touch of the pencil on the paper.

If this method of shading is new there are a few exercises that will help you to become familiar with the technique, before beginning with a plant study. Select a smooth cartridge paper, and if using a loose sheet rather than a pad or sketchbook, it is worth securing it to the board with a bit of masking tape. Do a few loose doodles in preparation, purely to relax into the study. Start practising the shading by drawing a strip on a sheet of smooth cartridge paper. Don't make it too long, just sufficient to be able to show a good variety of tones. A rectangle approximately 0.5cm by 3cm would be good.

Using a very light touch, barely dusting the paper, move the pencil across the paper in small ellipses. As previously mentioned the darker tones are achieved by building up layers of graphite with a very sharp point of the pencil, not through increased pressure. If pressure is increased the graphite can become burnished and too smooth, which will resist additional layers. Once the technique is mastered, the lightest tone can eventually be the paper and through very subtle incremental changes it can move towards the darkest achievable tone from that point. This exercise does require patience but, once conquered, it will be invaluable.

From the beginning it is useful to work out the tonal range of your subject. For example, a drawing of apple blossom will have

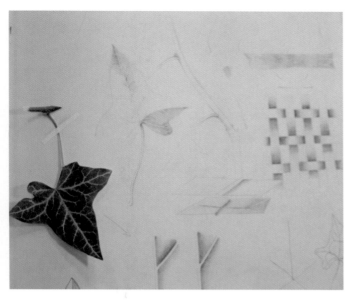

A sketchbook page with a photocopied ivy leaf and tonal exercises.

Shaded exercises within a sketchbook.

Tonal values in pencil relating to a study of apple blossom.

surrounding tones will need to be lighter, and *vice versa*. Once the tonal range has been established, it can be put into practice. The paper can provide the palest tone (0) and the object of the exercise is to work up to the darkest tone, which can be up to (10).

Colour can be a constant distraction, and until tonal analysis becomes second nature it can be useful to squint or peer through half-closed eyes in an attempt to assess the tonal values. As colour has the ability to dominate, peering reduces the intensity of the colour and sometimes it can be easier to see the tonal values. To help understand the theory of the basic form to which the tonal range is related, take a good solid shape such as an apple or gourd, and paint it with white household emulsion. This will prevent you from being distracted by the colour, as well as by any pattern present, and enable the form to reveal itself. Position the painted apple or gourd with a table lamp to the left of it to enhance the illumination, which will in turn enhance the form. Put a partner to the chosen subject beside the white one and just observe the difference and how the colour and pattern can cause distractions. A shaded drawing of the white object can be useful in itself.

By tradition the light source is seen to come from the top left of the subject matter. This helps prevent a shadow being cast by the hand, which could obscure the work for the right-handed. For those that are left-handed the light source can of course be reversed, to be seen coming from the top right. A further reason for having a constant light source is that it helps show the form and enables detail to be picked out with clarity. An additional benefit is that it is possible to work from theory; this means that when a situation presents itself, where the light source cannot be manipulated, or the source of daylight changes during the course of a day, work can still continue and the rendition of form will be constant.

A part of Botanical Painting that delights is the illusion of 3D; when it is almost as if the image could be plucked from the page.

a relatively small tonal range due to the delicacy of the flower. The leaves however, being darker, will have a greater tonal range, especially as some of the leaves can have a slightly shiny surface, which will read as a very pale tone. The progression will be from very dark to pale.

In observing nature it becomes apparent that there are many varying tones. However, a tone does not exist alone; it is always relative to another. It is the relationship between the tones that is important. Once this is mastered it will give vitality to the drawing and painting. It is useful to consider that if something appears dark in tone, in order for this to be observed, the

In order to create a feeling of 3D, a minimum of three tones are required: dark, medium and light. The greater the number of tones, the greater the impact will be. It takes courage as well as patience to make the dark the darkest possible and the light the lightest possible. Black and white photographs can be useful to study to see tonal values at work. Spend some time collecting photographed images from magazines. For this purpose, they do not have to be limited to plants as the object of the exercise is just to see how subtle the changes in tone can be, and at the same time how dramatic an effect this creates.

It does pay to be methodical. For example, when shading, a useful tip is to shade according to direction of the growth of the plant. It will save a lot of confusion in the interpretation of the facts. Do try to keep the use of the eraser to a minimum. Before beginning, establish from the outset the lightest and darkest areas. Generally, it is easier to begin in the darkest area and progressively move to the lightest area, but some people do not find this is so. As progress is made, as in all things, the approach will become a matter of personal choice. Sometimes it is useful to cover each area with a light pencil tone first and build up from there. The key to a successful shaded drawing will be practice. Regard this as a similar exercise as practising musical scales for the piano. Shading exercises will be of great help when it comes to painting the subject, so keep the drawing in a safe place so it can be referred to at a later date. A sketchbook is especially useful for this purpose as everything can be kept in one place and referenced both quickly and efficiently

As an exercise, first take a small subject to study such as a tulip bulb or crocus corm, or something similar. They have the benefit of being small but providing enough detail to be interesting and of manageable size. Try not to rush into the detail. It is useful to get into the habit of working from the general to the particular. Therefore establish the form first and then build up the detail gradually, responding to the areas of light and dark created.

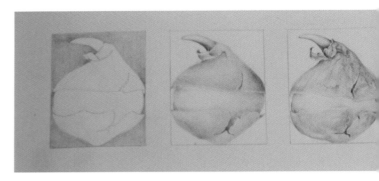

A tulip bulb study: (a) the use of the negative space when drawing the outline, (b) developing the form, and (c) adding the detail last.

Make use of the 'negative' spaces to help you. The positive space is the space the subject occupies; the negative space is the space around the subject. When satisfied with the outline, the shading can begin. Establish the lightest area and this will be left so the paper will show through as the lightest tone. Beginning with a very light touch which barely dusts the page, shade this area in with very small ellipses to fill it. Then begin to shade in the darkest area and progress gently towards the lighter tone, but stop at approximately one third of the way across the drawing. Three tones should be visible. These tones can now be enhanced by making them darker; in order to arrive at a darker tone, build up the layers by going over the previous layer, leaving a little of the latter visible. No extra pressure should be exerted, as the depth of tone is achieved through more layers and a very sharp point of the pencil. Do not rush to the detail, as this will be added once the form has been completed. Try to refrain from relying on an eraser; it should be used with great economy. Having mastered this method of shading it should be easier to progress to using the harder 2H pencil.

CROSS-HATCHING

The gradual progression from one tone to the next results in a smooth and lustrous effect, and this relates well to Botanical Painting. However, it can be a laborious task and this is why cross-hatching can be a most useful way of shading a drawing when time is of the essence. Cross-hatching can also be covered with a quick watercolour wash, which is especially useful for making quick sketchbook notes.

With some experience, cross-hatching and continual tone can be combined. As long as the touch is light the cross-hatching can be covered and ultimately hidden with continual tone. This is a good way of covering a large area quite rapidly, which is especially useful for larger subjects. The emphasis is on keeping a light touch.

Two gourds: one painted with household emulsion, to demonstrate the distraction of colour when looking at form.

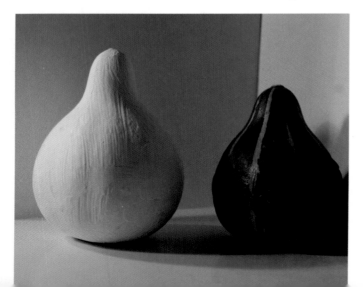

Cross-hatching overlaid with watercolour paint.

If undertaking a shaded drawing it is not essential to complete the whole drawing with pencil. Sometimes it is sufficient just to highlight the areas which might be considered problematic, to clarify specific areas of drawing, or perhaps where an interesting surface pattern is observed.

If a shaded drawing seems a laborious process, place a sheet of tracing paper over the line drawing, and shade the tracing paper. The slippery surface of the tracing paper will speed up the process.

RELATING THE SHADED DRAWING TO THE PAINTING

The seduction of colour is irresistible and there is a natural impatience to want to get to the painting immediately. If temptation can be resisted, patience will invariably be rewarded. A shaded drawing can be a thing of great beauty in itself and the time spent on such an exercise will rarely be wasted, and in fact a shaded drawing has the potential ability to help speed up the painting process. It has the added advantage that there is always a permanent record of the plant, which can be useful for compositions in the future or purely for reference. It can also act as a sort of insurance policy if the plant should suddenly die when least expected, or if an accident should befall your painting. Accidents can and do happen – spillage of dirty water pots, cups of coffee, inquisitive cats to name but a few.

When drawing, try to refrain from relying on an eraser. With practice, the use of it can be kept to a bare minimum. However, when erasers are needed it is useful to have both the putty rubber and the plastic eraser close to hand.

For the purpose of this exercise another small subject was selected. A simple outline of a Brussels sprout was drawn. Then the darkest areas and lightest areas were established before commencing the shading. Beginning in the darker area at the base of the right-hand side of the sprout the shading was gradually built up to obtain the form, and then the detail was

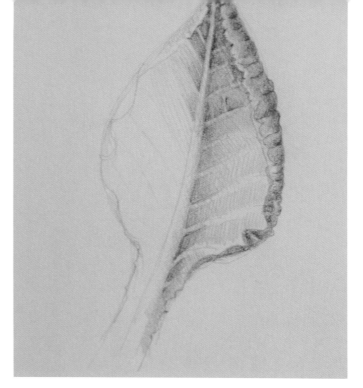

Cowslip leaf study.

added, relative to the local tone. From this a painting study was made, building the tones and detail in a similar way and adjusting the colour accordingly. The conversion of the drawing into watercolour is described in the following chapter.

Brussels sprout study: (a) the shaded drawing related to painting, (b) a painting using only the shaded drawing, and (c) a painting from the live specimen.

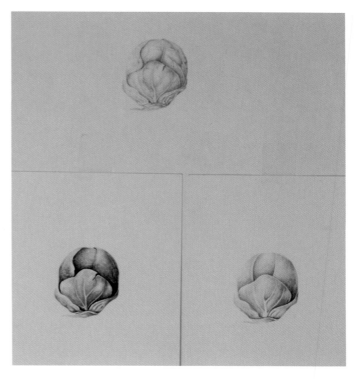

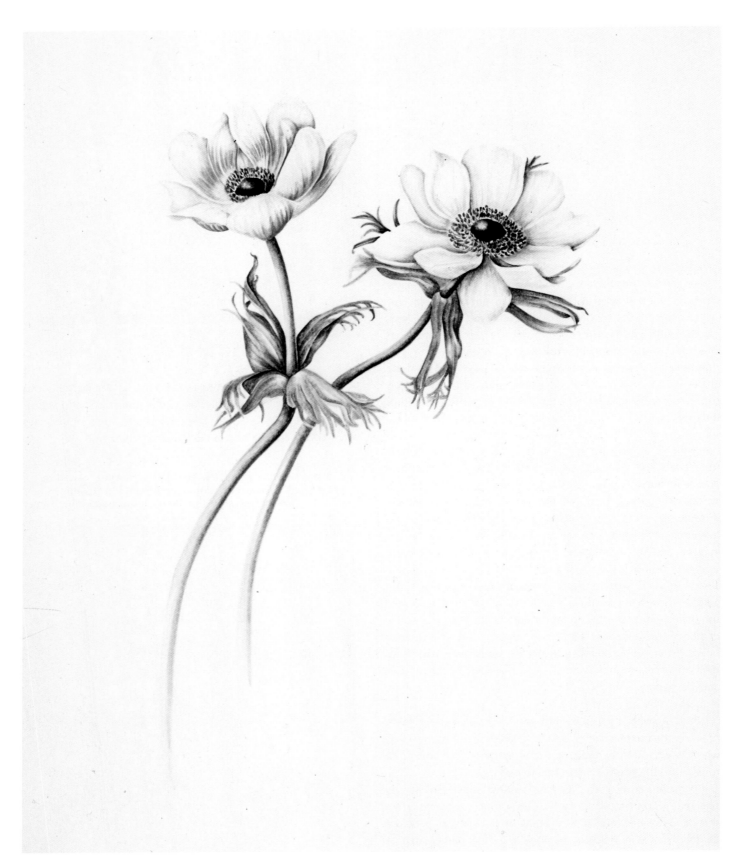

Anemone flowers.

PAINTING EXERCISES

One of the most distinctive features of Botanical Painting is that through the addition of layers of paint the beauty of the colour is able to shine out, going some small way to replicate the way in which plants shine out in nature. Each layer of paint rests on the previous one, giving an intensity that is not usually found in other watercolour techniques. By using hot-pressed paper which is very smooth, the layers of paint can be built up. The secret is to leave each layer to dry perfectly before adding another. As these are built up, so too is the quantity of paint; as the subsequent layers are added, the time taken to dry increases. The paper will only take a certain number of layers

before they start to move, and an understanding of this process will be achieved through trial and error as many factors come into play. The mobility of paint can be used to advantage in the later stages of painting.

BRUSH WORK

It is important to be well ordered and organized. Take a small sheet of hot-pressed paper and some kitchen towel, or blotting

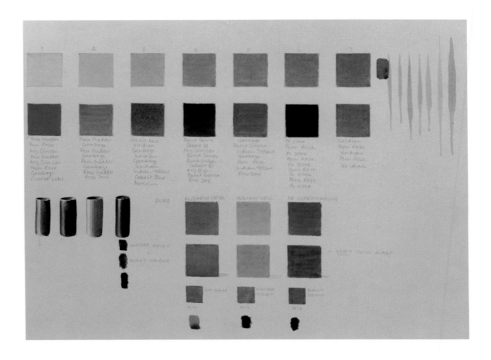

A study page using layers of different colours to reach a deep rich tone.

paper, to use for regulating the amount of water on the brush; this also can be used in the case of emergency for spills. A sheet of scrap watercolour paper or cartridge paper is useful as a hand guard to protect work, and this can also be used for testing the colour, even if using a mask for this purpose. Using an old brush to mix the paint, transfer the chosen colour to the palette and add enough water to dilute the paint sufficiently to mobilize it. Take a reasonably large brush, such as a No. 5 or No. 6, and load it with paint; as the brush is removed from the paint gently twist it against the side of the palette. This will ensure a good point is kept on the brush and excess water is squeezed out. The paint should be able to flow comfortably without gushing out. If too much water is held by the brush, gently dot the tip on the kitchen towel, or blotting paper, to take up the excess.

Beginning on the left-hand side of the page, paint a line from left to right. As progress is made across the page, gently press down on the brush to maximize the amount of contact the brush has with the paper. Once painted, charge the brush with more paint and start a new line. Repeat the exercise but, this time, just past the halfway mark slowly begin to reduce the pressure until at the end the brush is barely touching the paper. Once again start with a new line repeating the process of charging the brush and, beginning on the left hand side, press down on the brush and immediately begin to lessen the pressure, so that the tip of the brush is barely touching the paper, but is still in contact with it. Once you have achieved this, press down again and then begin to lift once more. Retain a good point at all times and do not be afraid of exerting pressure.

The last exercise should result in a wave effect. The purpose of these exercises is to demonstrate the different effects that can be achieved purely by adjusting pressure on the brush, and will give an idea of the possibilities. Hopefully it will also begin to show how the flow of paint can be regulated as well as increase the understanding of the potential of making full use of the brush.

LAYING WASHES

A few exercises are outlined which are designed to reveal the properties of the paper and to help the student grasp the idea of layering paint. These exercises both relate to and refer to the pencil shading method and use the building up of layers of paint to move from light to dark in much the same way.

One of the hardest things to convey is the ratio of paint to water – water to paint. It is important to have just the right amount for the job and this will vary from painting to painting. Control is everything. Too much water and the paint might run all over the place, with the danger of the paper cockling and the paint pooling. When paint pools it has the effect of leaving lines and hard edges, which can be difficult to eradicate. The lines caused by pooling can occasionally be put to good effect, but only when applied under strict control. If the paint is too dry it will stick and become streaky. The brush plays an important role in the control of the paint. Miniature brushes have a fat belly and an excellent point. The fat belly allows for a good deal of

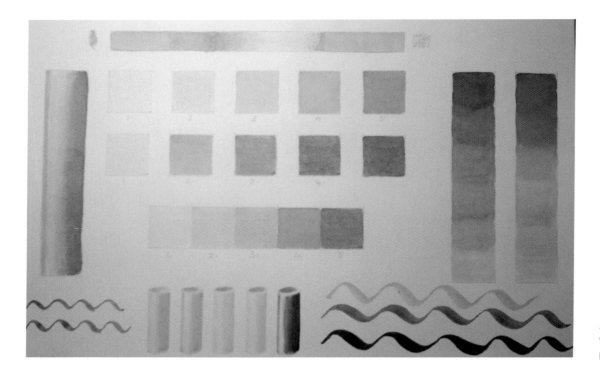

A study page laying washes and varying the pressure on the brush.

**A study page laying
washes to get
progressively lighter
and darker.**

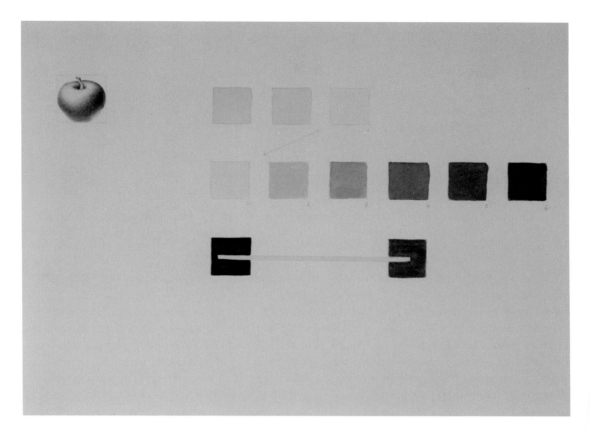

water to be held by the brush ensuring the paint flows evenly. It is important to learn just how much water is needed to mix with the paint and how far each load of paint will last.

Firstly, become familiar with the brush. A good exercise is to practise the application of paint into a series of small boxes. Using one colour straight from the pan, for example Burnt Umber or Winsor Violet, put a fair amount into the painting palette and dilute this with enough water to mobilize the paint. It should be fluid enough to be taken up by the brush easily, and be relatively dilute.

For the first exercise draw a row of three squares each measuring 2x2cm. Take the paint mixture described above and add more water until the mixture is very pale. Load the paintbrush with paint, gently twisting the brush as it is removed from the paint in order to keep a good point. Beginning in the top left-hand corner of the square, place the tip of the brush into the corner and, working swiftly, move the brush from right to left, keeping it in contact with the paper at all times. Just before reaching the right-hand corner, begin to lift the brush slightly. Moving down a small amount, overlapping the first line slightly, return to the left-hand side of the square making sure no gaps are left. The paint should move smoothly, if enough water is on the brush.

Having successfully filled one square, add a little more water to the paint and then apply this mix to the second square on the paper. Repeat this exercise one more time to complete the

third square. The final resulting wash should be very thin and pale. Observe how the paint dries slightly darker. The tone in the third square will be the tone required for the first application of paint. The first layer of paint seals the paper, making subsequent layers easier to apply. Although each paper reacts differently to paint, it is always worth applying this first thin wash of paint as it does provide a good base from which to proceed. Take care not to go over the pencil lines, as once painted over they cannot be erased easily. It is good to get into the habit of painting up to the pencil line and not straying beyond the margin.

This very pale tone provides the first wash of paint and relates to the palest tone in the shaded drawing. With very pale or white subjects, the first wash can be just pure water. From here the object is to build up gradually until the required depth of tone is achieved. The following exercise will demonstrate how this can be done. Try to make sure there is enough colour on the brush to complete the square without recharging the brush. This, in all probability, will take a little practice so don't be put off if it doesn't work immediately. If the finished product is streaky it could be the result of not having enough water in the mixture, or that too small a brush has been used relative to the size of the square. If the paint has pooled there was most probably too much water on the brush, or the brush was too large, relative to the size of the square.

Working methodically, there are two good ways of

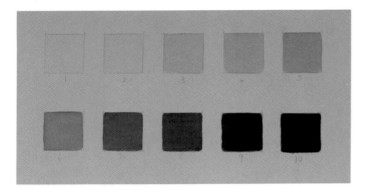

Ten washes of Winsor Violet to relate to the building up of tone in a painting.

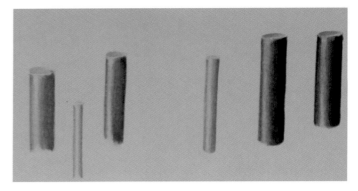

A series of tubes building up the sense of form in a range of tones.

achieving the full range of tones. One is to move from light to dark and another is to move from dark to light. Arguably the method offering the best control is where one progresses from light to dark by building up successive tones. For this exercise draw a row of at least six 2x2cm squares. Mix a very dilute colour as described in the previous exercise and, beginning at the left-hand side, fill each square with this mix, leaving it to dry thoroughly. Mark the first square with the number 1. Then adding a touch more paint to the mix begin to add a second layer, starting this time at the second square. When the row is completed mark it with the number 2. After completing the second square more paint can be added to the mix to make the colour stronger. Proceed in the same manner until all six squares have been filled. At the end of the exercise there will be six progressively darker tones and it should be possible to see a gradual deepening of the tone, giving a beautifully rich colour. Remember to leave each layer to dry perfectly before applying a subsequent layer. These squares, numbered 1 to 6, will show the quality of each of the layers. As a suggestion, do not number the layer until the row is completed, as it is easy to forget which squares have been painted until familiar with the process. Do not be limited to squares; any shape such as a circle, oval or rectangle can be used, but don't make them too big as this will only serve to increase the challenge.

The main reasons for leaving the paint to dry completely are threefold. Firstly, when the paint is applied, the fibres of the paper rise up and as they dry they return to the original position. If paint is applied when the fibres have expanded, the colour will be pushed into the paper rather than sitting on the surface. Secondly, if fibres become detached from the paper and mix with the paint, this can cause unsightly marks that are virtually impossible to remove. The third reason is that the layers of paint need to sit on top of each other rather than mix together. If the layers are not left to dry, the paint can mix on the paper resulting in a dull, muddy effect.

PAINTING A SIMPLE FORM

The next step is to transform the exercise into painting a shape that represents a botanical form. For the sake of simplicity, a tube is an excellent place to begin as it relates well to the shape of a simple stem. Draw a number of tubes, neither too large nor too long, and proceed to convert the exercise with the squares into tubes. Begin by filling each tube with the palest of washes. When this layer is dry, apply another layer but this time cover only one third of the tube. Blot the brush gently to remove only a little of the paint and, as swiftly as possible, soften the leading edge of the paint before the paint dries fully. The leading edge of the paint is where the application of paint ends and the new one will begin. If the paint dries before the leading edge is softened, a distinct line may appear. Neither fret nor try to fix the problem immediately. It is better to leave an unsightly line than fuss over it trying to make a correction. As the paint is applied in layers, any errors created will soon be covered by the subsequent layers, and will be hidden. Next, apply a third layer progressing to about half way across the tube and soften the leading edge in a similar way, then lift the brush and take it to the left-hand side of the tube, delicately painting a very thin line following the drawn line of the tube. This will provide the 'return', which will give the appearance of a round form, and the illusion of 3D. These layers can be repeated as many times as needed until the required depth of tone is achieved.

COLOUR MIXING

For the beginner there are a few exercises that can be useful to practise, in order to learn a bit about colour mixing. For the more experienced artist it is hoped there will be pieces of information which may prove useful to revisit or rediscover. It is often the case that information is sometimes forgotten along

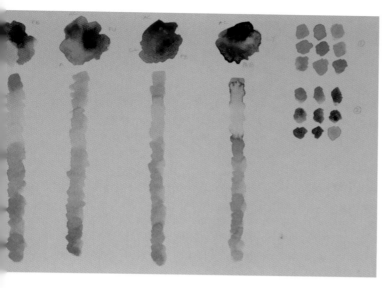

Colour mixing exercises to find a strong neutral tone.

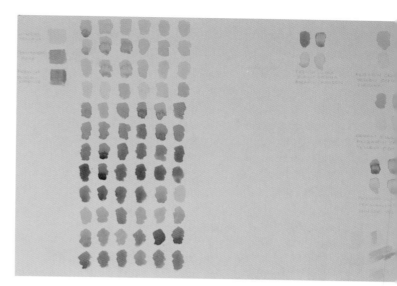

French Ultramarine, Permanent Rose and Winsor Yellow mixing, and an exercise in grey.

the way and it can be good to be reminded of it, or a different approach may be refreshing.

It is worth establishing a few basics, often taken as understood in many books on the subject of colour theory, but just to serve as a reminder:

- Hue – is the name of the colour.
- Tone – refers to the 'tonal value' – that is its lightness or darkness; pale or saturated.
- Intensity – pure colour, or greyed; modified.
- Temperature – can be warm or cool – warm colours are yellow/orange/red, while cool colours are green/blue/mauve.

When considering temperature, a red can be a warm red, being closer to the yellow side of the spectrum such as in a scarlet, or a cooler red, being closer to the blue side of the spectrum as in crimson. This will apply to almost all colours. It is one of the factors that makes colour mixing such a complex process and one which can become ever more compelling as knowledge and practice increases. Some artists have spent a lifetime dedicated purely to the study of colour and colour theories.

There is no need to buy a huge range of colours; it is possible to get a magnificent range by using just three primaries: yellow, red and blue. The secondary colours are arrived at by mixing yellow and red to get orange, then red and blue to get purple and finally yellow and blue to get green. With a little adjustment to the mixtures, the browns and greys (known as tertiaries) can be achieved very successfully and so it is that with just three

A colour mixing exercise using Alizarin Crimson, Prussian Blue and Transparent Yellow.

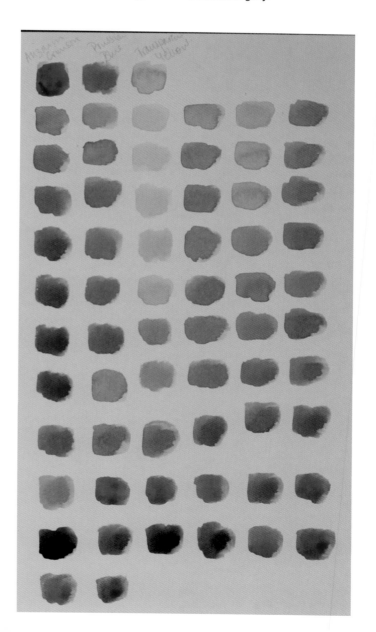

pans or tubes it is possible to paint any botanical subject. The skill lies in selecting the most versatile three colours. With a bit of experimentation it will soon become clear that some colours just do not work together, and others sing in perfect harmony. By limiting the palette, the task of colour mixing is relatively simple and just takes a little patience and perseverance to succeed. An excellent place to begin is French Ultramarine, Permanent Rose and Cadmium Lemon, as demonstrated in the Brussels Sprout exercise.

Once familiar with the idea of a limited palette, the move towards using a broader palette can be undertaken with greater confidence. However, once this theory is grasped, there is something very satisfying in using only three colours. There will however be times when a specific colour is called for in order to do justice to the botanical subject – some colours just cannot be mixed. Also, as will be seen later in the book, the use of thin glazes of specific colours enhances the painting and brings the work of art to life. This calls for specific colours that cannot be effectively mixed by using a limited palette. As will be demonstrated when it comes to painting a yellow subject, it is useful to have a broad range of yellows available. Equally, by having a good range of colours available, when a specific colour is called for, it is there to use without having to waste time trying to mix and match it. As mentioned earlier, it is useful, if not essential, to make a chart of the colours in your paintbox or collection, and label them with their names for quick reference. The colours can, and do, change from their appearance in the pan or when squeezed from the tube. For example, Aureolin in solid or tube form reveals nothing of the clear bright yellow that defines it. Colours will also vary from manufacturer to manufacturer.

Mixing some complementary colours.

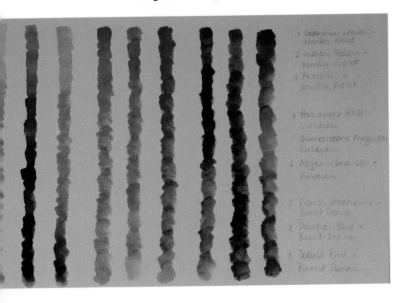

Colour chart in hand, it is useful to see just what can be achieved through mixing three colours: yellow, blue and red. Beginning with a yellow, gradually increase the red so as to change it from yellow, through orange to red. Then do the same with the yellow and blue, moving from pale green to dark green to dark blue. Repeat the process with blue and red. Then by taking the mixed colours, for example purple, begin to add increasing amounts of yellow. The object of the exercise is to mix the colours so as to get as full a range as possible. You should be able to obtain the full spectrum from red through to indigo if you have chosen well. This exercise can be repeated again with different mixes. Some mixes will just not work. It is just as good to learn the mixes that don't work as well as those that do, to prevent problems occurring. However it is inevitable that through practice these will be discovered in time.

Complementary Colours

There are many books written on the subject of colour theory and it can be helpful to do a bit of reading around the subject, especially if watercolour painting is a new venture. Although it has its limitations, the 'Color Wheel' (TM) is an excellent tool, especially for the beginner. The colours of the spectrum are arranged in a circle, and one of the theories when using a colour wheel is that a colour can be darkened by using the complementary colour, that is the colour found opposite on the colour wheel. However, with this theory, it is important to work out, for example, whether the yellow veers towards blue or towards red. That is, is it a blue-yellow, which is cool, or an orange-yellow, which is warm? Once this has been established it becomes easy to find its opposite. In the case of yellow, the complementary colour is violet. Depending on the yellow, the selection will be either a cool violet, in the case of the warm yellow, or a warm violet in the case of the green-yellow. Aware of the fact that this sounds very complicated, the best solution is to have a go and experiment. It will help enormously to know which colour mixes to employ and which to avoid. Do make copious notes of all mixes as even the most unlikely colours can suddenly come into their own for a specific project and much time will be saved if the mix has been labelled.

By mixing the complementary colours together a neutral tone, or a grey, can be achieved.

Neutral Tones

An example of a neutral tone comes in a ready-mixed colour such as Neutral Tint, (a cool grey), Payne's Grey (a blue-grey), Sepia (a dark blackish-brown). Alternatively, a more exciting colour can be mixed from colours in the paintbox and there

are a number of options. As mentioned earlier, it is possible to mix a grey by using complementary colours: that is, green and red, blue and orange, yellow and violet. Alternatively, the mixture of the three primaries – yellow, red and blue – will give a richer neutral tone. Once the concept has been grasped, different colours can be chosen to get a wonderful range of subtle colours.

It is a very worthwhile exercise to set aside a few hours to experiment with mixing a neutral tone. By using a neutral tone judiciously the beauty of a painting can be enhanced. By placing a little grey tone next to a pure tone, the vibrancy of the pure colour can appear to be even brighter. The greater the confidence gained, the greater the effectiveness of using neutral tones will be appreciated. Surprisingly, it is also a very good way of becoming familiar with all the colours in the paint-box. There will be a number of occasions when a neutral tone is required, such as to give the feeling of perspective to a painting by fading areas of the painting to grey or, for example, to cool down an area that has become too lively, or to create a shadow. Neutral tones are invaluable for painting white flowers.

When mixing a colour using yellow as one of the components, it is advisable to begin with the yellow. It is important to keep the paints clean and it will be quickly realized that yellow is the easiest colour to spoil by contamination. It doesn't matter which yellow is selected but what is important is to make a note of the colour chosen. The easiest method is to have a palette with dimples or sections so it is possible to put yellow in one, red in another and blue in yet another and begin to mix from there, making a note of each of the primary colours as they are chosen. Try to keep the colours in the box or palette as clean as possible as this helps avoid unfortunate contamination. On the whole, if wanting a dirty colour, it is best to achieve this through deliberate choice rather than happy accident.

Gradually, mix each colour drop by drop. It is surprising how little of each colour is needed to change the balance. Try to obtain a good variety of greys, that is, a warm grey, a cool grey, a green-grey, a purple-grey and so on. It is always possible to achieve a variety of temperatures within a specific colour, even though at times it can be very frustrating, as the balance is easily lost. Keep persevering and the reward will be an excellent reference sheet. As and when time permits, keep experimenting with colours, especially when a new purchase is made.

Getting to know the properties of watercolour paint is a worthwhile exercise. Such exercises can make use of the long winter evenings when the choice of plant material and available natural daylight is limited. They can equally be undertaken bit by bit, as and when time allows. One particularly useful exercise is to check the flow of a particular pigment. These vary quite considerably, and sometimes a struggle with a particular painting can be put down to the pigment selected causing the problem, not the ability to paint, or otherwise. Discovering this

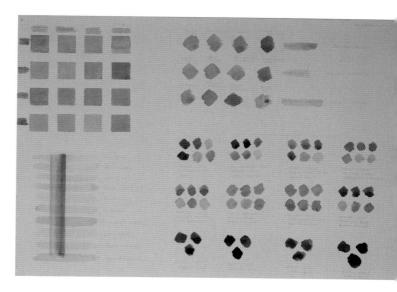

An exercise to mix greens, greys and to layer washes in order to modify the green to make it more naturalistic.

can be an enormous relief, but working this out before beginning will save a lot of time in the long run. It is important to work methodically to progress through the colours in the paint-box, and to choose a sheet of hot-pressed watercolour paper to make the exercise relevant. With a large clean brush (No. 5 or No. 6) put a large drop of water onto the paper and spread it out. Leave it to dry for a few seconds (the water should still have a slight sheen to it, but it must not dry completely). Then, taking a good amount of the selected colour, put the brush in

A painting in monotone using a mixed grey.

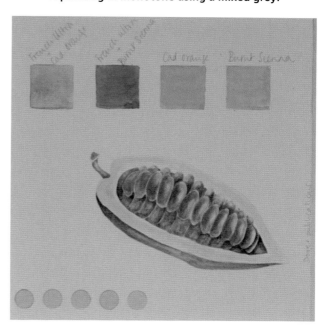

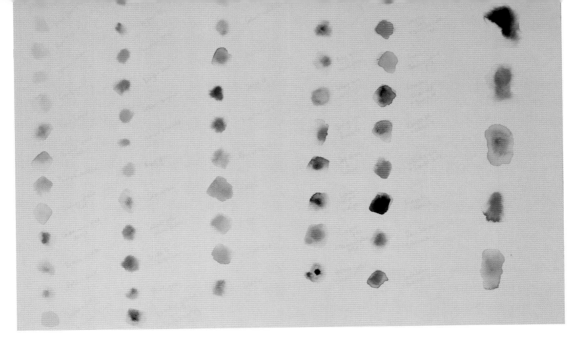

the middle of the water drop and hold it without moving for a few seconds to allow the paint to leave the brush. Leave this to dry thoroughly (depending on the climatic conditions this can take as much as twenty minutes). Proceed in the same way through each of the colours and label them. When they have all dried, observe and compare the results. Some colours will have filled the entire wetted area, others will have barely moved. Some colours will fade smoothly to nothing and others will granulate and separate.

This exercise should help the judicious selection of colours. Each colour has its own specific merits, so do not necessarily discard a colour; just be aware of its properties and use it for specific projects. It is interesting, for example, to compare two blues, Cobalt Blue and Prussian Blue, to observe the differences between them. It is important to know which colours granulate (separate) and which do not. The colour charts available from

manufacturers generally give this information, but there is nothing quite like practice to experience the effect personally. When mixing green for a plant, and there is usually much more green than any other colour, it is good to be able to not only depict the accurate colour but also the texture of the plant, and knowledge of the properties of the colours will help enormously in this task. Time spent over some exercises will never be wasted and indeed will speed up the process of painting in the long run.

Wet-in-Wet

Sometimes wet-in-wet can be useful for specific projects. For wet-in-wet the paper is wetted with plain water, or even a wash of colour, and then before the paper dries the paint is dropped onto the damp surface. This paint can then be gently manipulated with the paintbrush, or left to its own devices. Just remember that the paper should be damp, rather than wet. At first the water will give a gloss to the paper; the right moment to drop the paint onto the paper is when the lustre is just beginning to fade. Tilting the paper towards a lamp will help you see the change more clearly. Once applied, the paint must be left to dry thoroughly before continuing to paint. When the paper is damp the area painted will rise up slightly; it can be considered dry once the paper has returned to a flat surface.

A wet-in-wet study page.

Dry Brush

So far the concentration has been on the building up of layers of paint through washes. However, at a certain stage, which can be variable, it will not be possible to add more layers, as the paint will begin to lift off. The solution is to paint using a dry-brush method, applying the paint in little strokes, similar to

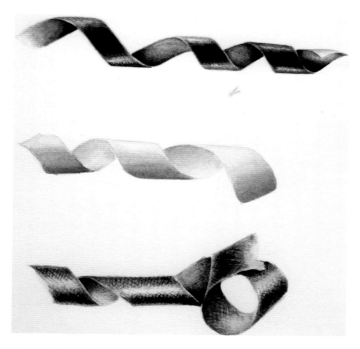

Paintings of wood shavings to contrast gradual tone and cross-hatching.

Cross-hatching watercolour to paint detail.

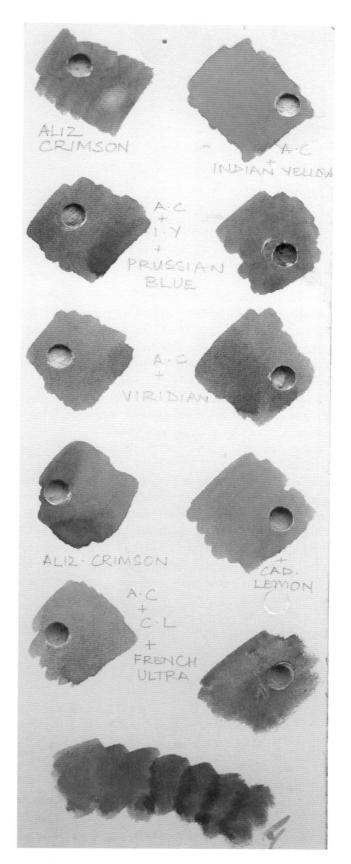

ALIZ CRIMSON

A.C + INDIAN YELLOW

A.C + I.Y + PRUSSIAN BLUE

A.C + VIRIDIAN

ALIZ. CRIMSON

CAD. LEMON

A.C + C.L + FRENCH ULTRA

A colour matching exercise to get an accurate colour match.

45

Thin washes of superimposed watercolour to use as glazes.

cross-hatching. It is also the most suitable method for coping with very small detail, where it would be impossible to build up the tone in layers. This dry-brush method is also useful when painting on an extremely smooth surface found on some hot-pressed papers, but especially with parchment and vellum. It is worth putting down a very pale wash to begin with and, thereafter, building up the form with very small brush strokes using a fine brush. The strokes, however, can be built up in a similar way as used for the layering of paint.

Having come to grips with some of the properties of the paint and its application, it is important to select the colours to be used accurately. The Royal Horticultural Society produces a magnificent colour chart used by botanists, which is matched by a magnificent price. It is an invaluable reference tool, especially for the artist who wishes to take the discipline further. Monographs written on plants frequently quote a reference for the colour identification. This number will refer to the Royal Horticultural Society chart. A simple and effective alternative is to mix a selection of colours that could be possibilities on a piece of scrap watercolour paper. Ensure a good saturation of colour is achieved and make a note of the colours mixed. Using a hole-punch, such as the type used for ring binders, punch a hole in each colour/tone and then match the colour to the subject by placing the colour patch against the subject.

Glazes

Once a painting is completed, a series of glazes in various areas will bring the finished painting to life. This is a good time for experimentation; very little can go wrong if attention is paid to a few basic rules. To begin with it is recommended to use transparent or semi-transparent colours, until the technique has been perfected. All watercolours are theoretically transparent but some are more transparent than others. Their transparency is listed on the manufacturer's colour chart, but they will soon become familiar. The following are some of the excellent colours that can be used very effectively for glazing:

Winsor Lemon, Aureolin, New Gamboge, Green Gold, Rose Doré, Quinacridone Rose, Quinacridone Magenta, Quinacridone Red, Scarlet Lake, Perylene Maroon, Winsor Violet, Winsor Green, Viridian, Phthalo Blue, Antwerp Blue, Cobalt Blue, Burnt Sienna, Prussian Green and Cobalt Violet.

The colour should be applied very thinly and used carefully. The art is not to disturb the underpainting so it is important to mix the colour with sufficient water and to use a good, large brush. The colour should be so pale that blending in is not a concern. The effect should be extremely subtle and the result barely visible. However, don't be afraid to add more layers if it is too subtle, just ensure that each layer is left to dry thoroughly, remembering that as the layers increase, so does the drying time. It is worth noting that cool colours (blues and mauves) recede and warm colours (yellows and reds) advance. These glazes can be used to give harmony to the finished work.

USING A SHADED DRAWING TO PAINT A BRUSSELS SPROUT

When happy with the control of paint and colour mixing it is a useful exercise to convert the shaded drawing to paint. A very simple line drawing will be required for the purpose of this exercise, and the pencil outline should be as pale as possible. The tones required for the painting will relate to the tones on the shaded drawing. The process of building up tones will relate to the way in which the tones on the shaded drawing were built up (as described in Chapter 2).

Taking the shaded drawing of the Brussels sprout as an example of how this works; the idea is to replicate the shaded

exercise in paint. The exercise will also demonstrate the use of a limited palette. Take one of each of the three primary colours – a yellow, a blue and a red – for the purpose of this exercise: Cadmium Lemon, or Winsor Lemon; French Ultramarine; and Permanent Rose would be good choices. Firstly, it is important to establish the colour mixes. The basic idea is that yellow and blue make green, but usually this colour is too vibrant and needs modifying. Adding the merest touch of red will reduce the brightness of the green and make the colour look more natural. By adapting the mixes, darker and paler greens can be achieved. Do test the colours first before committing to the painting.

Before starting to paint make sure the drawn lines are very faint; they should be just barely visible. It is important not to paint over the pencil lines, but paint up to just inside the line, because once painted over the line cannot be removed. Usually this is not a problem as the depth of colour, in all probability, will cover the line. Nevertheless, it is a good habit to get into.

Select an appropriate brush for the scale of the subject and mix a good quantity of paint as for the other exercises; a No. 3 brush should be perfect.

- Apply the palest tone to the sprout without painting over the edges, or any drawn lines. Each area should be treated as a completely separate area, rather like painting-by-numbers.
- Next, apply the second tone to the sprout, still keeping within the boundaries of the pencil line, but this time make sure a little of the first tone is left in the palest areas.
- Proceed by adding another layer in the darkest areas and ensuring that not all the palest colour is covered, while at the same time leaving some of the second layer visible. When this layer is completely dry add a further layer onto the last third. At this stage it should be possible to see the beginnings of the 3D effect. Try to perfect the manipulation of paint, moving seamlessly between layers and using just these three tones to grasp the idea before moving on to adding more layers.

The method of painting employed should follow the form: keeping the brush strokes in the direction of growth will give the painting coherence. At the same time, the tonal value of each area should relate to the form. For example, when describing a rib on the leaf, the tonal value will vary: it will be light in the lightest areas and dark in the darkest areas. On a spherical object, notice how the tone is paler at the high point of the curve. Relate this to the painting, as failure to do so could make the sprout look flat. If by misfortune the tonal value is too flat, all that needs to be done is darken the surrounding tones to regain the contrast. Try to remember that the detail will appear to be lost in the darkest and lightest tones. In the dark tones the detail will be hidden by the shadow, and in the light tones will

be bleached out by the light. This means that the detail really will only be seen fully in the mid-tones. This is excellent news because it can mean less work. If too much detail is included, the painting can become less convincing. When adding detail, the importance of paying attention to the tonal value cannot be emphasized enough.

To avoid harsh mistakes it is useful to remember the exercise where layers were built up and to apply this concept to everything painted, no matter how small. By building up the detail with this method, mistakes are less likely to occur. If a mistake is made when adding paint, do not try to fix it immediately. Leave the paint to dry completely (this may take up to twenty minutes). If the area is very pale, this can be resolved by adding a touch more paint to the area and then leaving it to dry. If, however, some of the paint needs to be lifted, apply some clean water to the offending area with your paintbrush, making sure the brush is not overloaded with water; then, using kitchen towel, blotting paper or rag, press firmly down on the paper to lift the paint. Leave this to dry thoroughly before continuing to paint.

At the point of completion of the painting, the fun can begin. It takes a leap of faith to go very dark, but this really can enhance a painting dramatically. Establish the darkest areas and begin to build these up, either with a series of washes in a deep shadow colour or with small strokes in the complementary colour, until the area can get no darker. In the case of the Sprout, using Cadmium Lemon and French Ultramarine with a touch of Permanent Rose, just alter the balance of the colours to obtain a rich dark green. Use the exercise to observe the effect of varying the green. In the areas facing forwards, consider adding a little more yellow to the green mix and, in the places turning away, consider adding a little more blue to the mix. This notion follows the theory that warm colours advance and cool colours recede, which enhances the three-dimensional effect.

The Brussels sprout drawing study converted to paint.

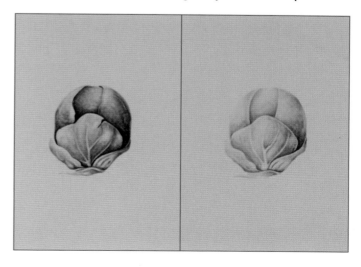

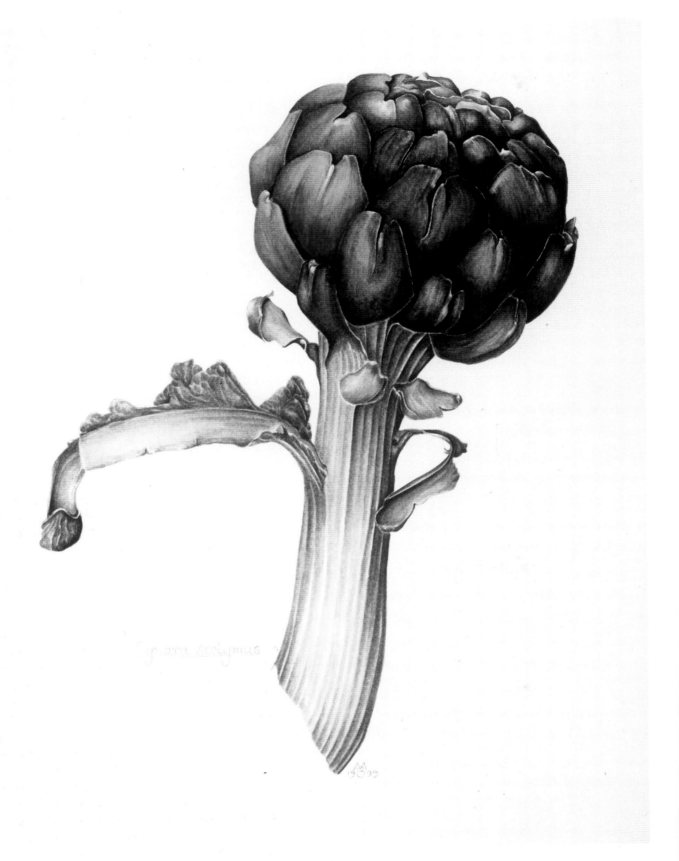

Purple artichoke.

SPECIFIC COLOURS FOR SPECIFIC PROJECTS

In the previous chapter on painting, colour theory was touched upon and some of the ideas and exercises will be repeated here; when addressing specific colours it is hoped that these exercises will reinforce various techniques. As explained, colour theory is a vast and complex subject and much of it can only begin to be appreciated through practice. The notes on colour are only suggestions, and to help avoid some pitfalls; however, they are to be seen only as suggestions. Nothing beats experimentation and part of the magic of painting lies in finding a personal path and palette. Take all this information in the spirit that it is given; to be of help. Ignore any or all suggestions. The very best way to success is to make informed choices through practice.

A white lily.

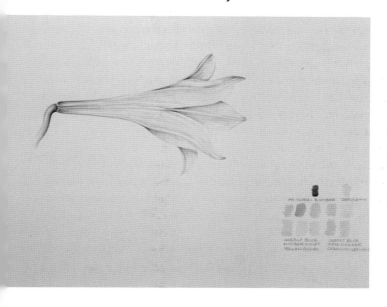

WHITE

White flowers are not nearly as difficult as they might first appear. They do, however, require careful planning before launching into the painting. The whiteness of the petal will be provided by the paper, and then the moulding of the form is created by using very gentle variations of grey or neutral tone. The first thing to establish is the nature of the white. Glancing through any available colour photographic images, study how white objects appear. Immediately it should be possible to observe the enormous variety of shades and tones there is in white. In almost every case, while the object appears white, there is in fact very little that is pure white. Having noticed the shadows appearing on the petals, caused by the veins of the petals, the light and the form, it will become clear that it should be necessary to leave as much white paper as possible. Too much grey, or a grey that is too dark, can make the flower appear leaden and heavy, so approach with care. When painting white flowers it is helpful to make a screen of white or grey mounting board to place behind the subject, which not only prevents distractions, but also prevents other colours from within the room interfering.

When a good grey has been matched to the plant and it is sufficiently pale, dilute the mix again twice more. It should barely look visible in the palette and may well just resemble dirty water – this will be a good starting point, especially as the paint tends to appear slightly darker when it is dry. If for any reason the paint separates in the palette, just move it around with the paintbrush to re-mix the colour.

A useful tip when painting a white subject is to try to place some foliage behind it. This will enable the white to really sing out, as the leaf colour will provide the background and the petal margin can be the paper. No paint needs to be applied to this

A double white camellia.

area as the work has been done by the background leaf. In the case of the petal of a flower, the petal edge will not need to be painted as the margin will be created by contrast to the colour of the leaf behind it. Where the white flower is going to be shown against white paper a very, very subtle grey edge may be needed for the petals to show. This edge should be of the palest possible hue, as it is always possible to make it a little darker if required. If the petal is frilled the line should vary in tone to reflect the frills. It is possible to depict this by using wet-in-wet technique. Firstly, make sure the paintbrush is immaculately clean. Load the brush with pure, clean water, and paint a line of a brush width round the edge of each petal, taking care not to go over the pencil line. Then take a small amount of grey paint and dot the brush along the edge of the petals, and after that leave the paint to dry completely. The pencil line can be erased once the paper is dry and a very delicate edge should reveal itself. It is definitely a good suggestion to practise this technique first on a piece of hot-pressed paper to see if this works before committing to a treasured composition. Once perfected, this technique can be used on any subject that requires a very delicate frilled edge, substituting the grey with the relevant local colour. This can be undertaken at the very beginning, before putting on the first wash, if desired.

Payne's Grey is quite a cold and strong grey, which can often be too harsh for the delicacy of white plants, even in dilution. Davy's Grey is a softer neutral tone and can be successfully used if the mixing of a grey seems too bothersome. Please do not be tempted to use a ready mixed black, or Chinese White.

YELLOW

The colour yellow is very pale in intensity which means additions must be made to get a full range of tones. This can be done in a number of ways and will to some extent depend on the yellow of the subject, for example it is useful to establish whether it is a pure yellow, a warm yellow which will be towards orange, or an acid yellow which will be towards green, or even a dirty yellow. When attempting to create a number of tones of yellow, consider using all the yellows available in the paintbox, beginning with the palest lemon yellow and finishing with the deepest yellow, possibly Cadmium Yellow. Once the yellows have been exhausted it will become apparent that a modifying colour will be needed in order to darken the yellow further. This can be achieved either by the addition of the complementary colour of yellow, which is violet, or by the addition of grey. In both cases, exercise extreme caution and ensure that the correct modifying colour has been selected. Test all experiments on a sheet of paper and don't forget to label the mixes.

For yellow flowers in particular it can be useful to paint the form of the flower first by using a soft grey added in layers, ensuring sufficient white paper is left for some of the pure yellow to shine through. This method can be used for any pale flower, or indeed can be developed for any botanical subject.

In the case of a yellow flower, try not to overdo the shadows, as they can easily look heavy, dull and lifeless. Be aware that any addition of blue in the mixture can make a yellow flower appear

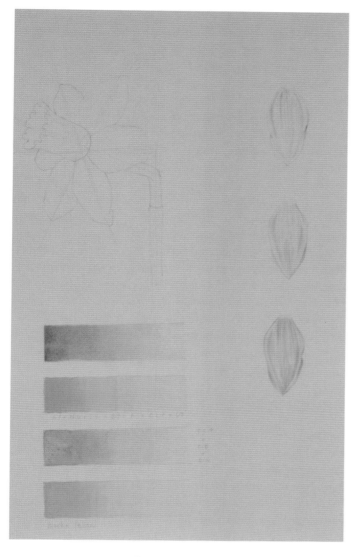

A yellow painting study.

green. Frequently green is seen in a yellow flower and this doesn't present a problem; nevertheless it is important to make sure that the green doesn't dominate. Always consider the implication of any addition to a colour and make tests before committing to a composition. Davy's Grey can be a useful neutral tone when painting a yellow flower but, as always, proceed with caution, as this colour has the ability to turn some yellows into green.

While the complementary colour for yellow is violet, some violets will turn the yellow orange, making it deeper, which can be most useful. Other violets will grey the yellow. The only solution is to experiment and make as many notes as possible.

A yellow colour mixing study.

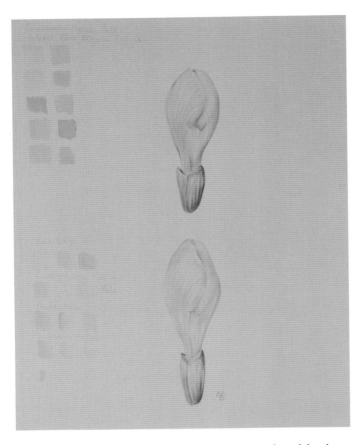

Painting a yellow crocus: two different approaches, (a) using grey to define the form, and (b) using the full range of available yellows.

ORANGE

When considering an orange subject it is possible to begin with yellow as the first wash, which can be interpreted as the palest of the orange tones. The richness of orange can be built up from this base. Don't forget the earth tones can come under

A piece of tangerine skin.

the umbrella of orange, and can be excellent, especially Burnt Sienna. Experiments in colour mixing often yield some wonderful surprises. When mixing orange, use the full range of reds and yellows and experiment as much as possible. A wash of red over the orange will serve to enrich the colour – and violet, depending on its properties, can either enrich or knock back the colour. Don't forget to keep a careful note of all the tests so these can be made use of at a later date. Winter presents an excellent opportunity to consolidate colour exercises. Equally rainy days can be put to good use, when the light isn't good enough for careful detailed observation and painting. Grey days can therefore be greeted with pleasure at the prospect of sloshing colours around with no particular end result anticipated, just the pure joy of experiencing alchemy and being openly speculative. Nothing can go wrong when undertaking exercises, only the accumulation of knowledge, as there is always something new to learn. Rose Doré is a delightful pale orange, very transparent and superb as a glaze. Scarlet Lake, while considered to be a red, in a pale wash can be seen as orange, and mixed with certain yellows it positively sings. The complementary colour for orange is blue.

BROWN

Consider brown as a deep orange. It is a magnificent colour and has the ability to produce rich and varied tones. When undertaking a brown subject for a painting, make full use of all the earth tones. They vary from the brightest Raw Sienna to deepest Burnt Umber. Sepia is a cool brown. It can provide some very good dark tones and the mixture of any of the colours in the paintbox will provide a wealth of choices to enhance any brown. French Ultramarine mixed with Burnt Umber will yield an almost black brown, while Cobalt Blue can produce a delicate smoky brown. Winsor Violet when mixed with Burnt Umber will produce an extraordinarily glowing rich brown, particularly useful for shiny brown subjects, such as conkers and various nuts. Experiment with some of the greens available as a mix with brown; they can be useful too, especially when painting branches and twigs. Woody subjects are rarely one brown only and it is good to be aware of the variety of browns that can be mixed. The complementary colour for brown will be blue.

RED

Red flowers can present a number of problems. The first problem is that almost all reds are staining colours, and difficult to remove if a mistake is made. Always try to begin with very pale tones and gradually build up to full saturation of colour.

An orange colour mixing study page.

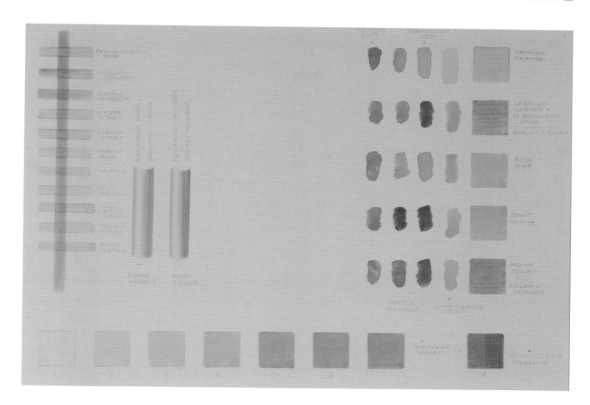

A painting of a shallot to demonstrate the possible variety of oranges and browns.

This is one of the colours for which this procedure will certainly pay off. The darkening of red too can be problematic, as the colour can all too easily turn brown, purple or just look miserably dirty. As always, it is good to analyse the colour accurately. Scarlet, crimson and pink all come under the umbrella of red. Frequently it will be possible to see all sorts of reds in one flower and these can be translated into paint by applying layers of each colour visible. However, to darken the red it will be important to work out the make-up of the red – that is, does it sit on the blue side (crimson) of the spectrum, or the yellow side (scarlet) of the spectrum? Each red will have its own particular modifying colour that will work sympathetically.

A red fuchsia study.

Experimentation and careful notetaking will help establish the best colours to use. Although this is time-consuming, it really will pay off in the long run. Such exercises only have to be done once and then a lasting record will have been achieved, which will be useful for every aspect of painting in the future. It has the added bonus of speeding up the process of painting a subject as time won't be wasted trying to find the right colour while the flower fades before the eye. Frequently, red flowers can look overly heavy so don't forget to make use of the full range of tones from the palest pink to the deepest red. Also don't be afraid of using a number of different reds and respond to each of the colours as you see it. When painting red flowers, clashing colours used sympathetically can give the flower the vitality that is witnessed

in nature. It is useful to establish which of the reds are staining and those that are not. Staining colours are particularly hard, if not impossible, to lift off the paper. The colour charts produced by paint manufacturers usually indicate the staining properties of a particular pigment and it is advisable to familiarize oneself with their properties. The complementary colour for red is green, but care needs to be taken in this consideration. A scarlet red will need a different green to a crimson red, and *vice versa*.

PINK

Think of pink as a pale red. Permanent Rose is an excellent colour in every way, either on its own or indeed to produce a wide variety of reds. It is naturally a bright pink that, with the addition of a touch of yellow, will produce a delicious scarlet. On its own it is a glorious pink, with a slight yellow hue. A touch of blue will produce a slightly mauvish pink and a touch of green will deepen the pink. Add a touch more green and the result will be a smoky, grey pink. On the other hand add too much green and it will turn brown. For a similar pink, but with a slight blue hue, turn to Quinacridone Magenta. A mixture of the two within a painting can complement each other, with Permanent Rose advancing slightly due to the element of yellow in its make-up, and Quiacridone Magenta receding slightly due to the element of blue in its make-up. Sometimes a pink will be pure pink, but at the same time there will be areas

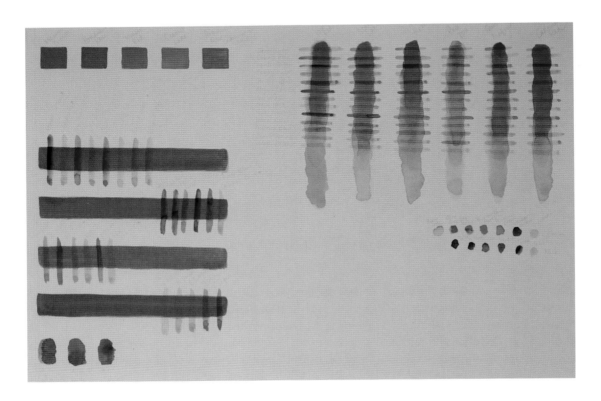

A study page for mixing and darkening red.

Darkening Quinacridone Magenta using its complementary colour, Viridian.

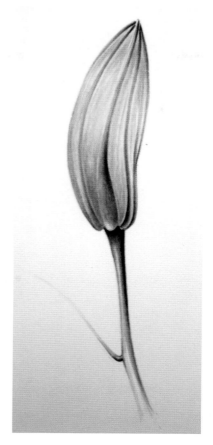

A green lily bud.

where the pink takes on a slightly yellow hue, and in other areas perhaps a slightly blue hue. Therefore be prepared to adjust the colours throughout the painting as the work proceeds and do not assume that because the flower looks pink it is one overall colour; it is seldom so. Cobalt Violet mixed with a touch of Alizarin Crimson can create a satisfying delicate pink. Cobalt Violet is a gummy colour, so it is best to use it as dilute as possible to keep it clear. The addition of Alizarin Crimson will literally be a mere touch. Taking a plant apart can help in the analysis of colour. Don't forget to examine the front surface of a petal as well as the back. There can be significant variations and this can have an effect on the whole. The complementary colour for pink is green.

GREEN

Green is the predominant colour experienced by the Botanical Painter and in all probability more green will be used than any other colour. It is not just confined to leaves, but can be found in virtually all vegetative features of plants, and the variety nature displays never fails to amaze.

There are a number of plants producing green flowers, such as in the hellebore family and the lily family. More frequently than not, buds of flowers appear green before they take on the hue of the plant in maturity. It is good to learn some good mixes for green. Rather than using a green straight from the paintbox, it really is worth mixing a green from scratch. Blue and yellow make green, however this mix is usually too

vivid to make a convincing match for a plant. The colour will need a little modification. This can be anything from an earth pigment, such as Yellow Ochre, Burnt Sienna, Burnt Umber, Raw Umber or Raw Sienna, depending on the required mix. Alternatively, red or pink can be a good choice, especially if the mature flower is red. Alizarin Crimson or Permanent Rose would be an excellent place to begin. Sometimes a slightly greyish green is required and violet is therefore a good choice; Winsor Violet, Permanent Mauve or Ultramarine Violet are all suitable, especially if the flower opens to blue or purple.

A most important thing to remember is that the modifying colour must be added as the merest touch. This applies to all the colours, but seems to be especially important when mixing green as all too often the green can become dull or too brown. Be rigorous in the mixing and make sure that the green has only been toned down a fraction, not changed to another colour. If the mix comes up too brown or too grey, the balance needs to be redressed by adding more yellow and blue to the mix. If a flower is bi-coloured with green, it is usually advisable to commence with the green. Painting over green with another colour usually enhances the colour, but if approached the other way around it is virtually impossible to return it to green. The

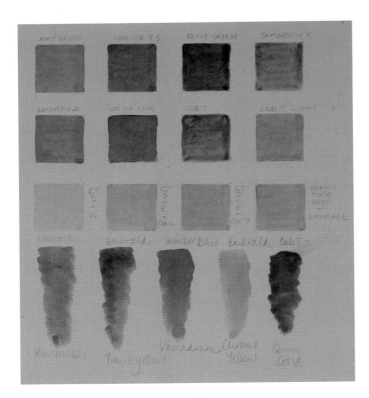

Ready-mixed greens.

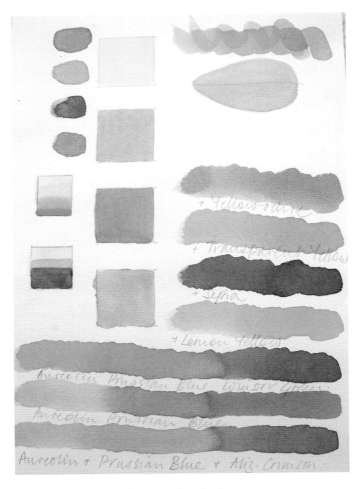

Modifying ready-mixed greens.

exception to this is in the painting of yellow or white flowers when the opposite is to be recommended, leaving the addition of green to the end.

Some artists prefer to use a ready-mixed green. If this is the case it is nevertheless good to add a touch of a modifying colour as described above, to match the observed colour. Some of the greens, such as Oxide of Chromium or Cobalt Green, are slightly more opaque colours than others and they can benefit from the addition of one of the transparent colours to make them semi-opaque. Depending on the type of green required, so too will the modifying colour vary. For the mixed greens, do consider the addition of a touch of yellow which will slightly brighten them, certainly if a bright clear green is required; or add a touch of an earth tone if a softer green is required.

While there are many colours found in leaves, predominantly they are associated with green and it is important to spend time observing and reflecting on the leaf intended for painting.

Matching an accurate green for the leaf is an important task. There isn't one green to suit all; the rich variety presented in nature is vast and, indeed, on one single leaf a variety of greens can be observed. An excellent exercise is to make a chart of mixed greens and this will be an invaluable guide for future reference. It is preferable to mix a green to match the leaf rather than using a green straight from the paintbox as they seldom, if ever, work convincingly – more often than not they

are mixtures of colours already in the paintbox. The individual properties of each pigment need to be taken into account when mixing greens; this will be a matter of practice as no amount of reading can compensate for getting to know the colours personally, through experimentation.

1. To make a chart, take each of the yellows in the paintbox in turn and fill a 2cm² box with the colour across the top of a page of watercolour paper and label.
2. Next, repeat the exercise with each of the blues vertically down the page and label.
3. Then mix each of the colours with each other and put in the appropriate boxes.

These mixes will give a basic green to which a modifying colour can be added which should make the green more convincing. A modifying colour for green can be orange, brown, red or purple. To select the best modifying colour it is useful to examine the plant and see what other colours are apparent in that plant. Work around the plant, looking at the stem or

An exercise in mixing a variety of greens for a botanical subject.

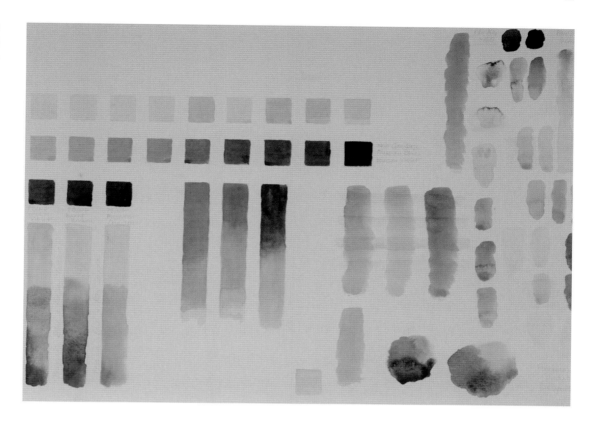

Mixing green from yellow and blue.

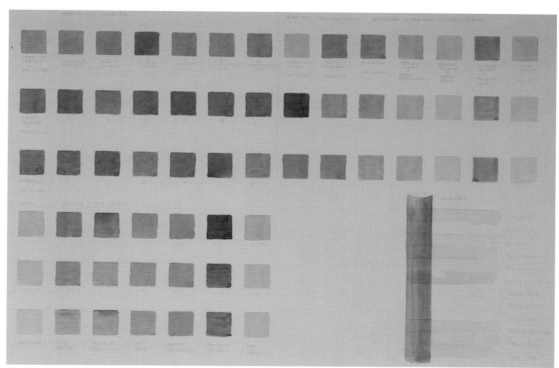

branch, bulb or root, flower and bud. Usually there will be some indication of another colour and this will give a clue as to the best colour to add to the green; however, always be cautious and only add a dot of the selected colour – increasing touch by touch until the required colour is achieved, which will give the green a more naturalistic feel. At each stage test the mix on a scrap of paper until the required colour has been accomplished. When trying to mix a very dark green a useful mix is French

Hydrangea study page and exercise in blue flowers.

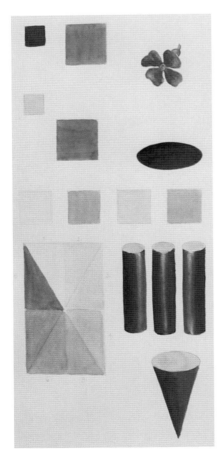

A French Ultramarine study page.

Ultramarine and Burnt Umber, which with careful mixing can produce a glowing, almost black-green. Glazes can be added to further enhance the green. The addition of violet, pink or pale violet will have the effect of darkening the green so for that reason it is best to leave this till last so that the pink or violet can shine out in its own right. It is very easy to lose the brightness of green and very hard to get it back. The complementary colour for green is red.

BLUE

Blue flowers are rarely, if ever, pure blue. There is nearly always a tinge of pink or mauve in the colour and this can direct the choice of blue as the predominant colour. French Ultramarine and Cobalt Blue are warm blues, which means they veer towards the red end of the spectrum and become mauvish blue; while Prussian Blue, Cerulean and Pthalo Blue are cool blues, and veer towards the yellow end of the spectrum, therefore they become greenish blue. It can be useful to use a mixture of the blues to create the blue to match the particular colour of the flower, and do consider mixing different blues together to achieve the required hue. Equally, a minute quantity of pink, red or purple can enhance the blue, but please do note the word 'minute'. French Ultramarine and Burnt Sienna mixed together make a very satisfactory substitute for Indigo or Payne's Grey according to the mix, and can make a beautiful shade that is useful as a

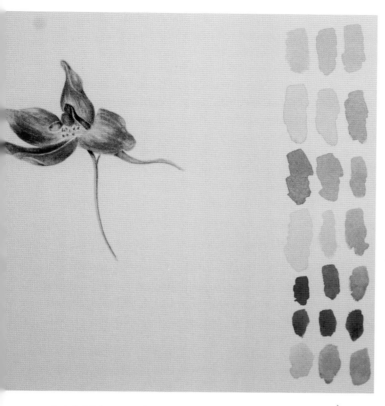

A delphinium study page to illustrate the variety of blues in one flower.

A purple mixing study page.

darkening agent. Rose Doré is a lovely colour for adding to blue, and can produce a very subtle shade. Depending upon the blue, Scarlet Lake can be useful too. The complementary colour to darken a blue is orange.

PURPLE

Purple and mauve flowers are perhaps the easiest of all the colours to paint as it is possible to get a wide range of tones from the palest lilac to almost black from just one purple. Of course it is never that simple. The colour will always be enhanced by the use of a modifying colour, which will help give it vivacity. Purple is one of the few colours that can take the addition of virtually any other colour, and almost every mixture seems to work. Purple can effectively be darkened with green, providing a natural harmony with the leaves. Equally a gorgeous rich deep purple can be achieved by the addition of brown. Winsor Violet is a magnificent colour and a most useful one too. However, it is rare that a flower is of the purest purple; there are usually undertones of something else. A mixture of French Ultramarine

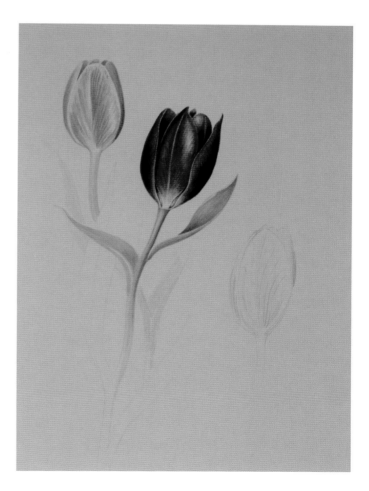

A tulip study page.

and Permanent Rose creates a fabulous violet colour and can be used in combination with Winsor Violet or alone, especially if Winsor Violet is missing from the collection of colours. The complementary colour for purple is yellow but, as with all theories, it is important to personally check and verify this before accepting the rule because nothing is that simple; there always seem to be exceptions to any rule. As purples vary so do yellows and therefore in combination they will also vary.

BLACK

Black flowers are never truly black, although many appear to be so. Generally, they are just really very dark and look black in different light. Close examination will reveal the true colour. Frequently this is a very dark purple or magenta, caused by an undertone of green. One effective method therefore to achieve the effect of a black flower is to underpaint the subject in green first and then build up the colours as they are seen. A thorough

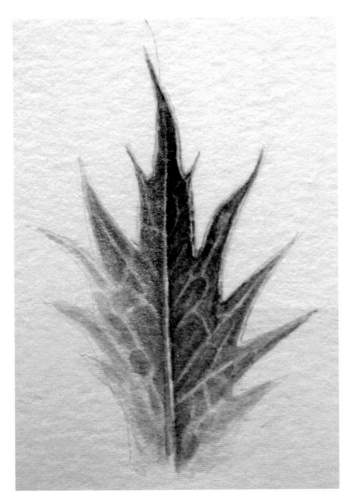

A silver leaf.

examination of the plant should reveal all sorts of colours and these can be incorporated to arrive at the end result of a seemingly black plant. In all probability blue, red and purple will be seen depending on how the light catches the flower and its parts. As a tip, make use of the darkest colours such as Alizarin Crimson, Prussian Blue, Phthalo Blue, Winsor Violet and Winsor Green to create a rich black. However, it is important to remember that the whole painting will rely on a variety of tones and so each layer should be allowed to shine through. It is the variety of tones that will give the painting life, even if the subject matter is very dark in colour.

SILVER

Some plants look as if they are almost metallic. It is useful to establish what exactly is causing the plant to look grey or silver. More often than not a slightly grey-green will replicate the desired effect. The addition of a minute amount of purple in the mix can help. French Ultramarine or Cobalt Blue, mixed with Yellow Ochre and a touch of Winsor Violet or one of the other purples can be useful. Schminke produce a Silver watercolour which can produce a shimmering effect too.

BI-COLOURS

Look to the palest colour of the two and begin with this, adding the darker colour afterwards, whatever it may be. The principle being that it is very easy to go darker but it can be very difficult, if not impossible, to go lighter when painting in watercolour. This is particularly important when painting a predominantly white or pale plant. Make sure a proper analysis of the colour has been undertaken so that additions don't fight with each other, but harmonize gently. Always make sure that each layer dries thoroughly before putting on subsequent ones as it is especially good to see the layers shining through. Sometimes in the darkest areas the colours will appear black. Do not be tempted to apply black pigment, but achieve this through the layering of colours, one on top of the other. Bi-coloured flowers can be a combination of any of the colours.

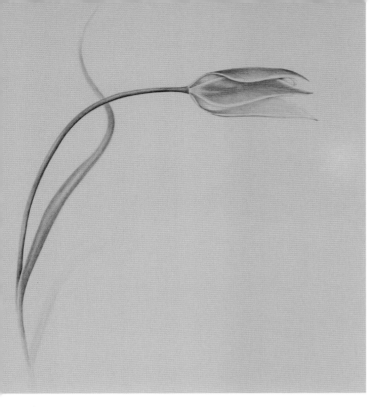

A bi-coloured tulip.

These brief notes only serve to illustrate the complexities of the colour-mixing process and go someway to reinforce the promotion of a limited palette. By using a limited palette confidence can be gained. Once confident, the adventure of branching out into the exciting possibilities that colour provides, can begin.

When time is valuable, colour exercises can seem impossible to fit in. As a compromise, whenever undertaking painting projects, keep a separate sheet or sketchbook specifically for noting the colour mixes for that particular project, or even make use of the hand guard for this purpose.

A red pansy to demonstrate the importance of leaving areas of light so the paler colours can shine out.

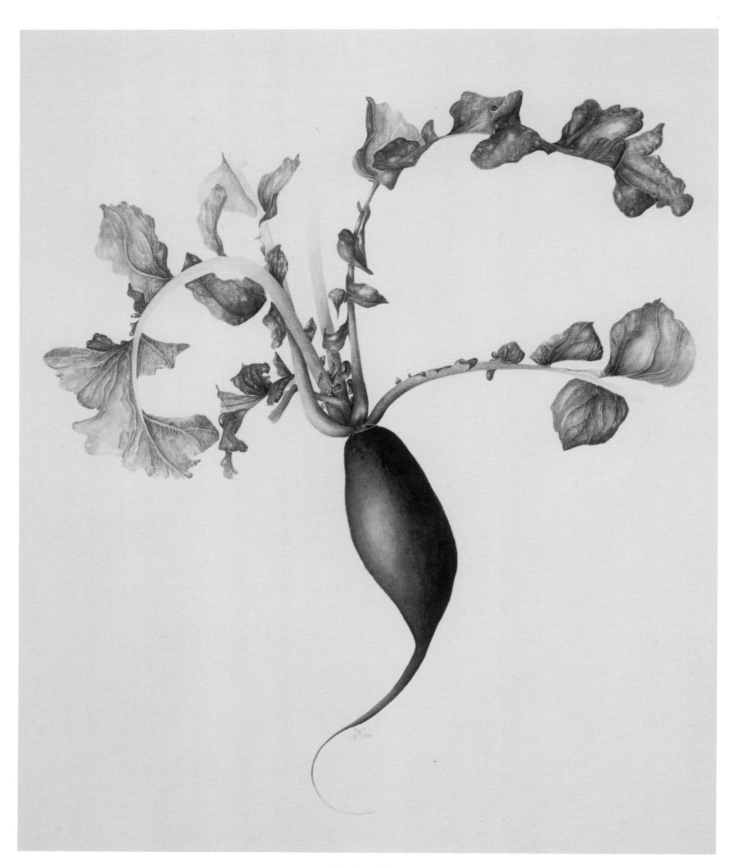

Black radish.

ROOTS AND STEMS

It seems an obvious observation that the roots are the part of the plant below ground and the stem above ground. However, never assume anything. Many bulbs and corms send up their stems from the bulb, which is below ground, and therefore part of the stem will be underground with an equal, or larger part of the stem above ground. Stems below ground have been deprived of light and will generally be of a paler colour. Be aware of this fact if including a bulb or corm in a composition. Some bulbs however sit on the surface of the soil, or very close to the surface, and may not demonstrate the same features. Nothing is better than close observation and reading around a subject. It is usual to depict a good representative of a species and therefore knowledge of the plant is invaluable.

ROOTS

Walking through exhibitions it is possible to notice a clear divide; some people hate seeing the roots included and others love seeing them. The root of the plant in many cases is a diagnostic feature of a plant. For the Botanical Painter it is a matter of personal choice whether to include them or not, while in Botanical Illustration they can be required for correct identification of the plant. The root system can provide an interesting subject if what goes on below ground is of specific interest, but more often than not it is the beauty of the plant above ground to which focus is given.

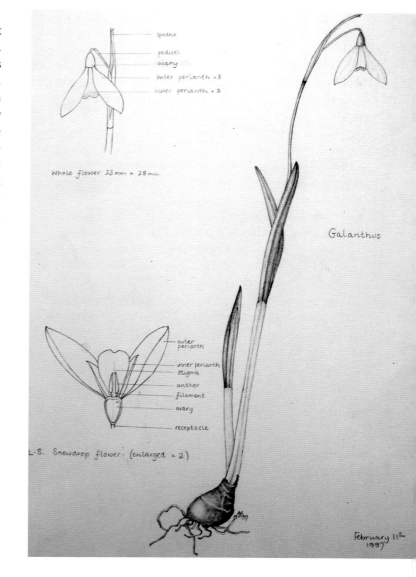

A snowdrop drawing to show the actual length of the stem, part of which is concealed underground.

The roots of a leek.

Frequently the roots are pale grey, almost white, transparent or ochre in colour, especially when observed in herbaceous plants and bulbs. It is important to relate this to what goes on above ground to what goes on underground. The roots are sent down and the stem grows upwards. Space here does not allow for discussion on all the different types of roots, nor for an explanation of the difference between roots, tubers and rhizomes. There are a number of excellent books on Botany for Botanical Painters, which are invaluable for reference. Nevertheless it is useful to outline the basic types of roots likely to be encountered.

- The bulb – is a swollen stem which stores the energy for the growth of the plant; it sends the stem and leaves upwards, and the roots downwards. Sometimes the bulb makes its way to the surface of the soil and other times is buried deep in the soil. Often part of the stem is in fact below ground. Bulbs either have a coat, such as in the hyacinth and tulip, or scales such as in the lily (examples: hyacinth, tulip, lily).
- The corm – is a swollen stem that renews itself annually. A new corm forms on top of the old corm (examples: crocus and some irises).
- The fibrous root – is represented by many herbaceous plants, and the roots are just that; fibrous, and frequently branched (examples: violet, lavender, some geranium).
- The tap root – a single root, which acts as an anchor as well as a storage organ, often with smaller lateral roots radiating from it, represented by the root vegetables (examples: carrot, dandelion, beetroot).
- The tuberous root – is a swollen underground stem used for storage of energy for growth (examples: dahlia, celandine).

- Rhizome – is a creeping underground stem, bearing roots and shoots (examples: flag iris, Solomon's seal, ginger).

It is good to know the structure and physical features of a plant, but do not feel compelled to illustrate every minute detail. The depiction of the mess of roots frequently found in plants can appear daunting but, as with most things, there are ways of overcoming problems. A practical solution is to break the subject down into manageable sections looking for patterns and simple forms as a guide.

As an example the leek provides good subject matter. Leeks tend to have their roots removed before they go to market, so being able to find them with roots attached usually means either growing them personally or adopting a vegetable gardener as a friend. If a leek with the roots attached seems elusive, the spring onion could be substituted as an alternative as usually their roots are left on and, although smaller, they grow in a similar way. Alternatively a bulb could be substituted, such as a tulip, hyacinth or amaryllis bulb. To coax them into root production, place the bulb on a jar filled with water so the base of the bulb barely touches the surface of the water. Whatever the choice, something with a relatively simple root system is good in order to just grasp the idea.

Observe how the roots of the plant are arranged. Some of the roots will be tangled into a mess of such confusion that it will be almost impossible to draw each and every one. The important thing is to capture the character and volume of the roots as well as possible. Form always plays a significant role when considering the accurate rendering. Try not to make the roots look like a pressed add-on. They tend to radiate outwards and will, in all probability, relate to an inverted cone in shape, although some will meander off on a horizontal plane. In the case of the leek, they should appear to be evenly spaced round the base, and even if it seems chaotic, there will be order. Observe the nature of the root. As a general rule they tend to taper towards a fine point, but take this generalization cautiously, as nothing beats careful observation. One common error is to end the roots bluntly. If a root has a sharp end, it is quite often because the delicate root has been snapped during the process of removing it from the soil.

When removing the soil from a plant, first dip the plant into a generous bucket of water and shake it gently to remove as much of the soil as possible, and then run it under a gentle tap to remove the soil that is caught up in the roots. If digging the plant from the garden, make allowance for the root ball and dig a larger hole than appears necessary in order to avoid damaging the roots. It is worth watering the plant beforehand and leaving it for twenty minutes or so before digging it up.

Once the plant is in place, ready for drawing, select a few prominent roots, that is the ones seen in totality from base to tip, as reference points. Draw them in, using a 2H pencil with a very sharp point. Then work round the base of the leek drawing

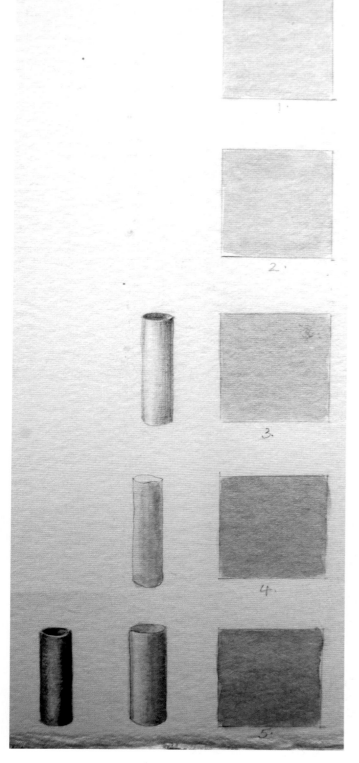

An exercise to find a delicate neutral tone for roots.

the plant. If the roots provide an uninteresting subject it is best not to include them. Lack of interest will, in all probability, be reflected in the painting and therefore can become a distraction. A useful method to reduce the work is to prune the roots, showing them as cut ends or alternatively, fade the roots to nothing. However, before doing this do consider the overall composition of the painting. Whichever method is adopted it should act to enhance the result and make it look well balanced. Contradictions and contrasts are to be encouraged, but these should be done from a place of knowledge, not happenstance.

Having drawn the roots the painting can begin. It is of course possible to paint each and every root as it is seen. This will be a labour of love and require an extraordinary level of patience and dedication but nevertheless is quite feasible. A rather more time-effective method, which can be excellent news to the less assiduously inclined artist, is as below.

Select a very pale neutral tone, ideally mixed from the three primary colours, but nevertheless related to the colour of the roots. A good choice for example could be Cobalt Blue, Yellow Ochre and Permanent Rose – mixed with plenty of water to obtain a very pale grey. Closely examine the overall effect of the roots to enable a suitable colour choice to be made, and play around with various mixes to obtain the best neutral tone. Alternatively, the colour Davy's Grey can be used.

Loading a large brush (No. 5 or No. 6 for example) with a good quantity of the grey mix, paint over all the roots in a semi-circular shape, dragging the colour down with more water to fade out to the paper. This is one of the rare occasions when the pencil lines can be painted over. Leave this painting to dry completely. Establish the most prominent roots and select say five or six. These should be left without any further paint, so they will stand out when the painting is complete, representing the first tone.

Keeping in mind the principle of form, moving from dark to light, apply a second layer of the pale neutral tone on the right-hand side of each root. Mark the five or six roots selected as the palest with a little pencil cross to remind you that these are to be left pale, but do make sure the wash is perfectly dry before marking them. The pencil mark can be erased later, when the painting is completed.

Once this layer is dry, a third layer can be added again to the right-hand side. Because the roots are small, it will be almost impossible to draw washes across each root, so it will be just a matter of darkening the dark side of each root, and merely softening the line, trying not to leave a harsh edge. The dark tone should be reduced in intensity as progress is made across the roots from right to left. The result so far should be fairly satisfactory. To enhance the overall effect, selected roots can be shaded on the dark side with the thinnest of lines. This requires a very fine brush, for example No. 0 or No. 1.

All pencil work can now be removed and a little fine tuning of

in as many as possible, but don't be tempted to invent. If the roots are too complicated or messy, gently prise them apart so they can be better observed. Frequently, less is more, and it is possible to show the nature of the roots without slaving over them. Overdone, the effect can be just a confusing muddle and resemble a rather unattractive bird's nest – and the eye will be immediately drawn to this, rather than the beauty of

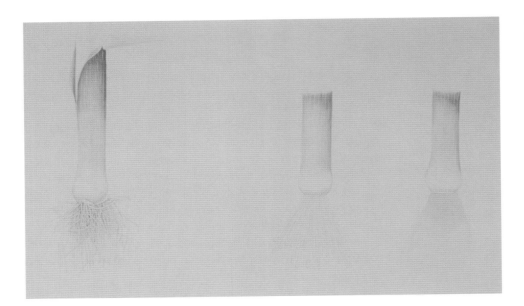

A leek study to demonstrate a method of painting the roots.

The magnification of a swede seedling to understand the structure before drawing.

construction of the plant, which almost always will be reflected in the end result.

BULBS

A number of plants have the ability to store energy underground, not only in bulbs, but in tubers, rhizomes and corms. They all can make fascinating subjects to study in themselves as well as additions to compositions. As with all natural forms they require careful observation to come to understand their structure.

A line drawing, followed by detailed shading of the complete plant, roots and all, will always be a useful reference tool with the added benefit of being informative as well as attractive in itself.

A garlic bulb.

the painting is called for. Where one root passes over another, this can be illustrated by shading the root behind with a little shadow tone, which should differ from the neutral tone used for the roots, at the place where the cross-over occurs. The addition of a little blue to the mix can be useful here.

There are many different types of roots and a good day spent in the garden weeding will demonstrate this. Some are so very small and fibrous, some large and easily damaged, some very tough and branched and others a simple tap-root. Close examination is always useful, even if the intention is not to include the roots. It just helps to have a better understanding of the

A radish study page.

An iris and tulip bulb study.

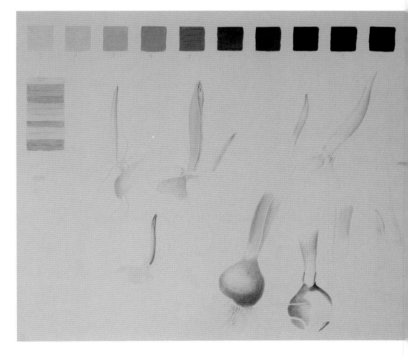

A tulip study page.

STEMS

Stems, like everything in nature, come in all shapes and sizes; however the principle is the same no matter what plant is being depicted. Firstly, it is important to accurately observe the subject and establish the profile of the stem. Once the profile has been worked out, it is important to look at the nature of the stem and how it grows. As with all parts of the plant, it is worth

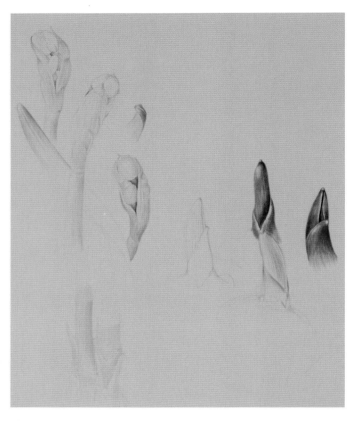

Shoots and stems.

making a checklist of things to look out for. The following list may be useful:

- Profile – round, square, oval, triangular
- Nature – sinuous, twisting, straight, angular
- Texture – smooth or rough, shiny or hairy, woody or fleshy
- Attachments – plain, branched, leafy, leafless, thorns, spines, prickles
- Colour – rarely are stems all one colour; usually there is some variation, especially when part of the stem is underground, where it will appear possibly white, or certainly very pale, as opposed to green.

A further consideration is to check that the selected specimen is true to type. It is worth examining similar plants just to make sure you haven't chosen something that is damaged, either by climate or animal, or as the result of some genetic malfunction. It can be devastating to complete a painting only to discover it doesn't accurately represent the species, even though it has been faithfully described. However, examining abnormalities could make an interesting study of work when viewed as a series of paintings, but not so easy to understand as a single, stand-alone painting. It has the danger of being considered just a bad painting, which on balance is to be avoided.

The watercolour exercise for tubes, when looking at simple forms, relates very well to the painting of stems for obvious reasons, especially if the stem is round. Referring back to the painting exercise for tubes, a tulip stem can be viewed as a very long tube. It is unlikely that the stem can be painted all in one go, so it is useful to break it into manageable sections. As a suggestion, consider tackling just 2cm at a time. To prevent a sharp line at the end of each section, just soften the leading edge. The leading edge is the edge just completed, and this will be the beginning of the next 2cm. If a harsh line appears do not worry, just begin the next section slightly higher than the leading edge, the last bit painted, and this should begin to disguise any definite line.

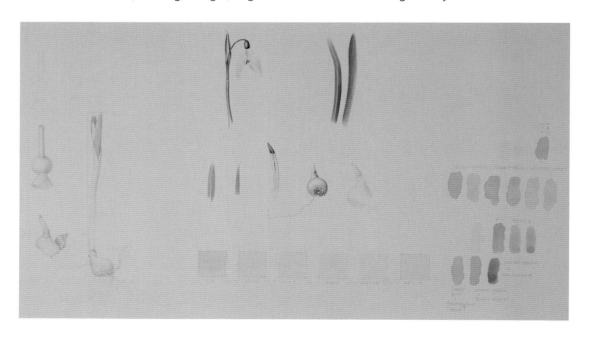

A snowdrop study page to illustrate the emergence of the root from the base.

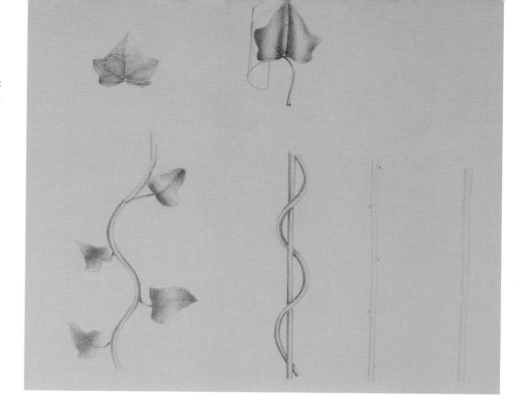

An ivy study to understand the effect of light.

Once the painting of a straight line has been mastered, move on to the idea of a curving stem. This time draw a series of 'S' shapes with parallel lines to create a tube. Consider the effect of the light source on the shape drawn. To help remember the light source, draw a small arrow on the page to indicate the direction of the light, as a reference point. Similar to the straight stem, if it proves difficult to draw a parallel line with a curve in it, simply turn the page around and use the first line as a guide-line to draw the second. This method helps as some find it easier to draw a horizontal line than a vertical line. A vertical line requires the whole arm to move to keep the line straight and, as for the majority of people the written word is written from left to right, it is a more natural way to work. When considering a curving line rather than a straight one, the first line can be relatively simple to draw, the problem is usually encountered on the second line.

These two simple, basic exercises are enough to get started. As confidence is gained more complex stems with attachments

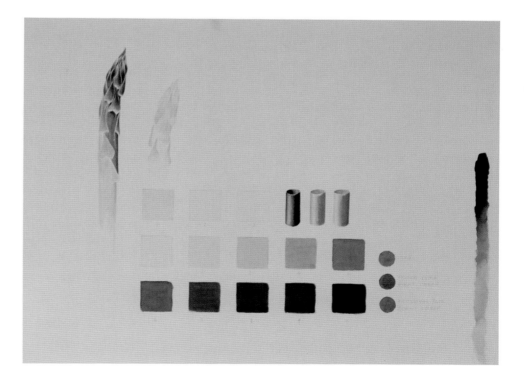

An asparagus study page in sepia.

A sustained study of stems can reveal that rarely is anything as straightforward as it may seem. The best strategy is to look for patterns and make a note of what is observed. To ensure a correct interpretation it can be useful to look up reference books, or consult the internet to get an accurate description of the plant. Gathering as much information as possible before beginning a project will ultimately pay off. When there are attachments to a stem it is very important to identify them correctly and describe them accurately. Look and look again to make sure you have fully understood the anatomy. Whether a stem is straight or branched, it tends to be thicker at the base and tapers as it grows. Sometimes this tapering is dramatic, sometimes it is very subtle. If you have difficulty in keeping the lines parallel on a stalk, draw the first line of the stem freely, then turn the page round so that the stem is horizontal. Using the horizontal line as a guide, draw a parallel line underneath to the required width. Do try to keep the lines as crisp as possible even if it means drawing a small section at a time. It is very difficult to draw a stem in one go, especially if it is long.

When it comes to painting stems, it is useful to remember that not only should the palest tone be chosen, but also the palest colour. Spend some time examining the stem from the very base to the tip to establish the palest colour. It is always possible to go darker in watercolour, however it can be difficult to attempt to go lighter. It isn't impossible to retrieve a paler shade, but the brightness of the colours may be sacrificed. Spend time experimenting with different effects of layering colours rather than mixing them in the palette; the results can be surprisingly effective. Depending on the type of stem, sometimes it can be good to mix and apply the colour as seen, and at other times it is more effective to achieve the colours by superimposing layer upon layer. Through practice and experience the best method for the job in hand will reveal itself.

Rules can be very tiresome, but a few are useful and worth considering when it comes to Botanical Painting. It is very easy to get bogged down with the detail too early and also very difficult to refrain from adding detail too early. It requires immense concentration and self-discipline, but the reward will be much clearer and the painting more luminous. Emphasis as always is on building up a good feeling of the form first and, when satisfied that this has been achieved, any detail such as markings can then be added.

When painting more complex stems don't forget to look out for attachments and secondary stems. Pay attention to the way in which they emerge from the main stem and especially the direction of growth. Look for the pattern of growth and any symmetry, which can be used as a guide. In particular look out for the formation of a spiral. There are many repetitive forms in

**A bunch of asparagus painting in progress
to reveal the process.**

can be attempted. It is useful to study a number of different stems, putting the exercise into practice. Once the basics are mastered the exercise can be put into practice with, for example, an asparagus spear.

A bramble study page with reference to thorns.

A bean study to show the leaf attachments.

nature and the spiral is one of the most common so look out for it at all times.

Woody Stems and Branches

These provide a rich subject matter and a huge variety of surfaces from the taut and shiny to the rough and gnarled, and everything in between. As with almost all botanical subjects, a branch of a tree can make a wonderful composition on its own as much as in part of a composition. The nature of the branch or woody stem should be closely observed before removing it from its home, as the direction of growth is very important. Some branches are erect and some drooping; some horizontal and others display complex branching. It is important too to consider the differing size of the branches as the plant spreads out. Make sure the progression is accurately represented in the drawing.

Branches and woody stems come in a rich variety of colours as well as textures. This is an excellent opportunity to use a broader palette to represent the many colours found in the bark. There will in all probability be a great breadth of tones, from the palest greys to the deepest browns or blacks. Use the grey tones cautiously and be prepared to add some of the glorious reds available to give warmth and life to the subject. Some of the opaque and granulating colours particularly come into their own when it comes to woody subjects, providing a way to get some rich texturing so characteristic of the subject matter.

Deciduous winter branches provide an excellent opportunity to make studies, due to the absence of leaves. The way the plant branches and grows can be observed well, which will add to a more secure depiction when undertaking a painting in full leaf.

A study of a branch with lichen.

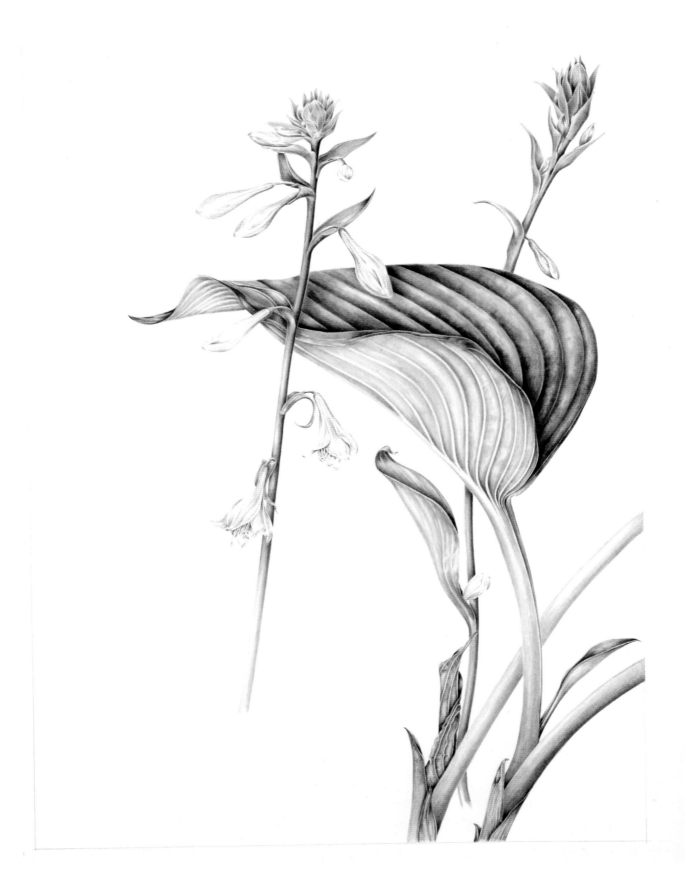

Hosta 'Prince of Wales'.

LEAVES

Some Botanical Painters are passionate about leaves, while for others it is an unfortunate fact of life that there are many more leaves to plants than flowers. One simple solution for those in the latter camp, apart from avoiding painting them, is to come to love them. The extraordinary variety of colours found within leaves as the seasons change is reason enough to want to paint them. They do not limit themselves to pure green, but when they do, one plant alone can appear as a complete symphony of greens, displaying almost every conceivable shade possible. The more practice undertaken in drawing and painting them, the more will be seen in them. There are many short cuts that can be performed to get the most out of leaves without making it a laborious task, but these will not compromise the end result.

When it comes to depicting leaves, one of the first things to be aware of is that flowering plants fall into two divisions: monocotyledons, commonly known as monocots, and dicotyledons or dicots. Monocots can usually be identified by the fact that their veins run parallel to each other, and examples can be found in the grasses, the lily and the iris family. The veins in dicots for the most part tend to be branched frequently, forming a network, and can be found in numerous herbaceous plants, such as in the buttercup and rose family.

A useful tip is to take a rubbing of the leaf, rather like the brass rubbings from school days. This helps enormously in revealing the detail of the veins, the leaf margins and the overall nature of the leaf. An effective way is to take a sheet of layout paper, which is a very thin, smooth and strong paper. Lay the chosen leaf on a clean hard surface, such as a drawing board, with the sheet of layout paper on top. Taking a soft pencil (a 6B is ideal) rub over the paper covering the leaf with the pencil on its side

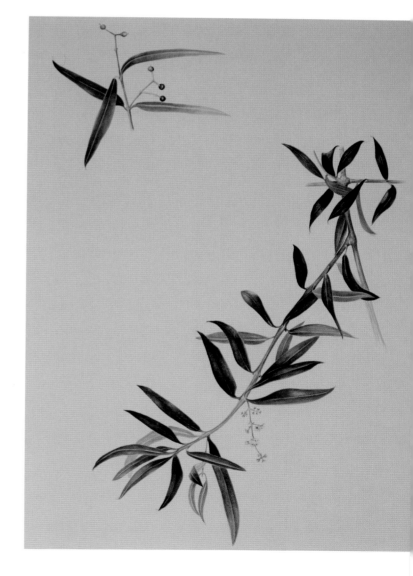

An olive study.

A leaf study page.

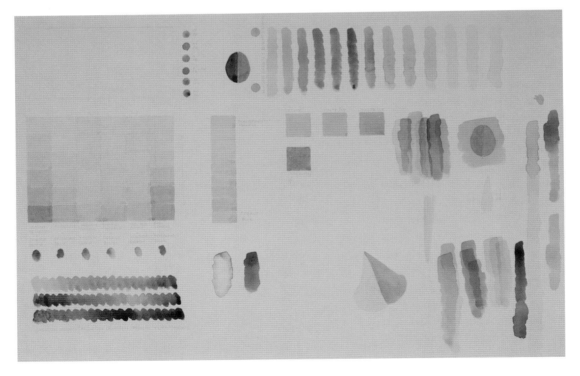

A work sheet to find the correct green for a project.

to get as smooth a covering as possible. Make sure both the leaf and paper are held firmly in place. Some leaves do respond better to this treatment than others and while it sounds a simple enough task it can be tricky, so persevere. It may take a couple of attempts to get a good result. The rubbing of the chosen leaf can be used to draw and paint from and can then be kept in the sketchbook for future reference. Another good method is to take a black and white photocopy of the leaf, which has the effect of simplifying the detail as the eye is not distracted by colour.

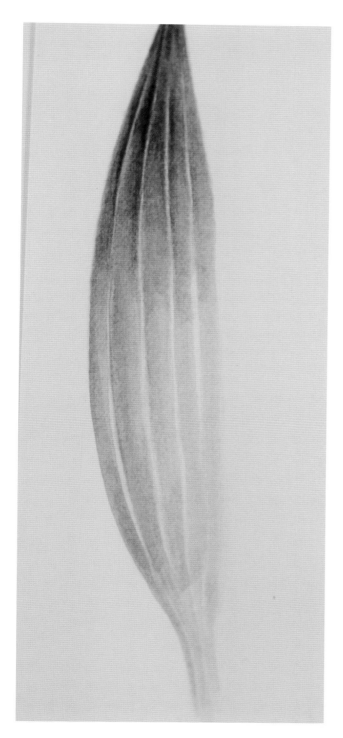

A plantain leaf – an example of a monocot.

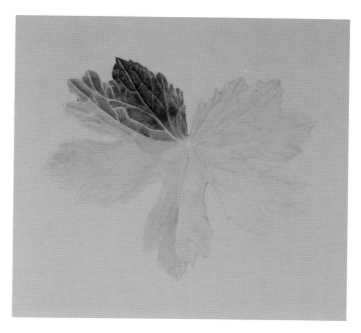

A geranium leaf – an example of a dicot.

of differentiating between the upper and lower surfaces of a leaf. When undertaking a complex painting with lots of leaves, it can be helpful from the outset to begin by painting the different surfaces with different colour washes so as to remember which the topside of the leaf is and which the underside. For example, the topside could begin with a pale yellow or green wash and the underside a blue or mauve wash.

A leaf rubbing of *Vitus Coignetiae*.

The veins on the upper surface of the leaf frequently appear quite different to the underside. Don't forget to observe both surfaces. When examining the underside also note the difference in colour too. This is important to note especially when it comes to painting the leaf as this simplifies the task

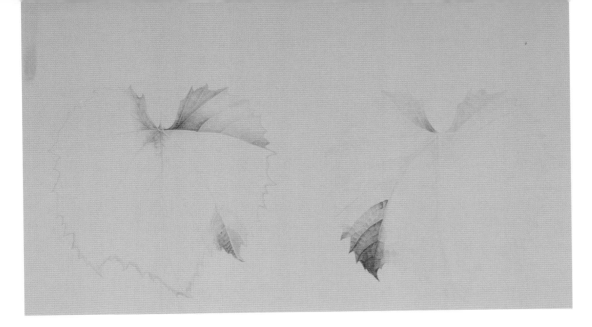

As a note of caution, do not overdo the detail, as it isn't always necessary. There are no prizes for painting every bit of excruciating detail and more often than not it can look too contrived and artificial, unless it is undertaken with the greatest sympathy. At any one time it is impossible to see everything in equal detail, and when economy is reflected in a painting it can be most effective. That little maxim 'less is more', comes to mind. If the plant is tilted towards the light the intensity of the colour will be reduced and when it is tilted away from the light the colour may well appear darker. In both instances the detail cannot be seen so well. It is really only in the mid-tones that the detail can be fully observed. It would be a different matter in Botanical Illustration, which relies on exacting detail in order to identify a plant accurately. This can be excellent news for Botanical Painters.

When drawing and painting leaves, the position of the mid-rib is very important as this gives a structure to the whole. The secondary veins can be important, depending on the plant. As a suggestion, if they can be seen with the naked eye easily, it would make sense to show them. If a magnifying glass has to be used to see them, or the leaf needs to be brought closer for inspection, it would be advisable not to over-emphasize them. However, as a leaf twists and turns according to its arrangement on the plant, some small veins can often be observed, whereas when present on a flat leaf they may be invisible. Detail can differ according to the play of light. In the dark tones the detail will be absorbed and in the lighter tones the detail will be bleached out and lost; it is in the mid-tones that the best detail will be seen.

The depiction of the veins is nevertheless very important, and a painting can easily be ruined if these are poorly rendered. Frequently, too much attention is given to them without sufficient empathy. Sometimes they can appear to be too skeletal or too prominent and thick. If unable to depict them accurately, it is better not to draw attention to this fact and maybe just show them in one or two places. The nature of the veins can

have a strong and characteristic effect on the whole leaf. Look at and compare the puckered leaves of primroses, the strong directional lines found in horse-chestnuts and strawberries, the parallel veins in leeks and bamboos, the strong puckering in hostas and cabbages, the flattish leaves with indented veins in hellebore, paeonies and roses, the lack of visible veins in

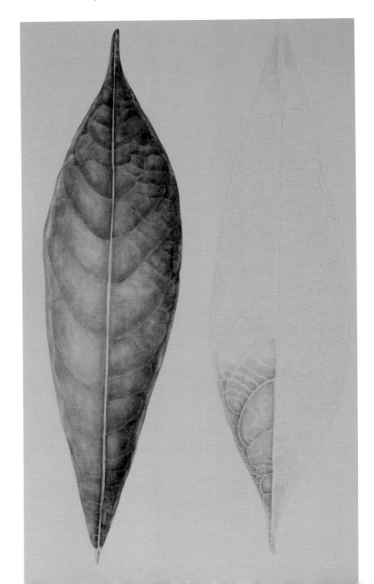

Amazonian leaf study – topside and underside.

Paeony leaves.

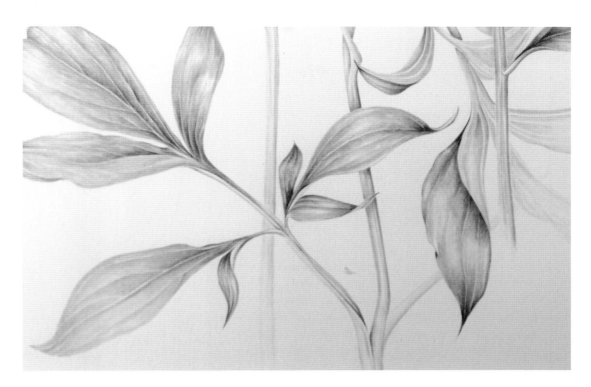

secondary veins can be adjusted very delicately. Once the veins are in place, the outer margin can be added, using the veins as guides. This basic format can be further developed for more complicated leaves. Don't forget to make use of the negative spaces as guides.

Leaf study making use of the negative spaces.

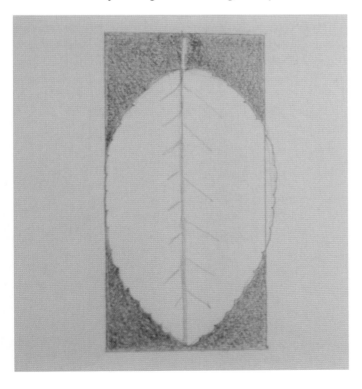

So far the concentration has been on simple, almost pressed specimens of leaves. However, in nature, leaves twist and turn and veritably dance around the plant and this provides the Botanical Painter with a number of challenges. Simplicity is the key to success and a foundation from which to develop. How the leaf is shaded, whether in pencil or watercolour, can have a dramatic influence on the appearance of the leaf. It is best to begin by concentrating on the effect of several leaves or leaflets in an arrangement to understand how to describe it on paper. Notice how the light hits each surface of the leaf and how much detail can be seen. Consider, as a leaf twists, how part of it moves towards the light and becomes paler while the compensating part becomes relatively darker. Also, as the leaf twists, it will be possible to see parts of both the underside and topside of the leaf. Not only will these be different tones, but more often than not the underside of the leaf will differ from the topside; however, sometimes the change can be so subtle as to be barely noticeable. Each change of tone should be graded very delicately so that no harsh lines are visible and the transition from one tone to another ideally should be barely visible to the naked eye. A few pointers can help maximize the effect. If all the leaves are drawn flat, that is precisely the effect that will be achieved. This does not have to be a negative as indeed some very flat paintings have great charm in their own right. This might be exactly the desired effect but, for the purpose of this exercise, the assumption is made that the aim is to achieve a certain degree of vitality. To deliver a feeling of life, and therefore movement, the odd twist and turn to a leaf will help. A useful aid would be to have a transparent leaf.

LEAF EXERCISE 1

1. Take a simple leaf, one with a good strong midrib.
2. Take a piece of tracing paper and trace round the leaf, marking veins with a fine black marker or felt pen.
3. Cut out the shape of the leaf.
4. The leaf can then be manually twisted, to observe the direction of the veins as the leaf twists on both the topside and the underside as well as to understand the outline of a twisted leaf.

The above exercise can help to describe how the veins and margins react to a twist and also make it simpler to draw, when attempting the leaf itself. When drawing a leaf with a turn, it is useful to note that there will be part of the leaf that will disappear from view. Although part of it will disappear it must still be accounted for even in its absence, so bear this in mind when drawing.

LEAF EXERCISE 2

1. Draw the midrib of the leaf in the desired position and shape.
2. Next draw the margin of the leaf nearest to you that you can see in its entirety.
3. Then fill in the back margin that appears broken.
4. Finally adjust the midrib so that it looks convincing, drawing in the ending of the top surface, and rubbing out the section of the midrib that is no longer relevant.

To practise some exercises with leaves, choose a leaf with a very simple shape and try to avoid one that is particularly glossy or hairy. Draw the leaf on a sheet of watercolour paper. Draw in the midrib, which will act as a guide, not only to its size and position but its nature too. Begin at the top of the leaf blade on the right and draw the outer margin and then return to the top of the leaf and draw in the left-hand outer margin. For the purpose of this exercise ignore any veins other than the midrib. At this stage all that is wanted is a very simple outline. Having mixed the colour as closely as possible, begin with a very pale wash over the leaf. Start with one side of the leaf and paint up to the midrib taking care not to go over any of your drawn lines. Then repeat on the other side of the leaf. This serves not only to

Cowslip watercolour study page.

A leaf tracing with marker pen to understand the formation of veins when a leaf twists.

give you your first tone, but to seal the paper so that the subsequent layers will sit on this rather than being absorbed by the paper. Do remember to leave each layer to dry out completely before adding the next layer. By making one side of the leaf or the other darker or lighter different illusions will be created. By giving each side of the leaf the same tone the leaf will appear flat. Through careful observation the more complex these shadings can become.

If undertaking this as an exercise, it is useful to draw a number of leaf shapes, drawing a dissecting line to indicate the midrib, and experiment with different shadings to understand the principle. In this way it will be possible to consider the results and

make comparisons for future reference. A further exercise is to begin with different colours as the base colour for the leaf. If the veins appear particularly yellow, a wash of pale yellow can be appropriate for the first layer, and if the veins appear red, begin with a pale rose colour and observe the differences. At all times make notes of your experiments. These will be invaluable for later projects for future reference, providing a useful guide in terms of what to try and what to avoid.

Once the first layer of paint has been applied, the secondary veins can be drawn in, making sure the paint is perfectly dry. If preferred, the veins can be drawn in from the outset, and then each section should be painted separately without going over any of the pencil lines. Keep steps as simple as possible. Depending on the variance of tonal value, the dramatic quality of the painting will differ and these exercises are an excellent way of determining the desired effect. At the same time, it is good to practise the control of paint when building up layers as this will be invaluable to future painting. Try to keep the gradations of tone as subtle as possible. The greater the variance of tone achieved in a painting, the greater its vitality. It cannot be emphasized strongly enough how important it is to avoid painting over the lines of the drawing. It does take practice and patience and this is always rewarded. If the pencil line has been covered with paint it will be sealed in and cannot be erased.

The next progression is to add the detail of veins on the topside of a leaf. Some veins are more prominent than others and some have the effect of puckering the leaf surface. Some veins are deeply channelled and others barely so; some are ridged and others grooved. As always, careful and accurate observation is essential. Having established the arrangement of the veins and their character, the next consideration will be shading to reveal the form. This generally needs to be very subtle indeed to reflect the nature of the veins and their effect on the leaf as a whole. It is wise to proceed with caution to ensure not too much prominence is given to something that only makes up a small part of the nature of the plant, although this is not to negate the importance of the veins to the overall character. This is the time to remember the maxim 'less is more'. It may, or may not be, appropriate, but it is worth thinking about. In order to see the tones clearly, take a black and white photocopy, or sometimes peering through half-closed eyes can help as the intensity of the colour will be reduced.

When undertaking any leaf, not only will the progression be from dark to light on the leaf overall, but each section between veins will require to be shaded from dark to light, although generally this gradation will be less dramatic. This of course will depend upon the nature of the leaf. Quite frequently, as

A sketchbook leaf study, showing the effect of perspective and light on a leaf surface.

in the case of a leaf like that of the primrose or foxglove, the variance in tone can be fairly dramatic in each section. Possibly the best way to approach the painting of the veins is to paint the surface of the leaf up to each vein, leaving a gap in the painting where the vein travels. In the final stage, when the leaf is painted, the veins can be delicately painted in their specific colour. Sometimes a wet-in-wet approach to the first layer can be useful, especially if the leaves being painted are large. As a reminder, this is where the first layer applied is pure water and then the required colour is gently dropped onto the surface. The colour can then be gently manipulated by the brush, or allowed to fill the space according to serendipity. A little experimentation with this method can be fun, by making

A sepia exercise to understand different light effects on a compound leaf.

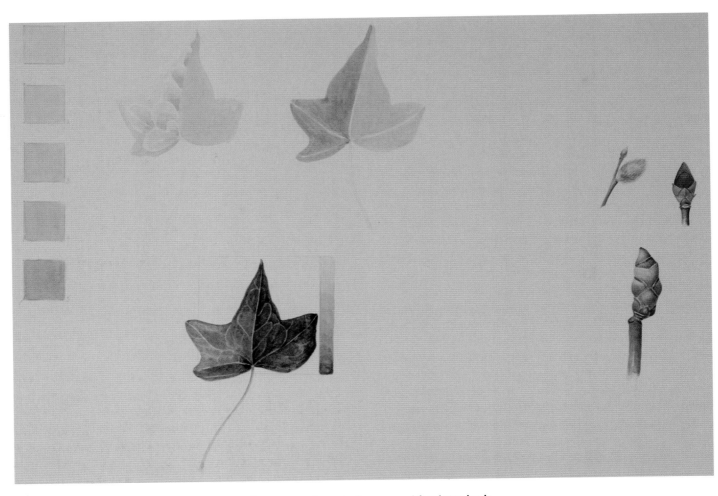

An ivy watercolour study page, with winter buds.

A shaded leaf drawing to demonstrate the effect of light on the leaf surface.

A shaded leaf drawing to demonstrate the effect of light as a leaf twists slightly.

A leaf study page in watercolour.

combinations of colours and dotting different shades of green into the water for example.

SOME DIFFERENT TYPES OF LEAF

There are a number of different leaf surfaces to consider, such as hairy, shiny, puckered, mottled, variegated, patterned and glaucous. It is useful to spend time gathering a variety of leaves

A viburnum leaf painting in progress showing the top and underside and the different colours and effects.

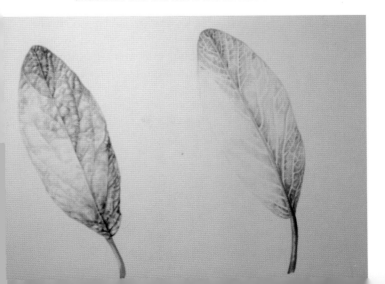

A foxglove leaf to show the initial development of form.

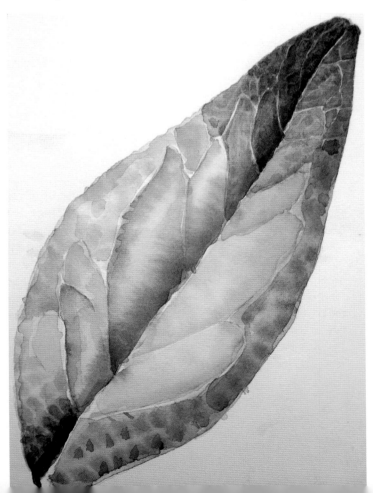

to compare and contrast and to come to some understanding as to why the surface is the way it is. This will always help with the depiction.

Hairy Leaves

The surface of a hairy leaf frequently looks grey due to the effect of the hairs. Generally, the hairs are so small as to be impossible to see with the naked eye. For the purpose of Botanical Painting they do not have to be fully described, but the character they give to the plant should be demonstrated. There may be sections where, against the light for instance, they are visible and it can be interesting to show this. In Botanical Illustration the detail of the hairs on a leaf are sometimes shown as a separate magnification on the page, sometimes only as a line drawing, to clarify its features. Quite often it will be sufficient just to adjust the paint colour to reflect the effect on the leaf, just as it is seen growing in nature. If applying the hairs with gouache this should be undertaken at the end once the painting has been completed, and a very small brush will be required. Another method can be to paint around the individual hairs, that is, by painting the negative spaces. For this method it pays to have very sharp eyes or use a magnifying glass. If describing the hairy surface of a leaf it is important to have made an attempt to observe the direction of growth, shape and size of the hairs. When the hairs on a leaf are very small and fine they often give the appearance of grey tone. It can be virtually impossible to see them with the naked eye. As a suggestion, Yellow Ochre is an excellent colour when used with a little purple or mauve to a green mix of blue and yellow. Two useful greens for describing hairy leaves are Oxide of Chrome and Terre Verte: especially in combination with other colours, these help to give the smoky feel that the hairy leaf displays.

Glaucous Leaves

Glaucous leaves are usually very fleshy and have a taut surface. Sometimes this surface can appear very pale, other times very shiny and sometimes they seem to have an opaque, almost chalky surface. The chalky surface is occasionally due to a bloom on the leaf surface, which affords the plant protection, either from wind, heat or water, or a combination of these elements. This protective device is similar to hairs on a leaf but tends to be on a smooth leaf surface, such as in the succulents cacti and aloes. This can be described in paint by adjusting the green in the relevant places closer to blue. A few colours are excellent for this purpose, for example Cobalt Turquoise. This is another of the

A shiny leaf in progress.

rare occasions where gouache can be used to create the effect. White gouache can be applied to the leaf only at the very end when everything else is completed. It should be applied very dry with a stubby bristle brush and with great caution. It should not be overdone. To stop the bloom appearing too glaring, a little amount of blue watercolour added to the mix can be a good idea. Cobalt Blue with a little Viridian or Cobalt Turquoise are excellent for this purpose. If applying gouache, remove as much paint from the brush as possible first, by stippling it onto a piece of kitchen towel or rag. This will mop up the excess water and allow for the hairs on the brush to separate slightly and therefore give a light but dotted appearance. The procedure can be repeated until the desired effect is achieved.

Shiny Leaves

The appearance of shine on leaves is usually because the surface of the leaf is very smooth and while the colour is sometimes very even, it changes dramatically through the effect of light being reflected from its surface. In order to achieve the effect of shine, the trick is to proceed from dark to light as quickly as possible without being aware of this progression. The lightest part of a leaf could be the white of the paper, proceeding to the darkest tone. It becomes quickly apparent that this is very tricky to achieve when one considers the size of some shiny leaves. Often there is more than one area of shine. Caution should be exercised against overdoing the effect; try to stick to just two areas per leaf maximum, for fear of the impact being lost and the result being unattractive. When the painting of the leaf is completed, a very pale wash of blue applied over the whole surface will prevent the white paper resembling a hole in the leaf, or a gap in the painting and create a more convincing effect. The shading should be so effective as not to allow this misinterpretation to occur. Good blues for this are Cerulean, Cobalt Blue or Cobalt Turquoise.

Puckered Leaves

It is easy to become distracted by the pattern presented by complicated puckering. To overcome this, the trick is to break the leaf down into its basics. A black and white photocopy of the leaf as well as a leaf rubbing will be useful for reference.

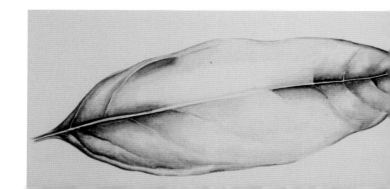

Two slices of a primula leaf study.

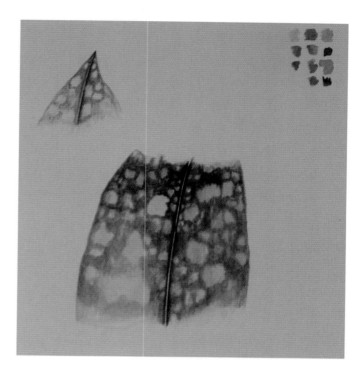

A variegated *Pulmonaria* leaf.

First find the midrib, which should be simple, then work out the pattern of the secondary veins. Once all this has been worked out, the arrangement of the other veins should begin to make sense. Observe carefully how they affect the leaf margins. It is quite a therapeutic exercise to take a Primrose leaf and make a study of it in pencil using continual tone, studying both the upper and lower surface. To make the exercise simpler, just cut a 2cm cross-section of the leaf with a sharp knife or a pair of scissors, which will give just a small strip of leaf to tackle. It is not obligatory to put down every little pucker; remember that some of the detail will diminish in the highlights and darker areas, and this can be used to good effect to reduce the amount of work.

Variegated Leaves

Many variegated leaves tend to be green combined with either white, very pale yellow or green and frequently these colours appear slightly grey, partly due to the effects of shadows that are more readily seen on paler colours. Variegation quite frequently follows a pattern. Therefore the easiest way to describe variegation is to draw the pattern very faintly on the leaf and begin with the darkest areas of the leaf; this allows for adjustment of the paler tones without making them appear too dark. Variegated leaves are not confined to green and white, other colours can be observed; however the principle is the same when it comes to painting them. When choosing a variegated leaf, do make sure that the variegation is characteristic of the plant and it is not mottled due to a disease or poor growing conditions. These can of course make good subjects for painting, but paint them from a place of knowledge.

Patterned Leaves

Patterned leaves are very similar to variegated leaves but can be a variety of different colours and not necessarily limited to green. Examples of patterned leaves are cyclamen or some of the ornamental begonia leaves. To demarcate the different colours it is useful to work out the pattern and then draw this in very faintly. Work out the palest areas and begin with those. In the case of the cyclamen apply the palest tone all over the leaf, then work out the next palest and add that to the appropriate areas. The darkest tones are then built up last. When it is necessary to produce a very dark green the addition of a modifying colour will in all probability be needed. Additional colours, which can be used to great effect for various projects, are Cobalt Turquoise, Oxide of Chrome, Terre Verte, Viridian, and Yellow Ochre. Observing the underside of the leaf can provide a clue as to which colour to use.

Grey-Green Leaves

Grey-green leaves have a serenity about them and a gentle presence. The selected colour needs to reflect this character. Grey-green colouring to leaves is present in many herbs such as lavender, sage and rue, to name but a few. Usually leaves display a vibrancy, and this is matched by the colours chosen. Grey-green leaves require a quieter mix and this is where the earth tones are particularly useful. Cobalt Blue and French Ultramarine are good places to start. With the addition of a little Yellow Ochre and a touch of Winsor Violet a good grey-green can be mixed. If the colour goes a little dead, consider

An exercise in mixing grey-greens for leaves.

the addition of a touch of Viridian to wake the mixture up. Alternatively, Oxide of Chromium with a little Cobalt Blue can be effective also. A little purple added to any green mix should help achieve the perfect match.

Brown Leaves

Autumn leaves and dead leaves can be beautiful subjects to study. They can vary from yellow, through orange and red to brown. Always begin with the palest colour possible. If the leaf is a bright brown, showing areas of red and orange, consider beginning the underpainting with a very pale yellow, Raw Sienna or Yellow Ochre, gradually building up layers of differing earth colours until the required brown is achieved. If the leaf is particularly dry and/or crisp it may be advisable to begin the underpainting with a very pale blue such as Cobalt Blue. Brown can be considered as an orange, and blue is the complementary colour to orange; the result should be a slightly greyish brown, which will serve to characteristically deaden the colour.

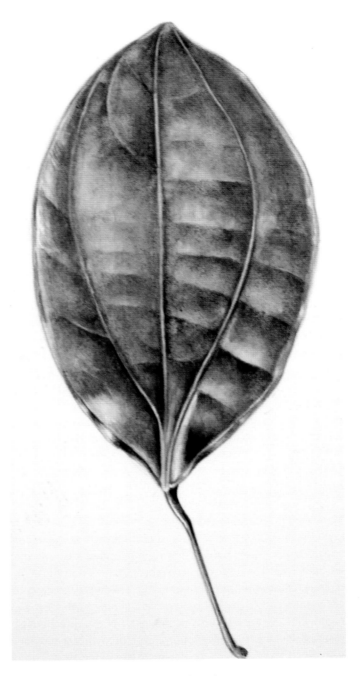

A dead leaf study.

Compound Leaves

Compound leaves are represented by those that are arranged on a secondary stem coming from the main stem, and seen in such plants as the wisteria and acacia, for example. When attempting these subjects try to simplify the drawing by first placing the direction of the stem. Then add the midribs of each leaf observing the direction of growth and the method of attachment to the stem, which are most important features.

Finally add the outer margins of the leaves, bearing in mind some may overlap each other. The negative spaces can help here in the correct placement.

A further consideration when depicting compound leaves, a complex branch of leaves or the arrangement of leaves in a composition is that in all probability the leaves, or even parts of the leaves, will appear on different planes. Consider the arrangement of leaves on a branch as a whole. Made up of individual leaves they nevertheless do not stand alone. They relate to each other and to the whole plant. Some leaves will be at the forefront of the painting, some will be in the middle and some will fall behind. When this occurs, in order to make sense of the whole, it can be helpful to make use of aerial or atmospheric perspective. This is where a colour becomes greyed, and the intensity is diminished, thus making it appear further away. By adding more water to the paint mix, or greying the colour, this effect can be achieved. Consider increasing the blue content of the mix or adding violet to the mix. By painting the leaves that are turning away with such a mix, aerial perspective will come into play. It is worth repeating here that warm colours advance and cool colours recede.

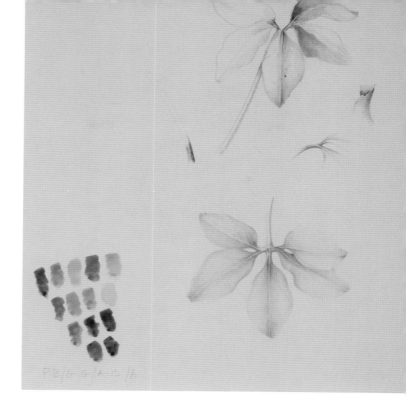

Helleborus niger – a compound leaf.

FORESHORTENING

Foreshortening is almost unavoidable in Botanical Painting. This is the way in which a leaf or petal appears to be shortened when observed face on. The important thing to remember is that only one plane will alter and if the leaf is facing the front it will be the vertical plane that will seem to change, not the horizontal one. That is, the width of the leaf as seen face on will be the actual width of the leaf. Part of the length of the leaf will be concealed and the observed part will appear shorter than it is in reality. What must be remembered is that just because parts of the leaf cannot be seen, they still exist, so any extreme foreshortening must look convincing. As this can be incredibly difficult to

achieve, and because it can lead to confusion, it is best avoided as much as possible.

A solution is to tilt the leaf slightly to one side in order to have a three-quarter view, which is simpler to depict with conviction and should therefore be easier to understand. However, in complex compositions there will be some tricky foreshortening that is unavoidable, so it is good to practise. A useful tip is to close one eye periodically, which will help to make the viewing easier. Equally, draw what you see, and not what you *think* you see. This can sound illogical but it is all too easy to look at something and make hasty assumptions that are, in fact, incorrect. Nothing beats constant referencing back and forth from the plant depicted to the drawing, checking and double-checking information.

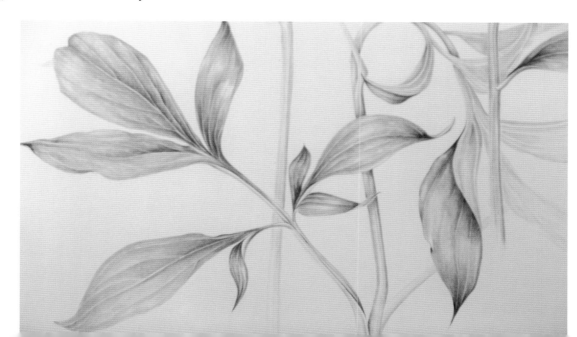

Paeony leaves to demonstrate the effect of aerial perspective.

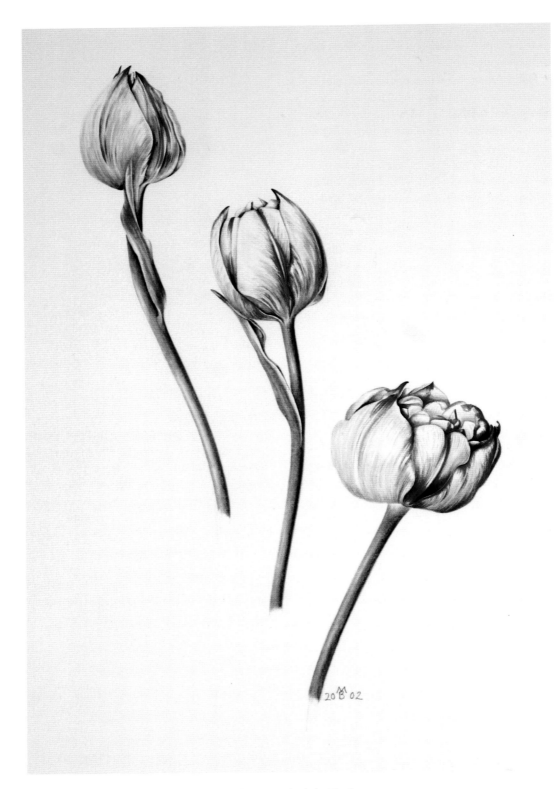

Tulips 'Carnival de Nice'.

FLOWERS AND THEIR PARTS

BUDS

Buds can provide delightful subjects for the Botanical Painter as stand-alone subjects or part of a composition. Obviously, they vary enormously in size and the method of painting should be adapted accordingly. On the whole, buds, whether those of a leaf or a flower, are tightly packed, and this should be reflected in the end result. The tension caused by the tightness of the

bud frequently makes them appear quite shiny. Also, they can often display all the colours of the plant in one tiny area. Part of the art in the successful interpretation of a bud is to keep the colours as clean and fresh as possible as they drift into each other. Increase each tonal value in very small increments that should be in relation to the scale of the bud.

Like everything the anatomy of the bud needs to be accurately observed. It is important to understand how it is attached

Amazonian buds.

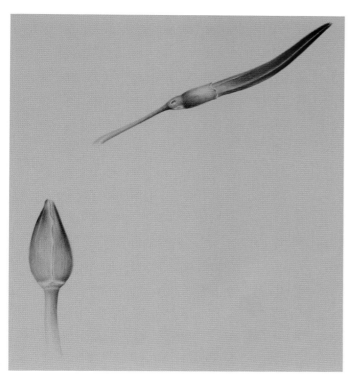

A dahlia bud study.

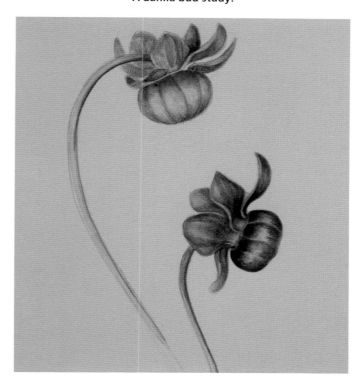

to the plant. Buds can display a great variation in colour and shape within one plant depending upon the position of the bud and its development before flower burst. Pay careful attention to this in order to get the best out of the painting. If a number of buds are present, do consider varying the intensity of the colour of the buds as progress is made up a stem. This will help give a feeling of movement and scale.

It goes without saying that there are thousands of different flowers, all with their unique features, which is partly what makes them such a captivating and rich subject for painting. The more their idiosyncrasies are studied, the more addictive it can become. The focus here is upon painting rather than Botany and so plant structure is only touched upon to help achieve the best from the painting. Emphasis is given on how to describe detail as effectively as possible through close examination, accurate depiction and effective painting, rather than the precise mechanics. Specialist books on the subject of Botany are always useful for furthering knowledge of the complexities of the plant world.

FLOWERS

The flowering plants of the plant kingdom are separated essentially into two different types of flower: those that are regular (actinomorphic) and those that are irregular (zygomorphic). A regular flower means that the flower can be cut on any plane and produce a mirror image, such as a daisy or primula, for example. A zygomorphic flower has symmetry on one plane

only, such as seen in a foxglove, orchid or delphinium. Once this is established, patterns occurring within the plant can be used as guides for drawing and ultimately, painting.

When beginning a new project, it really is useful to draw a very simple diagram of the flower. Not only is it a good way of getting to know the flower but, at the same time, it helps make it a less daunting task. To serve as a reminder, begin with a very faint pencil line to represent the stem. Then establish where the flower emerges from the stem and mark the centre of the flower with a small circle or large dot, depending on the size of the flower. Next draw two lines, one vertical and one horizontal, through the centre of the dot, thus quartering the subject. The flower can be measured and marked according to the guidelines drawn. Count the petals of the flower, if this is possible, and note their arrangement. An imaginary line to mark the centre of each petal can be of help if the veins of the petal are not apparent. This has the benefit of giving a guideline and also means that concentration can be given to drawing just half a petal at a time, as well as minimizing the room for error. It is surprisingly easy to be out by a mere millimetre on a petal, which in itself sounds very small, but the cumulative effect can amount to a significant error overall. At this point check the width of the petal and how the petals overlap. Once the petals have been arranged and drawn in, add the pistil and the stamens. Sometimes the stamens can be too numerous to depict faithfully one by one, so the overall nature needs to be grasped and effectively communicated. Even if all the detail cannot be painted, it is good to highlight and accurately describe a few of the stamens, so their nature can be understood. A reasonable amount of artistic licence can be applied and yet still capture the essence of the

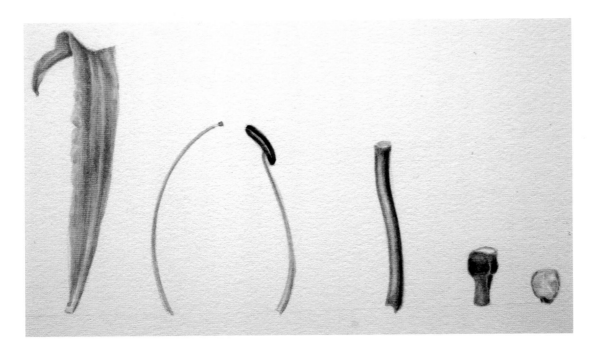

A nerine lily taken to pieces to study its component parts.

flower as long as this is done with integrity and sensitivity. Make sure the position of the pistil is accurately placed. The stigma is important too as this is frequently a diagnostic feature and should be correctly noted. Sometimes it is difficult to see this in detail with the naked eye, so it is worth looking at through a magnifying glass or lens. Even if the detail isn't drawn because it is too small, if knowledge of the construction is secure it will go some way to making the overall painting look convincing. It is worth taking time to examine how Botanical Painters and Illustrators have tackled various plant subjects and to work out how they have achieved their effects. Making a copy of a favourite painting can be a useful exercise.

Consider composition from the very beginning of a project: a balanced arrangement never fails to please and not only should consideration be given to the composition on the page but also to the plant itself. Think about the way in which the flowers are arranged, noticing the proportion of buds to open flowers if relevant, and the way in which they are arranged on their stem or stems. Show flowers from different aspects; for example, a side and back profile as well as a central view. This can be seen in many Botanical Paintings and illustrations as it serves to show the flower of the plant from every angle, which will help with accurate identification. As with leaves, describing a flower front-on can present a number of problems due to the effect of foreshortening. Therefore it is sometimes helpful to tilt the flower, which is to be seen face on, turning it slightly towards one side or another. Sometimes severe foreshortening will be unavoidable. A key point to remember is that only one of the planes will change for the effect to work. One aspect to note is that due to the effect of foreshortening, part of the petal will be concealed. Nevertheless, the hidden part of the petal should be accounted for in order for this to work.

Front-facing flowers will in all probability be seen in full detail; those facing towards the light may appear slightly lighter and those facing away from the light slightly darker. The colour of those facing away from the stem on the back side of the flower may be slightly greyed or faded. This is due to the effect of aerial or atmospheric perspective. As described for the painting of leaves, this is the condition where the intensity of the colour is diminished and/or greyed the further away it is. It follows the principle that, in the distance, everything fades to grey. When aerial perspective has been ignored, the overall effect can look as if the plant depicted has been pressed – that is, brought to one plane only. This can be a striking way to present a painting and of course it is a matter of personal choice. A clear decision is required in this regard, and it is better to make it through choice, rather than happenstance.

An autumn crocus.

Orchids

Orchids are wonderful subjects for Botanical Painting as they generally have the remarkable ability to stay very still. They have the added bonus that usually each individual flower lasts for an extraordinarily long time. Certainly this is true of the choice available from garden centres and florists. They are an enormous family and, while following a definite format, the changes between each variety can be minute. Many have specific pollinators, and these varieties have adapted especially to attract the pollinator to them. This is one of the reasons that makes them such an intriguing family. They are a zygomorphic flower, which means they have symmetry on one plane only, each side of which is a virtual mirror image of the other. This can be helpful when drawing the flower but, equally, can present its own problems as any inaccuracy will be swiftly spotted. A good deal of attention should be paid to the sexual parts of the flower as this is often a distinguishing feature. While appearing to be quite complex, if the plant is broken down into its component parts this helps not only in coming to an understanding of the flower, but also in the painting of the flower.

The structure of an orchid flower differs considerably from the majority of flowering plants encountered. If these flowers are of specific interest it is useful to refer to a specialist book on the subject. The orchids have specific terminology to describe them and this can be a fascinating area of study. These plants can of course be painted without expert knowledge of the plant, and a successful painting can come purely from careful and thoughtful observation. It helps to look for the basic construction of the flower, and find the simple shapes that effectively describe

what is seen. Measuring each and every component will be of great help.

Quite frequently the petals of the orchid family can seem quite fleshy and rigid. It can be difficult to differentiate between the sepals and the petals as they can be so similar, so do be aware of this. The shapes are sometimes very gently curving and others appear quite angular. The detail can be very subtle, and this should be reflected in the painting. The veins on the petals are barely visible and often can only be seen through the effects of shadows and sometimes the veins are more pronounced on the sepals. The only sure method of getting it right is by minute observation of the details. The use of a very dilute grey/neutral tone is a good method of showing the subtlety of the shading providing it is used with great caution. Too much grey and the painting will appear too heavy. It is vital that this grey mix is kept as pale as possible – most probably, no more than dirty water. This can be built up in layers to get to the required tonal value if the shadow applied appears too pale. Make sure each layer is allowed to dry before subsequent layers are added. Sometimes when a pattern is present on the petals the patterns seem random and at other times they seem definitely ordered. Even if a pattern seems to be made up of random daubs of colour, check and double-check to see if there is a coherent order to the markings. Make sure the colour follows the form too; keep it pale in the lightest areas and dark in the darkest areas. If the colour is applied flatly, with little variation of tone and no regard to the form across the flower, the flower can appear to be flat.

Referring back to the chapter on the shaded drawing will help as a reminder of the way in which the darks and lights work. The shading of the sexual parts will be very delicate and a No. 1 or smaller brush will be called for.

When approaching the centre of the plant, which contains the sexual parts, it will be observed that the structure makes them stand out from the plant. In order to convey this information it will be important to make adequate use of dark and light tones. The lightest tones need to be given to those closest and the darkest furthest away. As the centre recedes it seems to become darker, due to the shadows formed by its other parts. Be aware of the fact that if two darkened surfaces are next to each other, a phenomenon occurs called reflected light – that is light bouncing off a dark surface and reflecting light onto the neighbouring surface. This means there will be an area that is light in an area where one would expect it to be dark. The easiest way to remember this until one is familiar with it is to appreciate that when something is dark, what's next to it must be light and *vice versa*, otherwise the two areas could seem to merge. With botanical painting, where clarity of detail is important, it is best to avoid such merging. Before committing to paint, think of the impact each area will have on its neighbour. Lay tracing paper over the painting and test with pencil shading first before committing to the painting.

Work out the colours to be used carefully, beginning with the palest colour first. When painting the shadows do take care that the painting doesn't go too grey; it is important to be very subtle with the shading to keep the whole painting lively. Sorting out the colour mixes in advance and keeping to the notes can make sense.

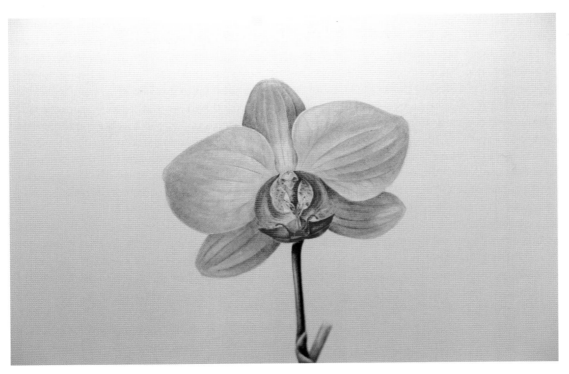

An orchid study.

Having described key points to bear in mind when studying an orchid, and in order to demonstrate a systematic approach to painting a flower, the orchid has been selected to show the development of a painting. Firstly, by applying washes to create the form together with a feeling of perspective, then adding the detail, and finally using washes to harmonize the whole. This exercise can be referred to when painting any Botanical subject.

A SYSTEMATIC METHOD OF PAINTING AN ORCHID

Throughout this book the emphasis has been on building up layers. It can seem to be a tricky process to come to terms with. Not only is the process itself difficult, but it forces decisions to be made in advance rather than plunging straight into the painting, which can be a completely novel way of working. The temptation is almost always to get to grips with the detail. This method of working does need a leap of faith into the unknown and the following might help to understand the process better.

The orchid is an irregular flower, which means it has symmetry on one plane only; one side is the virtual mirror image of the other. As mentioned, the hardest part is to hold back from adding the detail too soon. A set of ten images goes some way to show the process involved in building up the painting through layering the paint.

After a clear simple outline of the flower has been drawn, it is good to check any excess graphite is removed from the drawing by rolling a cylindrical-shaped piece of putty rubber over the surface. This will help to make sure the drawing is as sharp as possible. The next step is to work out the colours that will be used. Examining the plant from both front and back of the petals, as well as taking in the green of the leaves and the colour of the stem, helps to work out the best colours to use. Consider all parts of the plant, whether or not they are to be included. The pink of the flower is very clear and soft, with a hint of blue showing. Firstly Permanent Rose was chosen to depict the flower, with a touch of Cobalt Blue, but this seemed to take the colour too far towards Mauve. Therefore the decision was made to mix Permanent Rose with Quinacridone Magenta, which achieved a good match. It was also important to find a good neutral tone for the shading of the centre of the flower and to create the form. Cobalt Blue is a very delicate blue and seemed to be a good choice, combined with a touch of Raw Umber and the magenta mix, so that a warmish grey was achieved.

In the centre of the flower there is some yellow, and this was the next colour to be selected. A transparent yellow was required so as to keep the colours as clear as possible. Aureolin seemed the perfect choice as it mixes very well with Permanent Rose to obtain a rich scarlet, and it also seemed a good match

for the delicate yellow that is present in the centre as well. Having chosen a red and a yellow, it was just a matter of selecting a blue. Having selected Cobalt Blue for the neutral tone this was considered for mixing the green but it didn't seem quite strong or vibrant enough, as the stem was such a deep, luminous colour. French Ultramarine was considered, but eventually Phthalo Blue was chosen. Phthalo Blue and Aureolin together however was far too exuberant a mix, so was modified by the addition of Raw Umber. This was just enough to tone the green down and enabled the palette to be relatively restricted. These colours were noted in the sketchbook so that they could be referred to at a later date if needed.

In order to see the detail and understand the form, a table light was positioned to the left of the flower, and the light source was established. A very dilute mixture of the neutral tone was mixed, and this was delicately applied to indicate the darker areas to enable the form to stand out. Immediately after that a dilute mixture of Permanent Rose and Quinacridone Magenta was applied to the relevant pink areas so as to build up the form. After this a slightly stronger mix was applied, again building up the paint in between the veins on the petals. The veins were left unpainted for as long as possible.

All parts of the plant were built up at the same rate, including the stem. This would usually be the same no matter the size of the project. This can help prevent one part of the painting being overworked and therefore having the potential to spoil the balance. The stem of this particular orchid was very dark – almost black. Remembering the notion of complementary colours, that is that pink and green will darken each other, a very pale green was laid down as the first wash. The intention was to get to the very dark, almost black-green by mixing layers of different colours, rather than mixing a colour to match from the beginning.

Being aware of the fact that the sexual parts on the orchid are important for identification, these were studied carefully with a magnifying glass. In order to allow the pale parts to stand out, these areas were left as pale as possible, for as long as possible. Only very, very dilute washes of a neutral tone were applied when appropriate to give a feeling of form, which still allowed the parts to stand out. Work proceeded in a methodical way, starting with the uppermost petal, and then moving around the plant in a clockwise progression. At all times the thought was on the whole flower, and if an area was needed to be depicted as light then the surrounding areas would be slightly darker; while if the area was dark the surrounding areas needed to be lighter. Sharp contrasts were avoided with this painting, as the gradations of tone were very subtle. By adding some grey tones to various areas in contrast to the clarity of the true colour, the petals of the orchid could begin to shine out.

An initial very pale
wash to seal the paper.

Permanent Rose and
Quinacridone Magenta
applied thinly once the
first layer is dry.

A third thin layer of the colour mix applied considering the form.

A development of the form moving systematically around the flower.

A further development
of the form.

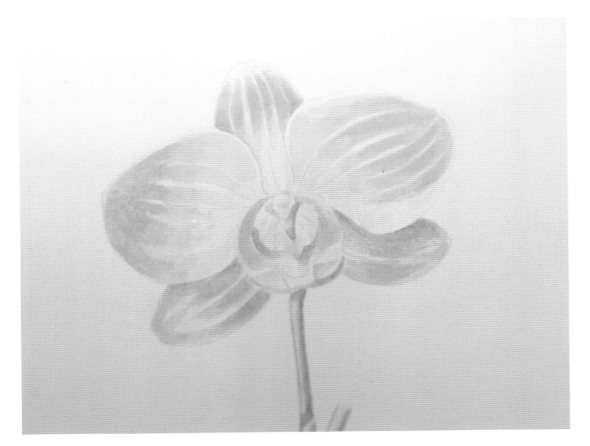

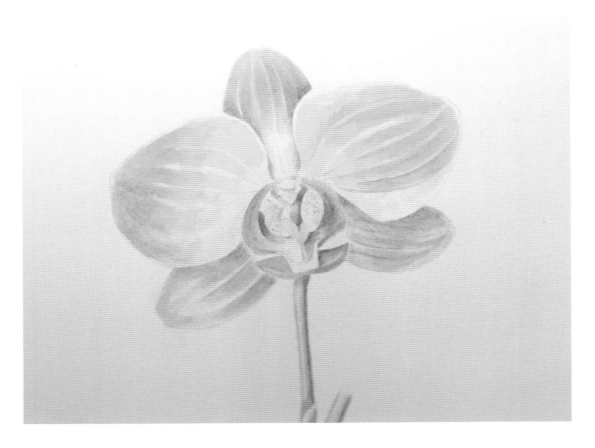

Beginning to give
attention to the
localized colour while
still considering the
overall form.

A gradual development of the centre of the flower.

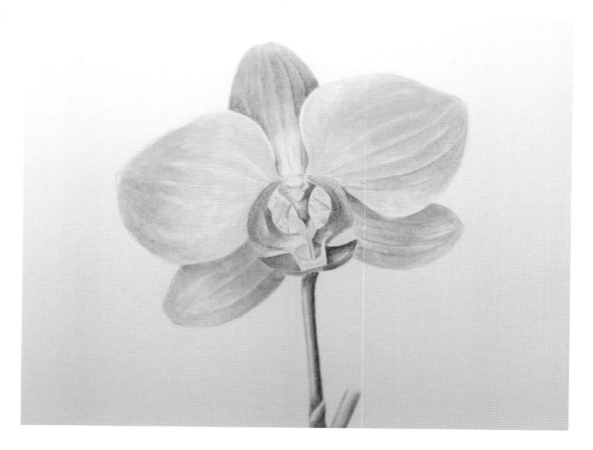

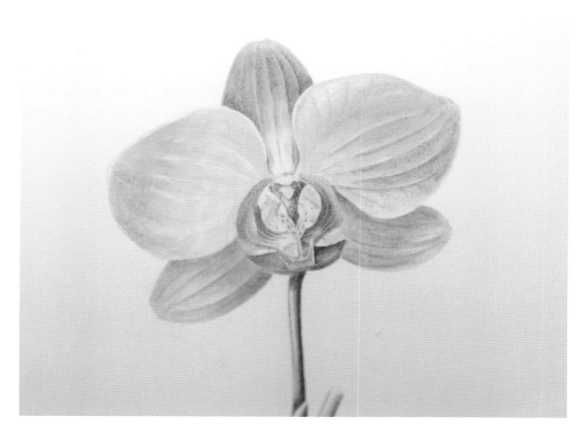

Developing the colour on the petals as well as the flower centre.

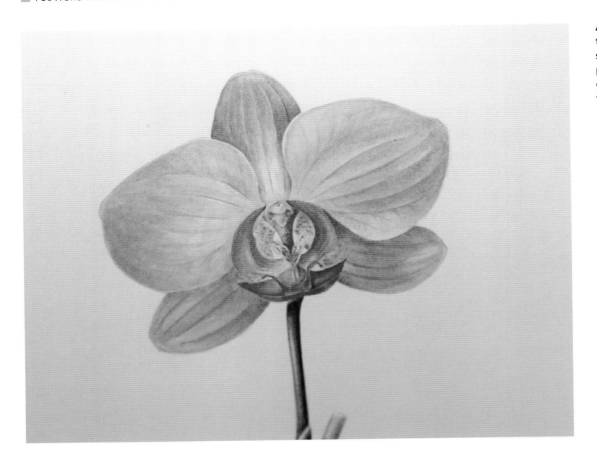

Adding the detail to
the centre and adding
shadow tone to the
places where parts
overlapped to make
them stand out.

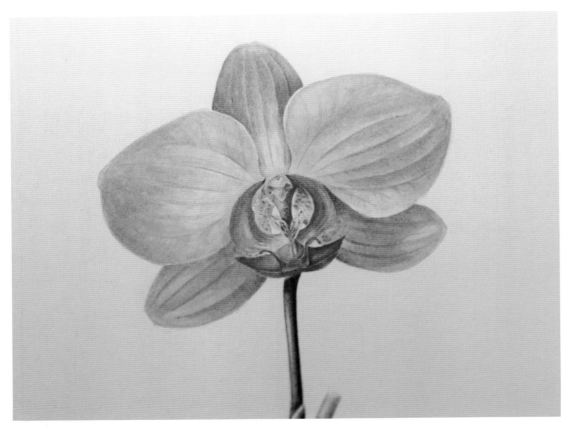

Tidying up the edges
and adding harmonious
layers of washes.

The stem of the flower, while having its base in green, seemed to be made up of all the colours and therefore Quinacridone Magenta was added to the green, which made the stem turn slightly brown, it was then rebalanced by the addition of Prussian Blue and more Aureolin in differing quantities. The layers were added bit by bit, to achieve the very dark murky green that was characteristic of the specimen.

For the deep magenta parts of the flower, Aureolin was mixed with the Permanent Rose and Quinacridone Magenta, then a touch of green was added to darken the colour. The grey mix was used to dull the colour where needed and applied as a separate layer. Careful attention was paid to the light source at all times.

The detail was increased very gently by painting in the veins on the petals and placing the markings where they were observed. Careful attention was given to the tone applied to make sure it related to the tone of the underlying colour. In every instance each addition of detail should be given the same attention relative to the tone to which it is applied. Once the detail was completed, some transparent glazes were applied. To prevent the flower becoming too sugary pink a very pale wash of Aureolin mixed with Viridian was applied over the pale areas of the petals closest to the centre. This had the effect of giving a very slight green wash to the areas that had been left unpainted, or a very pale grey, while darkening the areas of pink in a very subtle way. The two wings received a wash of Rose Doré and the three outer petals had Rose Doré applied on the edges closest to the light, and Cobalt Blue on the surfaces furthest from the light. Finally where the petals overlapped each other a little more of the neutral tone was added to enhance the aerial perspective, attempting to make these areas stand out from others.

When undertaking a stem of flowers, it is useful to draw the stem first, note how the flowers are attached to the stem and mark these with a very delicate pencil line. Then observe carefully the arrangement of the flowers in relationship to the attachments. Frequently, these attachments will be concealed by flower heads but they will nevertheless act as a guide. Also remember to vary the tone on the whole stem taking into consideration the form of the whole, the form of each individual element, and the effect of aerial perspective.

THE USE OF A STUDY SHEET FOR PAINTING

Having described a systematic approach to the painting process, it is good before beginning a painting to undertake a study sheet. The primula makes an interesting subject to study; it is neither too large nor too small. The primula is a regular flower, that is, it has symmetry on every plane, whichever way it is dissected.

To illustrate a study sheet in action, *Primula auricula* has been

chosen for the purpose of this exercise. The *Primula auricula* is also known as the 'Florists' auricula' and is the result of extensive hybridization by nurserymen and florists. These flowers have a rich history and were highly prized by collectors in the eighteenth and nineteenth century. On the whole they are well-mannered plants and lend themselves excellently to Botanical Painting.

After selecting the specimen it is always a good idea to spend some time making rough sketches to get to know the nature of the plant. It is worth drawing a bud, a half-opened flower and a fully-opened flower so that there is a good basis to work from. Using basic geometric forms as a guide (which in the case of a fully-opened primula flower is a disc with a cone behind) work out the centre of the plant, which will hold the stamens and pistil, and also work out the centre of each petal. Draw a faint line to mark the centres. In diagrammatic form each flower can be said to be made up of discs, vaguely resembling a target board. Use such a diagram as a guide which, while basic and elemental, will help with the construction. Then draw the margins of each petal, one half at a time, having first drawn a very soft line to mark the centre of each petal. Sometimes the chosen specimen just does not work, for a number of reasons, and a change of specimen has to be made. The time spent on study however will not have been wasted, as the new specimen will be more familiar and the subsequent observation time reduced.

Once the flower has been observed, the next stage is to see how the florets are arranged around the stem. In nature, as plants grow they tend to spiral and the arrangement of the parts of the plant may well reflect this spiralling. Some spirals are more obvious than others; in the *P. auricula* they are not so obvious, but to be aware of this fact can assist in the drawing and help to make the subsequent painting more convincing. When dealing with a flower such as the *P. auricula*, which is made up from florets known as 'pips', it is vital to be aware of both the complete inflorescence and the individual components at the same time. At first glance this can appear to be impossible mental gymnastics, but by taking a systematic approach, such complexities can be simplified. This is where a sketchbook can come into its own. It can help facilitate the working out of complex structures into simple forms, which can be easier to manage than plunging straight into the painting.

There will be a number of different viewpoints over the whole inflorescence, which will provide good practice for all sorts of flowers, especially those flowers that have a conical form as their basic shape. As previously mentioned it is good to make a note of each of the different viewpoints such as: a side view to the left; a three-quarters view to the left; face on; a three-quarters view to the right; and a side view to the right. These are in all probability the minimum that will be seen. These basic shapes

A sketchbook page.

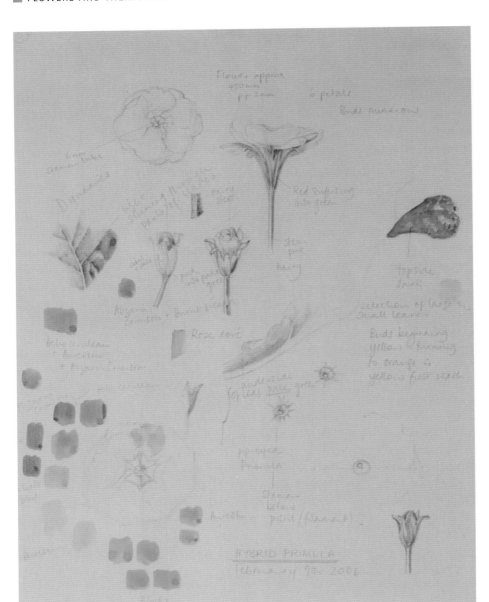

are further complicated as there will also be a tilt, which can be observed rising upwards and downwards. All this is before one tackles the florets facing away from the front. As a guide, it is good to plot a series of circles and ellipses from which the detail can be developed, remembering the principle of foreshortening. Sometimes these flowers have an abundance of 'pips', and other times merely one or two; these variations will often be a feature of the particular hybrid. *P. auriculas* provide an excellent demonstration of shifting planes, which can be translated into all sorts of plants with complex forms; examples would be members of the Umbellifer family, represented by the flowers of cow parsley and carrot, as well as other plants that have multiple flower heads, like agapanthus.

Consider the effect of light on the form of the flower and how it will affect the whole inflorescence, as well as each individual component. This is where theoretical knowledge can be of tremendous help, especially as the available natural light will change as the day progresses. As a reminder of the light-source, it is useful to put a pencil arrow at the top left of the paper, which can be erased when the painting is completed. Remember also that the detail will in all probability be fully seen only in the mid-tones. In the darkest tones the detail will be absorbed and in the lightest tones the detail will appear bleached. In both these cases the detail will be lost. The intensity of the colour will be affected too when it comes to painting. The darker tones will not only be darker but the colour may be somewhat greyed. In the lighter tones, the colour will be less intense, therefore more dilute.

As mentioned earlier in relation to leaves and buds, the components of the plant that are further away will be subject to aerial or atmospheric perspective. To achieve a good feeling of aerial perspective to the flower head so that there is an idea of size and depth to the whole, the florets that face away should be painted slightly paler or greyer, or a combination of the two.

P. auriculas are available in a wonderful array of colours, and the richness of their colours can be built up, maximizing the effect of layers. Carefully examine each flower, both front and back, to see the make-up of the colour and be prepared to mix in what is observed. As shown, a study page helps to provide much of the information that will be needed to complete a painting. Kept in a sketchbook, these can provide handy references. It is useful to date the work and, at the same time, to add as much research information about the plant as possible. Brenda Hyatt's monograph *Auriculas: Their Care and Consideration* provides excellent information on the plant to inform the painting.

As with all projects, work out a palette of colours in advance, whether using a limited palette or not. In the example of the red *P. auricula*, the flower head consists of a band of white (the circle of paste) and red (body colour). It was obvious that great care had to be taken to keep the parts that appeared white clear of any red. In order to get a good rich red, and having observed the presence of yellow on the back of the petals, a pale yellow wash of Aureolin was chosen to be put down first. The red petals were then gradually built up layer upon layer carefully observing the bumps and dips on the petals and how the colour was affected

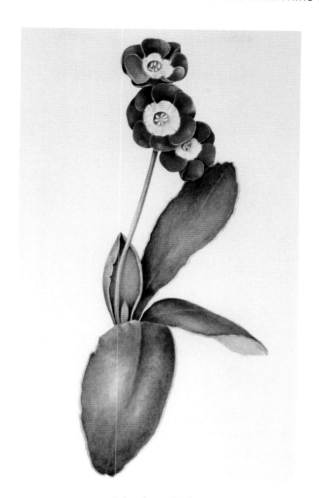

Primula auricula.

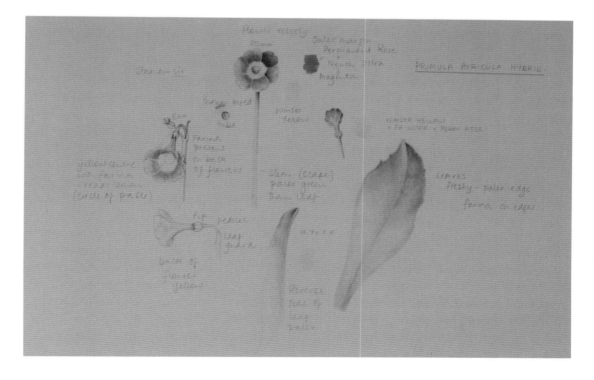

Primula auricula
sketchbook page.

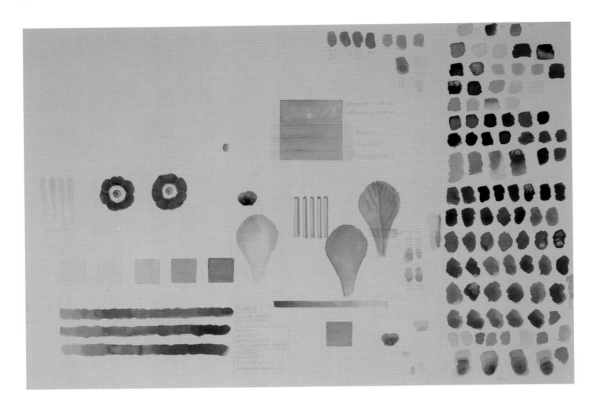

Primula auricula
painting study page.

by these undulations. Attention was given to the arrangement of the floret and to the overall form. Due to the effect of aerial perspective the topmost floret was made to appear slightly paler in tone, or slightly greyed. Equally the lower floret that is further from the light source was given washes to help it appear to be slightly darker, and equally greyed. To arrive at the desired final colour, different reds were applied sometimes in layers and sometimes as a single colour. The reds selected were Permanent Rose, Alizarin Crimson, Quinacridone Magenta and Rose Doré. To darken the red, when required, a touch of Viridian was added to the mix.

The stamen tube was then painted, with a pale wash of yellow, Aureolin. After this wash had been applied and dried thoroughly the stamens were drawn in. Dissecting a flower will help to understand the construction. This is an excellent example of the merits of taking a flower to pieces so as to better understand its distinguishing physical features.

As the stamens are so small, it is easier to paint around them with shadow tone rather than attempt to clumsily paint each one. The reason for painting the stamen tube of the flower yellow becomes apparent. This first wash will ensure that the stamens remain a clear clean yellow, which can be further developed later if desired. Remembering the light is seen to be coming from the top left, the shape of the tube can be painted with a very pale neutral tone. Permanent Rose, Cobalt Blue and Yellow Ochre make a very soft grey. A very watery mix can then be painted around each of the anthers. This can be built up gradually, paying attention to the way in which the light is cast

across the tube. It will be observed that the left-hand side of the tube is slightly darker than the right-hand side due to the light source. The anthers will possibly begin to look very flat. These can now be enhanced by adding a touch of darker yellow to the darker side of each anther, which should give them a bit of form. Try to retain a little of the pale wash on each anther.

The white band on the *P. auricula* is known as 'the circle of paste' or 'farina' and is caused by a mealy substance that resembles flour. To give a suggestion of the minute undulations, and to give this band form, a little judicious use of a neutral tone is called for. Following close observation, begin by using only little more than dirty water to demarcate the petals and build up form. This should be very subtle indeed. Leave as much of the paper as possible in order to have a good, bright white band.

Once satisfied with the general feel of the painting, it is useful to add some small modifications. These will always need to be left to the very end. In order to enhance the perspective, some areas may need to be knocked back and others advanced. It can be useful to use a very pale grey wash over the areas of the plant that recede. In the case of the particular example shown, the lower floret had a couple of washes of pale grey applied in a gentle swoop. The floret at the top of the plant had just one thin pale grey wash, but it was applied purely as a narrow line, as the shadow was not so deep. Where petals crossed over a more intense dark tone was added, only to the corners where the parts of the plant overlapped. This was applied in a tiny triangular shape and the edge was softened with a dry brush. The petals of the main floret in the centre of the arrangement were

USEFUL COLOURS FOR GLAZES

- Cobalt Blue, Prussian Blue
- Permanent Mauve, Cobalt Violet
- Aureolin, Transparent Yellow
- Rose Dore, Quinacridone Red
- Viridian, Terre Verte

Layering colours over green to achieve different effects.

then enhanced by the addition of a very pale wash of Aureolin over the red, but only on the petals that were on top. Aureolin has the magical property of giving life to many subjects especially when used in a glaze. The petals that were slightly tucked under and therefore were behind had a very thin glaze of Cobalt Violet applied that very discreetly pushed them back. To provide harmony to the whole composition, these two washes were applied to the leaves and stem in small areas that needed similar enhancement.

While mentioning glazes it is useful to reinforce the reasons for application. The addition of glazes allows the artist to create the appearance of elements of a flower advancing or receding. Equally, glazes are good for enhancing a particular colour by using a different hue. This stage of painting should be reserved until the very end. Blues and violets, being cool colours, have the effect of giving the illusion of something receding; while yellows and reds, being warm colours, have the effect of giving

the illusion of something advancing. Used judicially, and by selecting exactly the right colour, these washes can help bring a painting to life. A little experimentation and development of a personal choice will be good and it can be fun discovering unexpected results. These glazes must be very thin indeed and barely visible. They need to be applied with a relatively large brush in a quick swoop. Be brave; timidity and hesitancy can have the effect of picking up the paint already laid down and the effect can be lost. Glazes can be added in layers, but remember to leave each layer to dry thoroughly.

Glazes can be used to harmonize the whole composition. For example, if painting a red rose, a glaze of very dilute red on some of the leaves of the plant, when included in the composition, will give just a hint of the reflected colour from the petals. The glaze should scarcely be visible but it will, however faint, help to harmonize the whole. Likewise a little hint of green on the petals of a plant, reflected from the leaves, will have

Double pink paeonies.

the same effect. By means of this device there will be a feeling of cohesion about the composition. However, do use glazes cautiously – and remember they should be so subtle as not to be immediately obvious.

Much attention has been given to the flower, but it is important not to forget the other elements such as stem, sepals and thorns in the case of roses, for example. It is useful to work up each of these elements in tandem with the flower. This helps to retain a sense of balance at all times.

It is always prudent to consider the whole painting continuously. It is easy to have one's nose so close to the paper and the subject that the overall composition can be neglected. While it is good to work up each element of a plant with relation to the rest of the composition, it would be wise to begin with the flower as this is generally the first to fade. On the whole, the leaves will be around for longer than the flower, although this is not always the case. For example, in the case of *Alliums*, the leaves usually start to die back just as the flowers come into their full glory. Always be on guard for exceptions to the rule; there will always be exceptions and the more that is examined about the plant to be painted, the less these will be a cause for concern. Time spent on research is rarely wasted and can help to avoid unhappy pitfalls.

So far attention has been paid to specific colours and simple mixing. However, one of the delights of Botanical Painting is the process of layering colours on the paper to achieve a different effect. The transparent nature of watercolour means that it is possible to build up thin layers of colour which will create a delicacy that is observed in nature. This method is far more effective than relying on mixing one specific colour and sticking to it. This is where time spent in contemplation of the subject really pays off. Seeing, *really* seeing, requires concentration and with practice it will begin to happen and all sorts of possibilities will present themselves. When examining a flower try to visualize each colour in turn, and see what happens. After a bit of practice, it is surprising what colours can be seen. It almost becomes a meditation. It is quite simple to look at a flower and make a snap decision as to its colour, only to be disappointed when painting commences to find that the colour witnessed has not been replicated throughout the painting. Frequently this is because the colour is not that simple, for example a purple flower often reveals magenta in some areas and blue in others. It is the combination, rather than the mixture, of colours that can give the flower its vitality.

Double Flowers such as Roses and Paeonies

Single-flowered roses and paeonies are, in comparison to the double varieties, fairly simple; it is the double-flowered varieties that can present difficulties – partly due to the complicated nature of the petals and partly due to the difficulty in keeping the delicacy. The notes here should provide a few solutions to overcome the problems encountered with roses and multi-flowered plants such as paeonies. Firstly, as often repeated, find the centre and prepare a section of guidelines from which to work. When there are so many petals it is often impossible to capture each one. Even if it is hard to keep track of them, it is nevertheless essential that those described are accounted for. This means they must come from the centre and relate to a position on the stem of the flower, as well as to the whole whorl, even if this is not visible or obvious. Stray petals can be the undoing of a very competent and beautiful painting and can ruin the work. Check and double-check that each and every petal can at least work theoretically.

The majority of these petals are incredibly delicate, even if they happen to be dark in tone. This quality needs to be reflected if the painting is to be a success, and this can be achieved by the manner in which they are painted. A further consideration, which may be of help, is that the outer edge of the petals often appear much lighter than they do at the base. There are a number of reasons for this: as the petal expands it gets lighter; the colour naturally fades as the petal grows; more light is able to reach the outer petals, making them appear paler. There will be exceptions, such as when the petal margins are actually darker in colour, for example. At this point it is as well to remember to try not to confuse colour with tone. It is the tone that is lighter, which in turn makes the colour *appear* lighter. The theory can be easier to understand if a shaded drawing has been undertaken first. This of course confuses the issue further, and provides the artist with an interesting challenge. One approach is to shade each petal relative to its

partner, therefore establishing all the dark areas of the whole flower and painting those first, rather than addressing the flower petal by petal. The shading, while apparent, should be as pale as possible. To make a very good, but delicate, shadow tone for roses and paeonies often in a colour range from white through pink to red, try Cobalt Blue and Rose Doré. This can make a very delicate warm shade of grey, or try Davy's Grey. Another alternative is to use the palest of the three primary colours in your watercolour box such as Cobalt Blue, Permanent Rose well diluted and Cadmium Lemon or Winsor Lemon. Do remember that the detail will be lost both in the highlights and in the depth of shadow and therefore the greatest detail primarily will be seen in the mid-tones.

A common mistake is to paint a margin on each petal as a straight line. While a definite margin is often present, it will vary in width and tone, even though this may be barely perceptible. The outline of the petal should relate to the shape of the petal. In all probability, the dips will be darker and the elevated margin lighter. The art is to convey the margin sympathetically to each petal and vary the intensity of tone. The greater the variance of tone, the lighter the effect will be. Even when painting the petal margin, the same consideration to the whole should be given. That is, remember the whole form of the flower while working on any individual element.

When adding shadow tones, in order to separate one petal from another, make sure the shadow is so subtle that it is barely visible. If it is too pale another layer can be added, and remember to allow each layer to dry completely. If the flower is a very

Rosa gallica **study to reveal the painting process.**

pale one, the addition of just dirty paint water can be sufficient to create the illusion of a shadow. Once satisfied with the overall effect, it is possible to add glazes of transparent watercolour washes to enhance the finished flower.

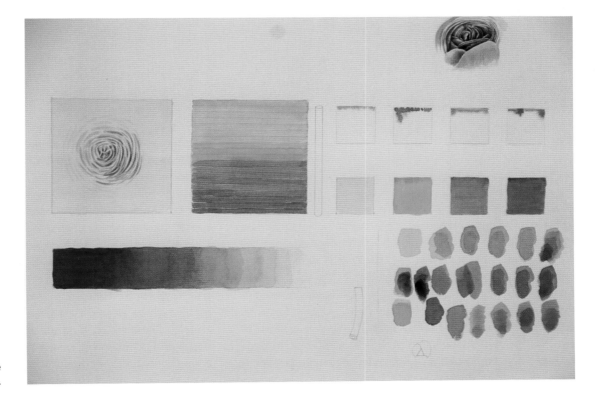

Study page for double flowers.

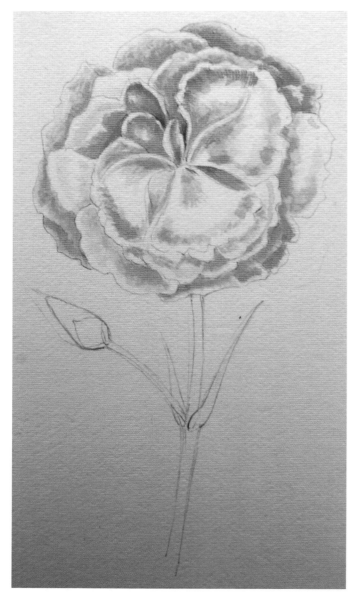

Development of petals for a garden pink.

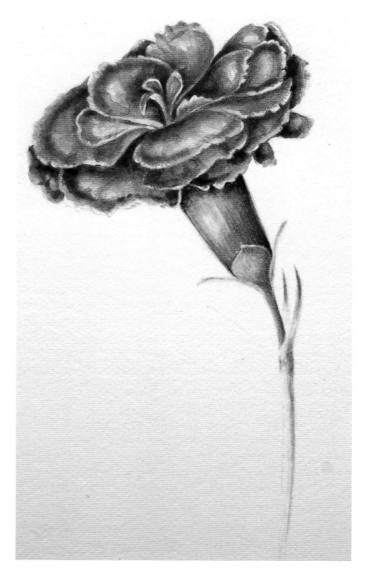

The completed garden pink.

Daisies – the Compositae Family

Daisy-shaped flowers are from the Compositae family. The flower is in fact made up of hundreds of tiny individual flowers and these form a distinct pattern, which once learnt will be invaluable. The spiralling nature of their growth is particularly evident in flowers from this family and was observed and described by the sixteenth-century mathematician Fibonacci. It is most readily noticed in the enormous flower heads of the sunflower. Once it has been observed on a large scale it is easier to see the pattern, even in something as small as the humble lawn daisy. This pattern is not exclusive to the daisy family and other examples are seen in the pineapple, artichoke and pine cone. Understanding this pattern

will make the depiction of such flowers much faster as a system can be applied to grasp this characteristic. Once observed, it can be seen everywhere in nature.

The Fibonacci sequence is witnessed throughout nature and it is also the basis for the 'golden section' rule, which can be used as the foundation of a good composition. Put simply, the Fibonacci sequence is developed from the sum of the previous number in the sequence. 1+1 =2, 1+2 =3, 2+3=5 etc. Thus, 1, 1, 2, 3, 5, 8, 13, 21, 34, . . . etc. The result of this sequence is that a type of tiled effect is observed, but unlike the tiles on a roof, which are generally on a horizontal plane, this tiling is at an angle and therefore on a spiralling progression. To illustrate this and to show how it can be applied it is useful to refer to a pine cone. It is important to note that the spirals work both clockwise and anti-clockwise. Knowledge of this will give a

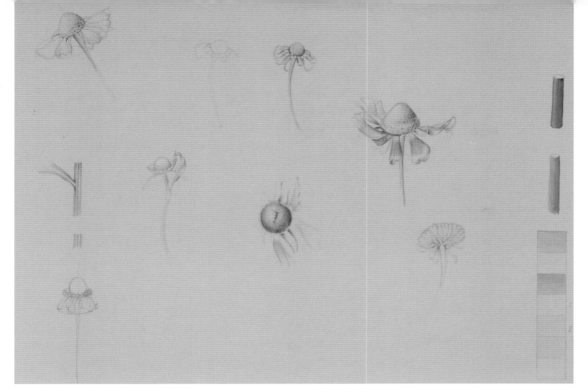

Compositae study page.

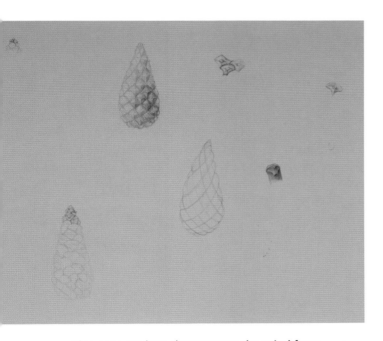

Pine cone study to demonstrate the spiral form.

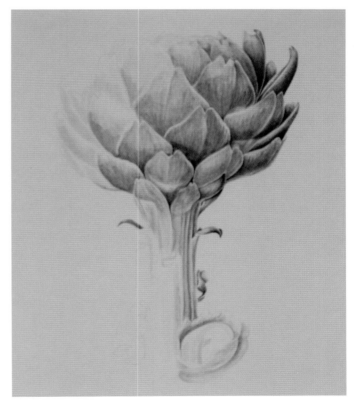

An artichoke painting in progress to reveal the spiral in process.

painting greater integrity; even if it isn't depicted in minute detail. It is important to be aware of its existence. As mentioned, an important element to observe is that the flower is in fact an inflorescence, meaning that it is made up of ray florets on the outside, and disc florets in the centre. It is the disc florets that give prominence to the Fibonacci sequence and where it is most clearly observed. It helps to look for a basic simplified shape and work from that as a guide. As with almost everything it is useful to begin with a point for the centre. From this it is possible to work out towards the outer margins of the flower in

a systematic fashion. Measure the centre and draw an approximate circle to mark this, then measure across the whole flower and draw another approximate circle to complete the flower. This gives a basic diagram from which the close observational

drawing can be made. To further simplify the drawing, a very faint pencil line to denote the vertical and horizontal can be of help. From this a further simplification can be made by drawing a theoretical bisecting line through each petal to plot them, from which an accurate drawing can be made. Attention can be focused on dealing with one half petal at a time, which can help in creating a sympathetic rendition. By breaking each element down into its basic form, a very complex flower can be built up, minimizing the margin of error. Once the outer petals (ray florets) have been plotted, the inner section (disc florets) can be added, using the position of the ray florets to guide the positioning of the spirals and therefore the disc florets.

When it comes to the painting, time can be saved by working out the palette ahead and making a note of the proposed colours. When beginning to paint, plan a system in advance. The key to success is to fathom out and establish a method that works best. With a relatively circular flower it seems to make sense to begin in the centre and work outwards, but this is by no means a rule, merely a suggestion. Before commencing it is important to establish the light source and the effect it will have on the whole. Then decide the best way to proceed by choosing whether to begin in the lightest area or the darkest area. This can only be a matter of personal choice but do remember: it is always possible to go darker, but not such an easy task to go lighter.

Although the Compositae family are relatively flat flowers, that is, shallow saucer-shaped as opposed to bowl-shaped, it can be easy to render the whole to look very flat and heavy, whereas the petals that make up the ray florets are frequently light and dancing. Therefore, take care with the shading and keep a good variety of tones on the petals. Try to be as sensitive to the form as possible, remembering some of the detail will be lost in the lightest and darkest tones. It is most probably in the mid-tones that the detail is revealed with clarity. Any shading applied should be kept as close to the base of the petals as possible to give the effect of light passing in front of, and between, them. If the shadow applied is allowed to stray too far up a petal, the message received will be that no light can pass between them, and this can make the petals look as if they are stuck together and the whole plant will appear too heavy.

Some Other Flowers

Violas make an excellent subject for the beginner. They have the advantage of being relatively flat and simple to draw. They also come in a lovely array of colours and are available for much of the year. Frequently they are bi-coloured which gives a further advantage when it comes to painting as it helps define each petal. The colours are naturally harmonizing too. They can make excellent studies or a composition in their own right.

When considering a raceme for painting, such as a wisteria, pay careful attention to the arrangement of the flowers. It can be useful to draw a selection of differing views of each individual flower before attempting the whole raceme. Don't forget to vary the tones as much as possible. The greater the use of darks and lights, the more dancing the end result will be. Vary the intensity of the colour as much as the colour itself. Remember also to make accurate placements of each individual flower on the stem and give consideration to the effect of the whole at all times.

Flowering plants are not exclusive to the herbaceous border. Weeds, herbs and wild flowers all make excellent subjects for painting. These tend to be on a smaller scale, but nevertheless are interesting to study. Trees, shrubs and vegetables too provide a rich source of fascinating floral structures for depiction in watercolour.

Plant portraits do not need to be confined to one single specimen and it is perfectly acceptable to mix and match. The most successful combinations are when care has been given to the choice of combination and this will be covered in the chapter on composition.

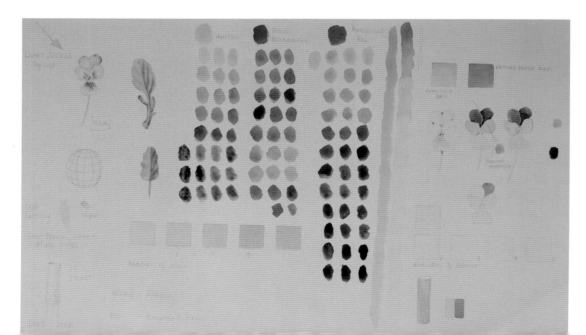

A viola study page.

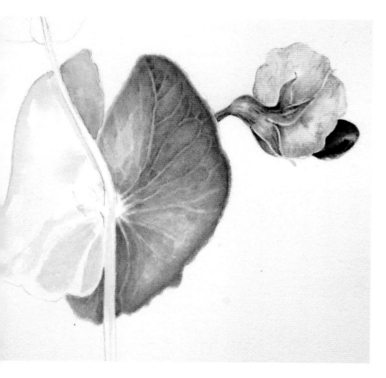

The purple-podded pea.

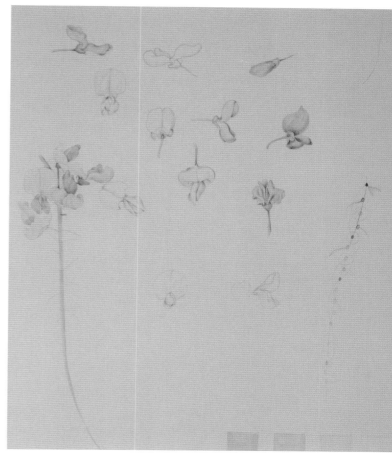

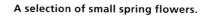

A convolvulus – study of a weed.

A wisteria study page to show the process of constructing a painting of a raceme.

A selection of small spring flowers.

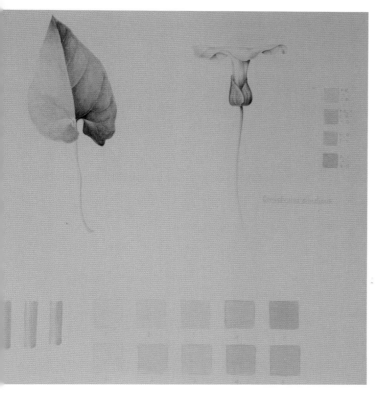

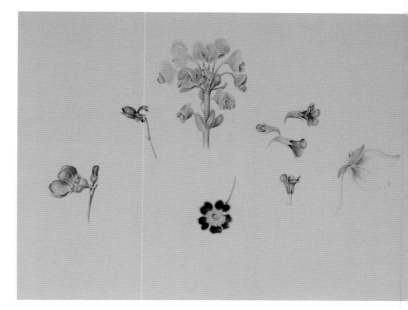

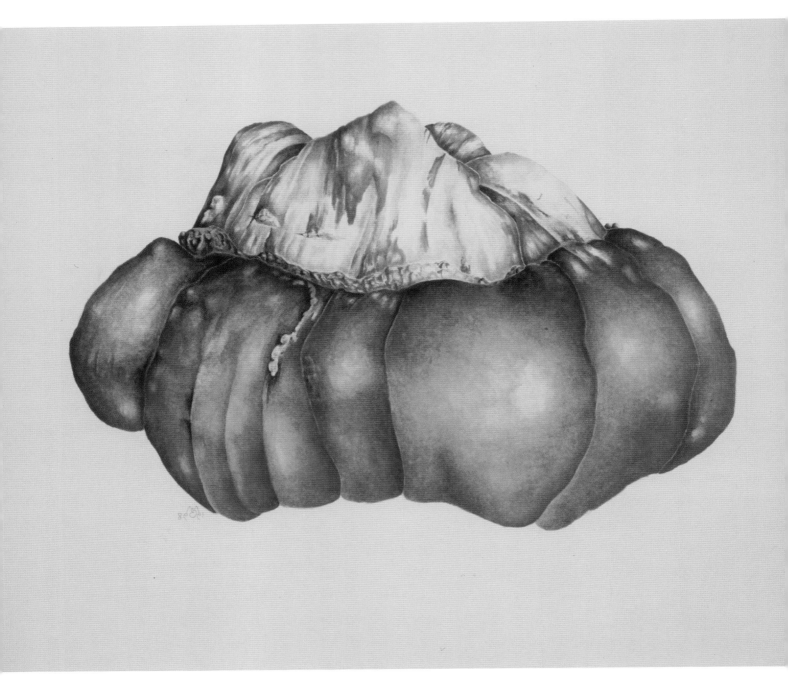

Pumpkin *Cucurbita maxima* 'Turk's Turban'.

FRUIT

After a flower has been pollinated the seeds begin to develop. Fruits come in an enormous variety of shapes and sizes and their interesting forms make excellent subjects for botanical painting. As a collective group they are all known as the fruit. However there are different names allocated according to their characteristics. For simplicity's sake the fleshy ones seem to be known as fruit, the dry ones are referred to as seeds, or nuts and the seed cases, pods. Fruits fall into numerous categories according to their nature and that alone is a vast subject. This extraordinary variety provides a rich area of study, especially for Botanical Painting.

As the fruits appear after flowering, it is important to make the distinction in the painting if including them. Therefore it is advisable to show the fruit as part of a composition, but as a separate item, so as to avoid confusion. There will be exceptions to this as some flowers display both fruit and flowers at the same time. Form is particularly important when considering a solid shape so it can be helpful to enhance the directional light with the use of a lamp to reinforce the fruit's three-dimensional quality. Depending on the maturity and variety of fruit the texture will vary accordingly. Soft fruit on the whole have taut, shiny skin and fleshy interiors; peas and beans can show a broad variety of textures according to their maturity, the fruit being velvety soft when young and frequently hard and shiny when mature. The shine can diminish as they age, and often they become wrinkled in the final stage of maturity. Walnuts and Brazil nuts show a variety of textures, as do the ripe seed pods of plants such as the Cape gooseberry and paeony. Strawberries are fleshy with the seeds on the outside; apples and pears can be dull or shiny, plain or patterned, with their seeds enclosed. Rosehips provide a wonderful variety of shapes, sizes and colours. Vegetables of all sorts, including pumpkins,

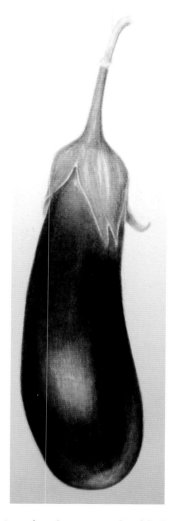

An aubergine – example of fruit.

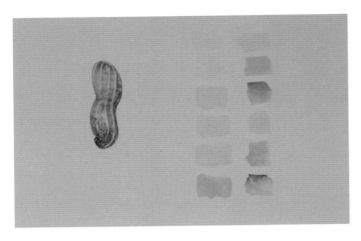

A peanut study.

squash and gourds too, provide a rich and exciting variety of subjects. Autumn walks, whether in the city or countryside, are never the same again once one has got the bug of Botanical Painting. Each season provides a rich opportunity to study different aspects of plant form. Vegetable gardens and allotments become a rich resource too.

It is relevant to mention that it is usually the mature fruit of a plant that is depicted. Unripe fruit of course can be painted. Generally this would be as part of a composition, either to show the individual stages of the development of a fruit, or where a plant subject displays both mature and immature fruit. It is by no means a rule, but when chancing upon a green fruit, do consider that it is unripe. There are, of course, exceptions to be found; the most obvious ones being a lime and an avocado pear. The bright green casing of a developing walnut is an alluring subject to paint, as too are many immature nuts. Although many of them are green, as many, if not more, are not. A little research, however, should unveil the true colour of the mature

A purple-podded pea.

An open purple-podded pea.

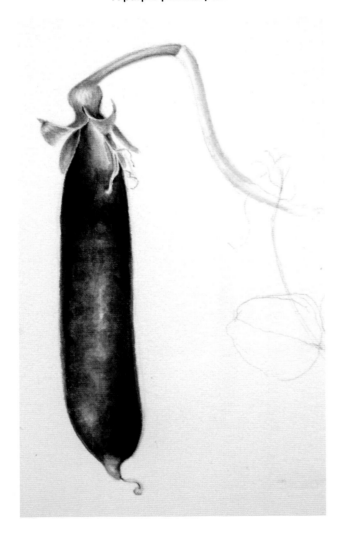

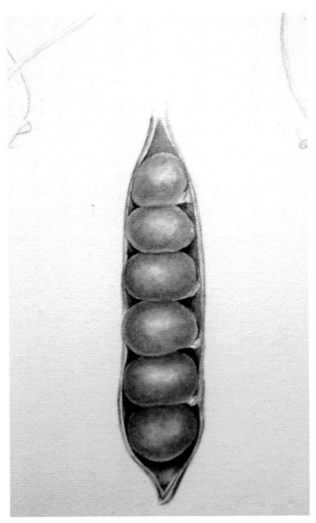

fruit. It is always better to paint from a place of knowledge, whatever the choice.

Whether the chosen fruit is large or small, it is important to make a careful study and ensure that the specimen is appropriately characteristic. By examining a number of seeds, a selection can be made as to the best for painting. Begin with the form and work out the tonal range and colours that will be required. The importance of tonal value cannot be overemphasized; the greater the tonal range the more dynamic the painting will be. With the interesting shapes seeds and their capsules provide it is possible to make good use of directional lighting; this will enhance the form depending upon the position of the light, but most importantly reveal their specific identifying characteristics. Spend time moving the light around to get the best possible effect. The shaded drawing can assist in appreciating the importance of tonal value to form, because by being limited to pencil it is not so easy to be distracted by the colour; therefore greater attention can be directed to the overall form.

Consider making a 'room' for the subject by arranging two boards or an open book so as to minimize light interfering from other sources and preventing distractions from the surroundings. Then, using a directional light from a table lamp, the illumination can be increased, which in turn will enhance the feeling of form. This technique can be particularly useful when the surface detail of a subject is important to understand. Looking at seeds with a lens or microscope can provide wondrous surprises at the surface. The amount of information that can be contained in a tiny seed is almost unbelievable. This detail is impossible to convey on a small seed. If the surface of a small seed is of interest a study can always be undertaken as a magnification.

Larger subjects can have the form built up with layers of washes applied as smoothly as possible. Build up the tones from the darkest to the lightest, having established the lightest and darkest areas beforehand. Use all sorts of references as aids to the painting: a shaded drawing, a photograph of the subject, sketchbook notes. As frequently mentioned, time spent on observational notes is rarely wasted.

Smaller seeds, because of the size and scale, sometimes cannot have their tones built up by washes alone. Although covered in the chapter on painting, the use of the dry-brush method requires further explanation here. It is recommended to lay in the first wash with a very pale colour, that is the palest local colour possible. This will serve as a base from which to build up layers, using a dry-brush method with very small strokes which, while not exactly dry, is distinctly drier than when painting in loose washes. By having less moisture on the brush it is possible to make smaller marks. It is the layering of the small strokes that will build up the form, and by using small strokes it is possible to get a lot of detail in a very small space. Care should be taken not to overload the brush with pigment; there is the optimum amount that will work perfectly. If problems are encountered it is frequently due to the fact that there isn't enough water on the brush so that the paint is not released, or there is too much water and the paint is released too quickly, causing loss of control. The brush strokes can be just that – minute strokes,

A sketchbook shaded drawing study of a pod.

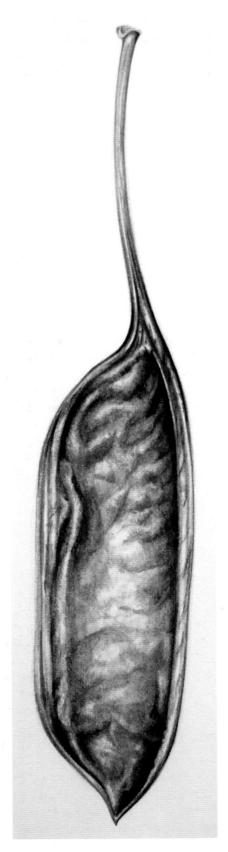

A painted version of the same pod from a different viewpoint.

cross-hatches or even dots. As in all methods, it boils down to a matter of preference and what works best for the subject under observation, as well as what works best for the artist. There is no right way or wrong way, although it is prudent to follow the direction of growth of the plant with the same direction of the paintbrush. If this is a new method of working, just experiment and see what gives the best results. After the layers have been built up and a good rendition of form has been achieved it is always possible to follow this up with successive thin washes, which can help to give a smoother appearance, if desired.

One of the joys of using a dry-brush method is that a specific colour can be achieved by using lots of different colours and tones, side by side or in layers, to achieve the right effect. This can be especially useful when the subject is particularly textural, as is the case with many seeds. It is sometimes very difficult to pin-point an exact colour, and the dry-brush method allows for an approximation of colour to be read as that seen. On the whole, when using a dry-brush method a smaller brush is useful, because of the scale of the subject being painted, but also to enable good control. The smaller the brush the finer the work will be, but equally it will take longer. A No. 1 brush should be adequate, but for the very brave and patient a smaller brush can be used to great effect.

Strawberries are a particular fruit that can present their own specific problems and a number of factors need to be taken into account. Their seeds sit on the surface and then each seed sits in a tiny undulation. The seeds and corresponding undulations often form a pattern following the Fibonacci sequence, but due to the uneven growth of the developing fruit the pattern can be interrupted. The most helpful advice when taking on the complexities of a Strawberry is to consider each element in relation to the whole, that is the effects of directional light on each seed and the dimple it sits in, as well as the overall form. Consider that in all likelihood the detail will be diminished in the lighter areas and concealed in the darker areas. This allows for concentration to be focused on the mid-tones. The shape of both seed and dimple will also appear to alter as the Fibonacci sequence progresses, as each seed and dimple will not be fully visible.

Consider dissecting and bisecting fruit, seeds and pods – they are delightful subjects. Cut them in half, or cut them into segments to reveal the beauty hidden within. They warrant a place as a portrait in their own right, but when part of a composition they can serve to enhance the overall effect. When cutting them, do make sure a sharp knife is used so as to prevent tearing and snagging. It is usually good to have a clean cut edge if possible, unless the intention is to show a fruit split open, in which case the edges would be ragged and uneven.

Experiment by using complementary colours next to each other, and also using separate colours – for example, red and yellow side by side in order to arrive at a shade of orange. This method is often used by miniaturists and painters who work on

A shaded drawing study of rosehips.

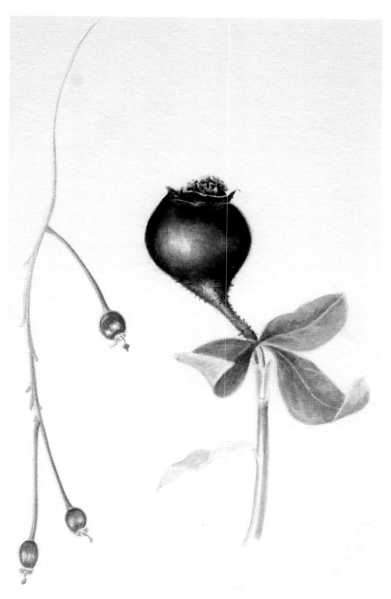

A painted study of rosehips.

A study of rosehips with watercolour laid over the shaded drawing.

vellum, as the technique is particularly useful for applying paint on very smooth surfaces that do not allow for the building up of layers.

Sometimes the fruit and flower appear on the plant at the same time, such as in the pea family, but possibly more frequently, the mature fruits appear later. Paintings can take up to a year to complete if the artist wants to include all the parts of the plant in one composition. If the intention is that the flower and fruit appear in the same composition, consideration to the space the fruit will occupy should be given at the beginning and sufficient space set aside for inclusion. The beauty of the fruit can often justify a painting devoted entirely to them as stand-alone subjects. It can be interesting to dissect the fruit or seed pod, to reveal the seeds and the forms enclosed. When attempting a cut subject, protect the cut surface with a piece of damp kitchen towel or cling film to preserve its moisture, especially if that is a distinguishing feature and one of specific interest. The towel can be removed for observation, and replaced when needed. Keep the other cut side in the refrigerator in a dish covered with cling film to protect its moisture, just in case it is needed.

To describe moisture, the simplest method is to leave as much paper as possible to begin with and to build up the colour with thin washes. Keep the washes as pale as possible, making minute adjustments as necessary. Make sure as much of the palest tone and paper is retained as possible. A final wash can be applied over the whole cut surface at the end if the paper is too bright. When it comes to describing seeds within a pod or in the centre of fruit, the judicious use of shadow colour will help make the seeds look seated in the pod. Don't forget the directional light and in all probability the shadow will be more intense on the dark side of the seed. Enhancing the directional light with a table lamp can be particularly helpful to see the effect of the shadows more clearly. By placing a sheet of tracing paper over the painting and shading this with pencil, it can be possible to work out the light and shade before committing to paint. The deeper the shadow, the deeper the seed will seem to be seated in its pod. Do remember the form of the seed when considering adding shadow. Try not to paint a straight line to convey the shadow, unless of course the seed is flat. In all probability there will be curves, and if this is the case remember to vary the line. Unless hairy or covered with some other coating, seeds on the whole have very sharp outlines, especially if shiny, and this should be reflected in the painting. It is therefore particularly important to keep a good clean edge to the painting.

The use of a magnifying glass or microscope will help to establish the exact surface of the seeds and provide some understanding of the structure. It can be helpful to refer to

A blue wash on a chilli pepper to enhance the shine and give it a more natural look.

Chapter Four on specific colours because, as mentioned when discussing this, nothing beats mixing a colour in response to the subject. Do consider that although the seeds appear to be black, they could be any dark colour. Please do consider mixing a dark colour rather than using a ready-made black. There are a number of ready-made blacks but frequently the mix is just too harsh and not suitable for a plant painting. Black can be mixed by using the three primary colours, in equal quantities. The balance can be adjusted according to whether a warm black or cool black is required. An excellent black can be achieved by mixing French Ultramarine and Burnt Umber.

If a seed or fruit is particularly shiny, the shine will come from the paper. Shine is covered in the next chapter covering special effects, but it is worth a mention here. When beginning to paint a shiny fruit or seed, leave a small area of white paper to allow this shine to work. When the painting is completed the white paper can receive a thin wash of blue, such as Cobalt Blue, so the white paper doesn't read as a hole in the paper, and also to give a more realistic finish. If the seed is a shiny black one, or dark brown, consider laying a wash of pale blue first and make sure a little of this wash is left so it can shine through.

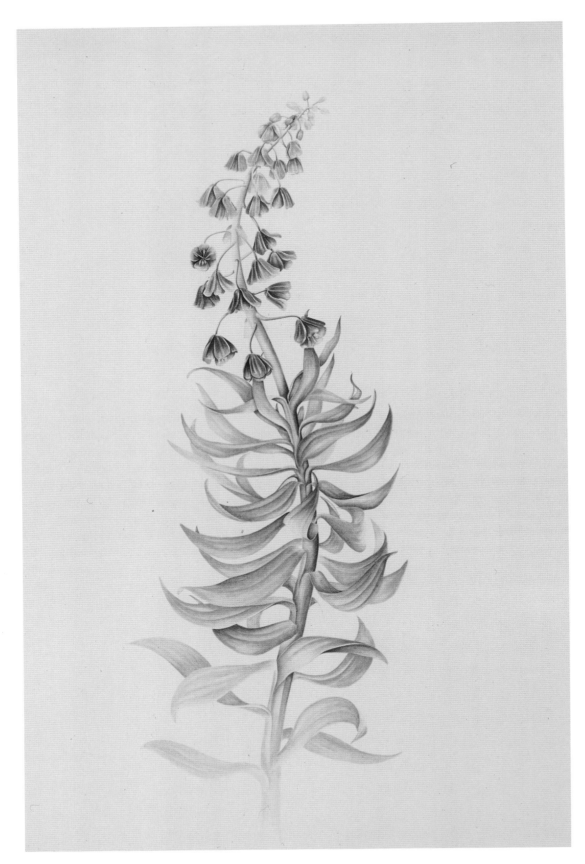

Fritillaria persica.

SPECIAL TECHNIQUES

VELVET FLOWERS

The appearance of rich velvet petals as seen in pansies and flag irises, in particular, can be almost irresistible for the Botanical Artist. This effect can be mastered relatively easily, but requires perhaps a little more patience and practice than required for other subjects. The secret is to build up the colour very gradually with layers of different colours and, after some experimentation, this is fairly simple. Leaving a little of each layer visible on some part of the flower, for example on the petal edge, allows the painting to virtually shimmer. With courage, keep building up layers of paint, letting them get progressively thicker with the proportion of paint to water, until the required depth of tone for the darkest areas has been achieved. Once allowed to dry, it will be possible to move the paint around using a damp brush to reveal the form of the petals created by the veins. Alternatively, the form can be built up from the outset controlling the layers. Whichever method is undertaken, remember to leave each layer to dry perfectly so that the colours will sit on top of each other. This way the colours will have the opportunity to sing out, rather than being mixed together on the paper, which can cause them to become dull and lifeless.

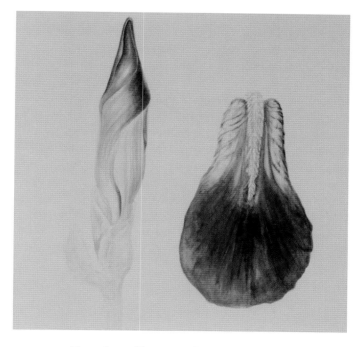

The velvet effect on an iris petal and bud.

HAIRS

Hairs can be seen often on plants, on stems and leaves in particular, as well as on petals, and until a detailed study has been undertaken it would be impossible to consider the ways in which they can differ. Like all vegetative features hairs are classified according to type, and inspection under a magnifying glass, lens or microscope is to be advised, purely to understand their nature. Sometimes they are too small to warrant description; however the more prominent hairs as seen in poppies and sunflowers for example are particularly characteristic of the plant and need to be shown. Nevertheless, caution should be exercised: it is so easy to see hairs and overdo the effect. Economy is definitely the key, as the hairs will, in all probability, only be seen where light hits the plant or show up against

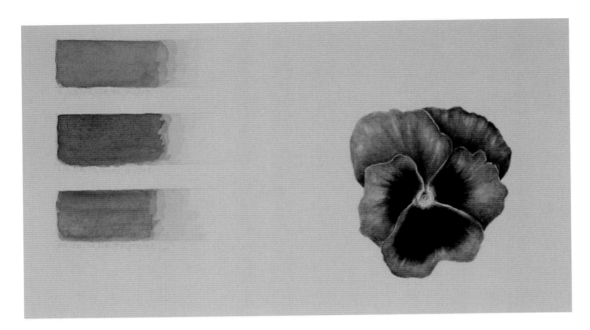

To illustrate the method of layering different colours to achieve a rich velvet tone.

a relatively darker surface. If depicting hairs, it is important to establish their nature and direction of growth at the outset, even if this cannot be seen very clearly. As a checklist, first consider how the hairs are arranged, their direction of growth, shape and size. When undertaking such a study, as a note of advice, only describe a feature such as hairs when it can be seen with the naked eye – unless the whole plant is shown as a magnification of the original. Consider also that some hairs will be seen in profile and others head on. When looking directly at a hair, it will appear as a dot and can be shown as such.

The simplest method for painting hairs is to use white gouache. Gouache is an opaque paint sometimes referred to as bodycolour that can be applied on top of the watercolour. If using gouache, it is vital that this is left until the very end, and it is very important to make sure the surface is completely dry before applying. When applying the hairs over the stem they may appear to be white, but as they extend past the stem against the paper they will need to be painted in their own colour where they protrude. Remember it is most important to study the nature of the hairs and establish their direction of growth. Don't be tempted to overdo them; there are no prizes for overzealousness. It is appropriate to show what can be seen with the naked eye and it is unlikely that each and every hair will be obvious. In Botanical Illustration, a magnification could be included to show the precise nature of the hairs, but for the purpose of Botanical Painting this is not essential.

A second method sometimes employed does away with the necessity of using gouache and involves painting around the hairs. This method can be very tricky, but effective. It requires

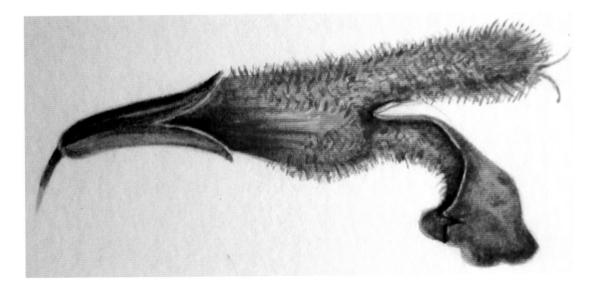

Hairs on a salvia flower.

practice – and a very small brush. The key is to keep the shading to the base of the hair and to fill in the negative spaces with very pale layers of colour until the right tone is achieved.

Both the methods described can be used for painting hairs wherever they are observed within the plant.

BLOOM

Bloom is the opaque coating that appears on some fruit, such as blueberries, plums and grapes. This is another occasion when gouache, or bodycolour, can be usefully applied. As mentioned before, gouache is an opaque paint that has excellent covering properties, which means it will sit on top of watercolour paint. It is important that this stage is left to the very last as it will all too quickly mix with the watercolour and dull it. When using gouache in this context it should be applied very dry to prevent it from spreading. Definitely try a few experiments before committing to a particular painting. This technique can also be applied to peaches, various seed pods and other vegetative features that have a fur-like coating. Gouache paint generally comes in tubes and for the purpose of bloom Permanent White by Winsor and Newton is an excellent choice.

Method

Squeeze a small amount of gouache onto a palette, about the size of a small pea. Mix the paint with a little water, just enough to allow the paint to flow without being sticky. It should still remain quite thick. To this add a minute amount of Cerulean or Cobalt Turquoise, just enough to tint the white. The blue will make the white appear cooler and brighter. Then, using a hog bristle brush or something similar with very stiff hairs, pick up a decent amount of paint. Before applying this to the painting, remove most of the moisture by stamping the brush on a piece of kitchen towel or rag until the bristles are almost dry, then stipple the paint over the final surface of the painting according to the areas where bloom can be observed. The paint should appear uneven and blotched to give the required effect. However, it is necessary to experiment and also not to become too regular with the effect or it will appear formulaic and boring. Use this method very judiciously and not over the whole plant. It is very important that the gouache is applied at the very end of painting as any water or paint added to it will spoil the effect.

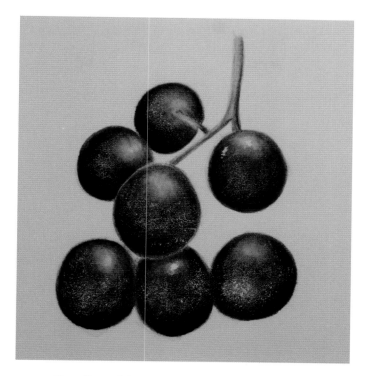

The effect of 'bloom' on a small bunch of grapes.

CACTI AND SUCCULENTS

Bodycolour can be used to good effect for cacti and succulents to describe the protective coating that some plants produce. This protective coating serves to protect plants from extreme elements of nature. The gouache can be applied by the same method employed to describe bloom on fruit, by mixing the gouache with a touch of Cobalt Turquoise or Cerulean, using the stipple method with a stiff dry brush.

SHEEN AND SHINE

There is a subtle difference between sheen and shine and, paradoxically, a significant difference. They both describe reflected light on a smooth surface. A simple way to differentiate between them is that sheen gently glows, while shine is brilliant. On the whole the smoother the surface the more brilliant the shine, but this is also dependent upon the brightness of the light and the position of the subject in relation to the light. A good way to depict sheen is to use pencil or paint to move from dark to light, or light to dark, as smoothly as possible with a gradual and progressive change, using the full range of tones from the darkest to the palest. An effective method to depict shine, and distinguish it from sheen, is to progress from dark

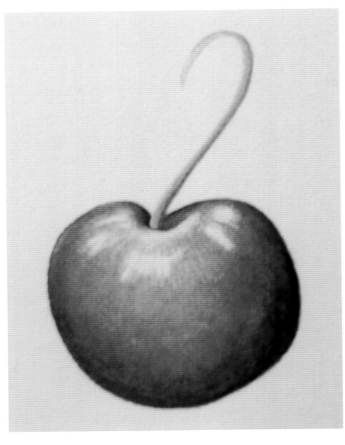

Shine on a cherry.

to light as quickly as possible but at the same time produce no sharp lines. The progression should be graded, but the steps will be so small as to be barely visible. Another difference will be that the progression from dark to light will be greater, with the paper producing the palest tone, thus increasing the tonal values. With sheen, the palest tone will most probably be the first pale wash of local colour.

Cherries and chillis are excellent subjects to practise both sheen and shine as they tend to reveal both. One important thing to remember before embarking on this project is that the light illuminating the subject will change during the day. This is of course the case with all painting, but becomes far more noticeable when concentrating purely on a shiny surface. There are a number of ways to overcome this problem. One is to work purely from theory, that is, from a theoretical light source, coming from the top left. Once the areas of light and dark have been plotted, and an accurate drawing has been undertaken, then the information is fixed and working from life is partially abandoned. This method works very well if the theory has been firmly established. Another way is to set up the subject and then set aside the same time each day to study and paint. The disadvantage to working like this is that not only is it difficult to set aside the exact same time over a number of days, but equally the weather and atmospherics too can change, so that while working at the same time, the quality of light may not be the same – and of course the chosen specimen may die in the meantime. A third method, and possibly the easiest, is to set

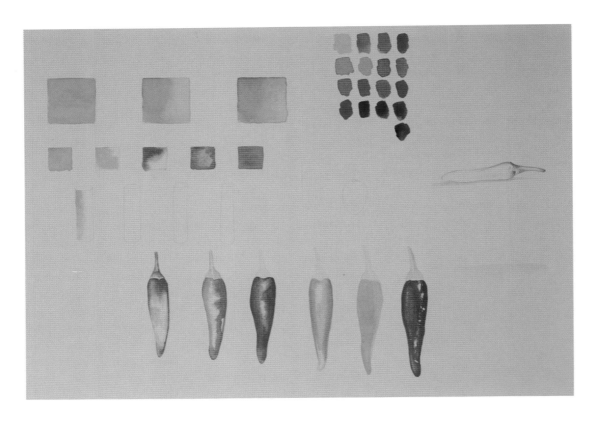

A chilli pepper study page to experiment with colour and effects.

An exercise for shiny red fruit.

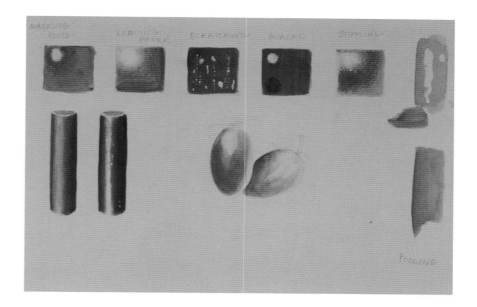

up a sort of theatre that can be illuminated using a directional light, which will remain constant.

It is very simple to set up this arrangement. All that is required is a lamp fitted preferably with a daylight bulb or halogen lamp. Position the lamp and the subject so that the illumination is coming from the top left. To the right of the subject place a jointed mount, or failing that, a book opened at right angles to prevent other light from causing confusion. In this way the directional light can be seen clearly and, with luck, areas of shine will be observed as well as sheen. Do not overdo the shine, one or two highlights should be sufficient.

Having established the areas of highlight these will be left as plain paper; the white of the paper will provide the shine. To demark these to prevent accidentally painting over them, mark them in lightly with a faint pencil mark. The first wash could be just plain water and then the layers could be built up gradually in the desired colour. Consider varying the colours to arrive at the chosen colour. For example, for a red chilli, a layer of yellow such as Aureolin, followed by a layer of Alizarin Crimson, then a layer of Permanent Rose could produce a good result. Build the layers up very gradually moving towards the proposed areas of shine, but progress very carefully so that each layer ends just short of the last. Remember to follow the form at all times so the white paper reads as shine on the surface as opposed to a hole.

Once the painting is finished and a good sense of shine has been achieved a wash of very pale blue helps to achieve a more naturalistic finish. Cerulean, Cobalt Blue or Cobalt Turquoise can all be used to great effect, providing they are applied as pale as possible. The colour should be barely visible but surprisingly it will make a difference.

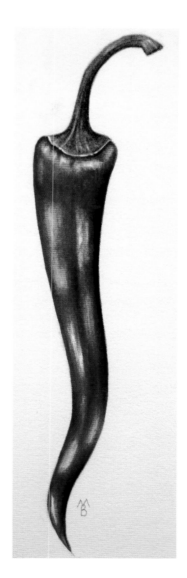

A chilli pepper.

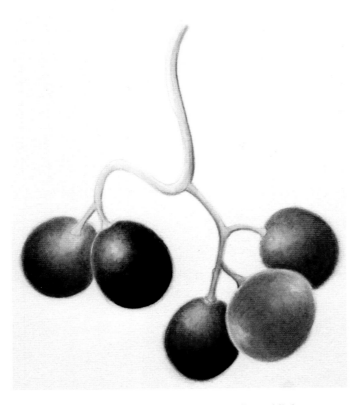

A small bunch of grapes to show reflected light.

dark colours. If a bunch of dark grapes is put under scrutiny, this effect can be observed as an area of paler light, just slightly in from the edge of the fruit. It is this phenomenon that allows for each individual grape to be seen. In order to achieve this in paint it is useful to leave a light edge to each fruit, working up the darkest tones inwards from this area. Although seemingly difficult, with a little practice it can be mastered and, once mastered, consideration can be given to using washes of glaze colour to enhance the effect.

AERIAL OR ATMOSPHERIC PERSPECTIVE

This notion was touched upon in Chapter Six about leaves. The use of aerial perspective, also known as atmospheric perspective, allows volume to be given to the painting. Therefore the greatest attention and detail is given to the parts of the plant in the foreground; the parts that fall away are diminished either in tone or intensity – they may be paler, or greyer. In some ways it follows the Law of Contrast, put forward by John Ruskin in *The Elements of Drawing*. This book is a worthwhile read and much can be gleaned from Ruskin's words. Although he was writing at the end of the nineteenth century and some of his language can seem long-winded, he has much to offer the Botanical Painter of today. At the same time as looking at the tonal and colour values, give consideration to the fact that the scale of the diminished parts will appear to be slightly smaller too. This will help to give the overall painting a feeling of a physical presence in space.

SHADOWS

Some artists like to ground paintings with the use of shadows, rather than have an image suspended in space. If the use of shadows is to be undertaken it must be done with great care so as not to dominate the painting and distract from the main subject. Position a light so that there is only one shadow cast to avoid confusion. Placing a sheet of tracing paper over the painting can be helpful to test the area of shadow, using a soft pencil before committing to paint. When using a shadow, do not forget the principle of layering the paint, and do build it up gently. The first and subsequent layers should be little more than dirty water. The intensity of the shadow usually diminishes as it spreads out from the object casting the shadow.

Shadows within a composition are sometimes needed to define the form, and will be present for example in the

Sometimes the white paper gets accidentally covered with paint and the light is lost. This all too easily can happen and cause despair. If the light has been lost there are a number of ways of overcoming the problem. Firstly try to lift off some of the paint by damping the area with clean water and then blotting a piece of rag or kitchen towel on the dampened area. Sometimes this will be sufficient. The painting can then recommence once the surface is perfectly dry and the layers can be built up. If this doesn't work, the shine can be lifted out by picking at the painting in the appropriate area with the sharp tip of a craft knife revealing the paper that will denote shine. Do not attempt to apply washes over this as the surface has been disturbed and the washes will not work. A further method can be to add white gouache in the appropriate areas. This is possibly the easiest method, but it can lack the subtlety of the other methods.

REFLECTED LIGHT

When two dark surfaces are next to each other they give the effect of reflected light. This doesn't apply only to dark subjects, but equally to pale ones; it is just that it is more noticeable in

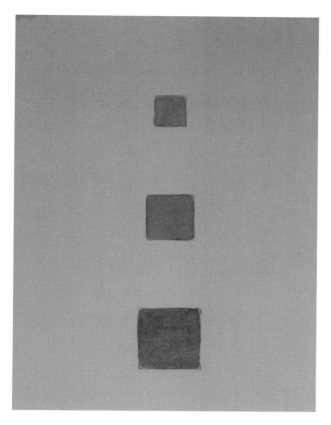

An exercise to demonstrate the effect of aerial perspective through the use of scale and a paler colour.

A rosehip study to show the effect of aerial perspective.

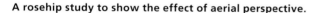

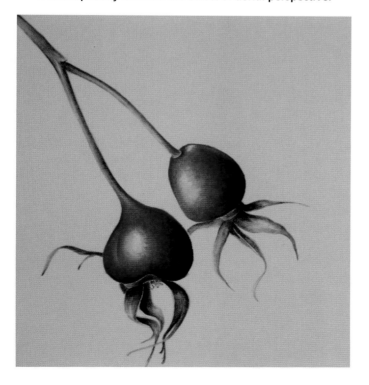

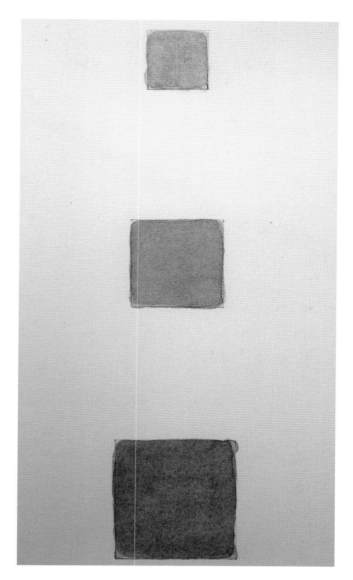

An exercise to demonstrate the effect of aerial perspective through the use of scale and greyed colour.

depiction of a branch of many leaves or in a bowl-shaped flower. This type of shadow should be delicately undertaken and the over-use of shadows is to be cautioned against. The reason being is that shadows can cause confusion so make use of them wisely. As mentioned, shadows will occur within a complex form, and to a certain extent they help define the form but they should not be over-emphasized or used unnecessarily. If a shadow occurs within a flower, for example as a result of pronounced directional lighting, and as such is a cast shadow, it is to best to ignore it.

To show a twig resting on a page with a delicate shadow.

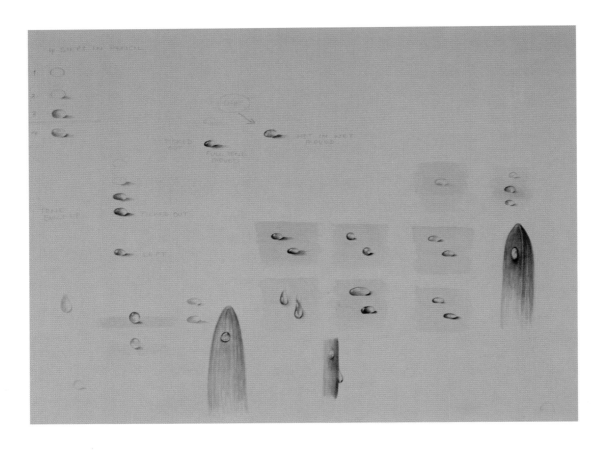

An exercise in dewdrops.

DEWDROPS

These are an irresistible feature and something that is not as difficult to achieve as one might think. They can be used effectively to conceal unsightly marks that appear within the painting. They should be used however with great care and sensitivity. Dewdrops should be left to the end as a rule. Always practise on a scrap of watercolour paper before launching into a painting if these have not been tackled before. While they are not complicated, it would be unwise to experiment on a finished painting. First draw the outline of the drop lightly with pencil then, with a very pale grey, paint a small semi-circle behind the line drawn to indicate a shadow, which will appear on the surface of the plant. Next paint a very light grey wash starting from the left-hand side of the drop to just past the midway point. Repeat this process but stop at the midway point and then when this layer is dry put another layer just on the area closest to the light. Finally, in the area just above the shadow which was initially painted, pick this out with a sharp blade to give a perfectly white dot to indicate the highlight. This will in all probability take a few attempts to achieve the best effect.

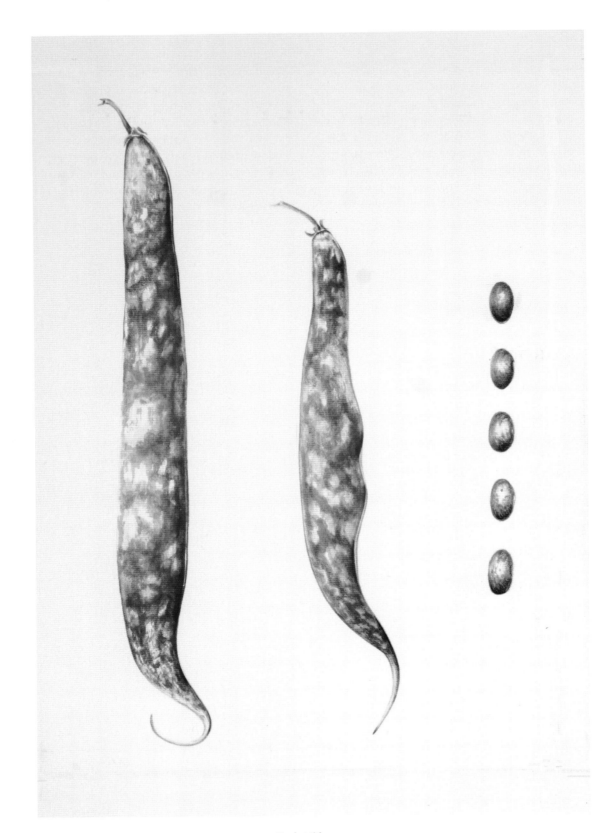

Borlotti beans.

THE SKETCHBOOK AND COMPOSITION

THE SKETCHBOOK

Sketchbooks are invaluable to a botanical artist and it is a good idea to get into the habit of using one. Once up and running it becomes a wonderful repository for notes, information, references and ideas. It keeps everything in one place and theoretically increases efficiency, saving time taken up rummaging through sheafs of paper, boxes and cupboards. Apart from containing valuable information all in one place, they are a useful record of dates and places. Select the paper carefully and make sure it will fit the purpose rather than being seduced by the outer cover. However, a beautiful outer cover can help make the proposition more attractive.

A sketchbook study page.

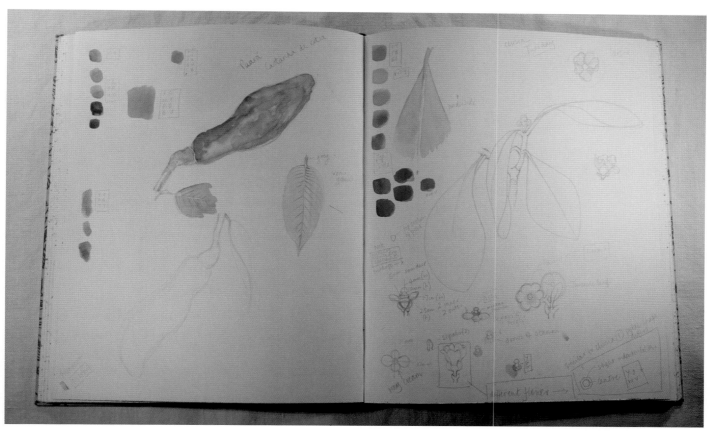

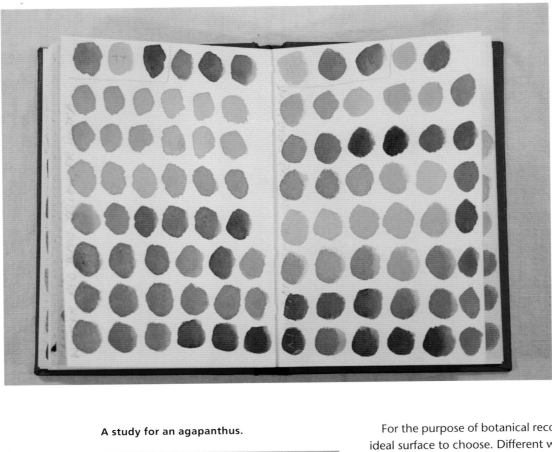

A sketchbook used for watercolour exercises.

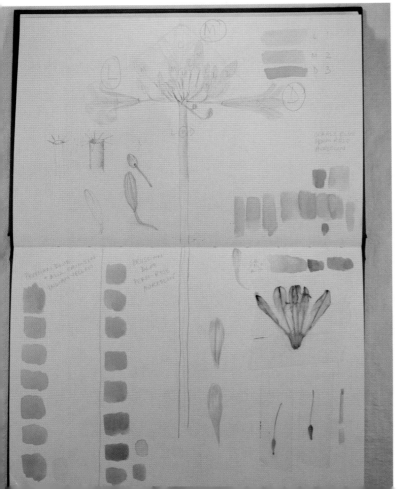

A study for an agapanthus.

For the purpose of botanical recording, a smooth paper is the ideal surface to choose. Different weights of paper are available and this will effect the definition of the line. Thicker papers allow for the use of washes; thinner paper is not so good for washes or ink, but is usually excellent for line and tonal drawing. A gentle touch of the paper should reveal the properties of the paper; that is the weight and the surface. Testing as many papers as possible will help you to understand the properties and potential of different papers. There are various bindings available too. The most common ones available are spiral-bound or book-bound. The spiral-bound books are great for adding such things as material, plant pressings and photographs as they allow for growth. Bound books come in a variety of shapes and sizes; it can be useful to have a number of different sizes – a larger one for projects and a smaller one for use when travelling.

The sketchbook is a good place for testing colour mixes. It gives freedom to experiment without expecting any particular outcome and therefore can allow room for surprises, some of which will be invaluable. Through investigation into colour, favourites will emerge and when fully developed this can begin to reveal a personal palette, which may become a limited one, and has the potential to become almost a signature. The restricted palette can simplify things, and a limited palette doesn't mean the painting will be boring – indeed some of the best botanical paintings use a very limited range of colours, reflecting the often quoted 'less is more'. There are no mistakes

Paeony pods.

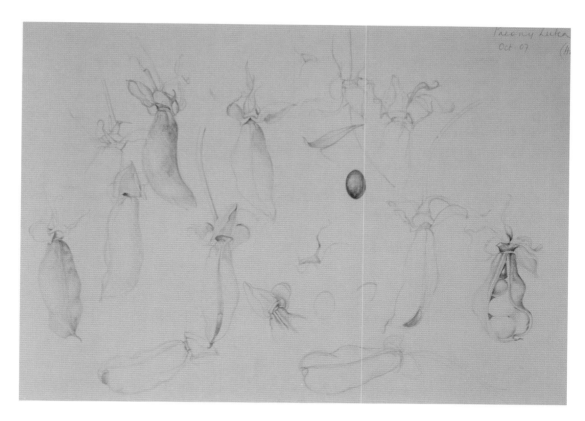

when experimenting with colour. Anything and everything can be used for future reference, even when the decision is made *never* to use a particular combination again. Experimentation can be a real time saver.

With a new sketchbook, just as with a new painting or drawing, the terror of the blank page can strike. It's bad enough to be confronted with a beautiful sheet of white paper when preparing to paint, let alone a whole new book. There can be a strong urge to produce a masterpiece on the opening page. Reduce this pressure by starting in the middle, then work both backwards and forwards; it does not need to be a chronological document.

The sketchbook is a private space, providing freedom to examine ideas and thoughts away from public scrutiny. Enjoy this and use the space expressively; this testing ground can result in breakthroughs in ideas and can allow for greater creativity. The sketchbook can be used for working out compositions, by making thumbnail sketches, especially useful when working out the layout for a complicated composition.

It is not necessary to be limited to one sketchbook. A number of sketchbooks can be run side-by-side, using different books for different purposes. A book with smooth paper may be favoured for drawings, used for preparatory work and for detailed observational drawings; while one with thicker paper can be used for more extensive note-taking and using colour washes. These books become a permanent record of work undertaken and can be used for reference time and time again.

Pressing Plant Material

It can be very useful to press plant material for inclusion in a sketchbook. Traditionally, botanical illustrators back up their paintings with a pressing, known as a Herbarium Specimen. This records the identity of the plant and the date and the place from where the specimen was gathered, its provenance and botanical heritage, and can include any interesting information about

A pressed vine leaf.

the plant. When picking plant material for pressing it is best, if possible, to collect them first thing in the morning, preferably on a dry day. It is important to press the material as quickly as you can to preserve as much of the nature of the plant as possible. Flower presses are available to buy in numerous formats but it is not necessary to go to all this expense, unless the intention is to do many pressings. The materials needed to make a simple press include: blotting paper, newsprint or old newspaper, two wooden boards, and a couple of bricks, tins of baked beans or similar heavy weights to place on the boards.

First put one of the boards on a good flat surface and then place a sheet of blotting paper on the board. Lay the plant material on the sheet of blotting paper, spreading it out as much as possible to avoid stems crossing over one another; sometimes this is not possible, but try to keep crossovers to a

Amazonian seed pods.

minimum. If the plant is very large, it may be necessary to cut the plant up into manageable pieces. The purpose of the exercise is to have parts of the plant for reference, not necessarily as a thing of beauty. As soon as the plant is placed, write its name on the blotting paper in pencil, together with the date and place collected. Then place a second sheet of blotting paper over the plant, making sure everything is covered. Next, lay a couple of sheets of newsprint over the blotting paper and place the second board on top weighted down with either some bricks or even a pile of good heavy books. After a day or so, check the pressing to make sure there isn't too much moisture on the blotting paper. If so, gently remove the plant, change the blotting paper and delicately replace the plant on the new sheet of blotting paper, checking regularly until the plant material is completely dry. Do not dispose of the discarded blotting paper; once dried out completely it can be reused. Drying times will vary according to the plant, so there is no set formula. When it is dry it can be transferred to the sketchbook for future reference. Either use PVA glue to stick the plant down, or affix small pieces of sticky tape to the stem in various places to secure and prevent it from dropping out of the book.

A further method for plant pressing, while not considered conventional, is with the use of an iron. Ensure the ironing board is protected with an old sheet or scrap of fabric, and then place a sheet of blotting paper on top. Place the plant specimen on the blotting paper and then cover with a sheet of paper and on top of that place a piece of clean rag. Apply the iron to the cloth, pressing down onto the specimen. Repeat the exercise a few times until the specimen is relatively dry. The plant material can then be put to one side between two pieces of blotting paper and weighted with a heavy book for a few hours. This can be sufficient for inclusion in a sketchbook, but not for a Herbarium Specimen required for Botanical Illustration, when it would be important to allow the plant to dry out as slowly and consistently as possible. This process is not suitable for succulent or fleshy plant material.

COMPOSITION

How the work is presented is very important for any painting or drawing, and this needs to be given careful thought. It is useful to get into the habit of beginning to think of the composition from the very moment the pencil is picked up. Consideration as to the layout of a drawing or painting on a sketchbook page is a useful place to begin. Every pencil mark should be accounted for. Beginning the day with loose sketches, either within the book or on a scrap of paper to be discarded, can help to focus the mind and attention to the process of the layout. The sketchbook is a great place for experimentation and should not be

Study page for a
composition.

Primula composition.

overly self-conscious. Learn to enjoy mistakes and bad drawing days; these make the successes all the more enjoyable and satisfying. A collection of rough sketches and vague ideas can make the gems shine out. Attention will be drawn to the highlights, and the other bits and pieces will just provide the background. Rough sketches can be necessary for the development of the end result, even if they are insignificant visually. Nevertheless, do consider the layout on the sketchbook page at all times because moments of genius rarely announce themselves in advance. The reason for the emphasis of layout in the sketchbook is merely as a method of training, so that the presentation of the subject becomes almost an automatic habit.

When beginning a project the first consideration is usually the size of the finished painting. This is frequently determined by the size of the plant subject. Whether it is a single specimen or an arrangement, the choice of format is important. The next consideration should be the orientation of the page; this can be landscape, portrait, square, circular – or possibly even something else. Whatever the choice, this decision should be made in advance. By leaving good margins of paper around the composition the choice of orientation can possibly be delayed until the painting is completed. To reiterate, always leave a good margin of paper as it does allow for greater flexibility.

If the finished painting is to be framed it will be important to consider the method of framing. If a painting is to be 'float' mounted, that is framed with the margins of the paper visible, the painting can go right to the edge of the paper. If the painting is 'close' framed, that is framed without a mount, then a small amount of the edge of the paper will be covered by the fittings of the frame. Equally, if a painting is to be mounted, a small margin of paper is required to fix to the mount and therefore part of the paper will be concealed. This illustrates the need to consider the margins and edges of the paper at all times. Leaving a sufficient margin means that the picture framer will be able to trim the painting to size, rather than having no choice at all.

Frequently the subject will define the composition purely through the way the plant presents itself. Consider the intended layout from the outset. A composition can be harmonious or contrasting. If the intention is for a composition that is harmonious it is useful to establish a number of factors such as scale, tonal value, shapes, and colours. Harmony will be achieved if the scales, tonal values, shapes and colours are similar. If the intention is for contrast these factors can be taken into account, but will possibly be reversed. For example, place a large flower or fruit beside a smaller specimen; or a strong vibrant painting with a shaded pencil drawing beside it; a smooth gourd beside a knobbly one; a red apple with a

A series of compositions on a theme of Tradescant's flowers: *Primula auricula* with a box-leaf border.

Fritillaria meleagris with a box-leaf border.

Tulipa clusiana with a box-leaf border.

Rosa muscosa with a box-leaf border.

green apple, and so on. A further consideration could be a discordant composition. This is where two or more elements are included that normally wouldn't be considered together. Care is needed with this selection to make sure the combination works. Spacing of the pictorial elements should be considered too. These benefit from a feeling of rhythm not unlike music. If everything has the same space between it the result can be uninteresting. Therefore vary the distances between elements in the painting to give variety, unless a very measured, evenly spaced painting is particularly desired. All these ideas offer just small examples of the possible scope. If undertaking a thematic project, such as plants from a particular species, it is useful to use a format so that the paintings will be understood to be part of a series. A format can be anything under the sun, however it is usually the intention that it should be relatively uniform and eye-catching.

Study the work of other Botanical Painters, past and present, but do not be limited by the purely botanical; any painting incorporating plant material can be useful. There are many books available on a botanical theme. Choose one painting or drawing – the selection can be quite random. It does not matter whether it is historical or contemporary; it can be anything of choice. Spend at least five minutes in contemplation of the painting, taking time to assess its size, subject matter, temperature, arrangement and the palette used. Consider the contrasts of dark and light, the balance within the composition and make brief notes on the immediate impression. Refer to any information the author might have provided on the painting and try to discover as much as possible about the plant and the period it comes from. Return to the painting and spend a further ten minutes in examination. Use the same checklist and re-assess the earlier notes made. This excellent exercise reveals the importance of composition and also shows us that every decision should be made deliberately. Take charge of the painting; don't let the painting take charge! Nothing quite beats looking at the real thing so take any opportunity to visit a museum or gallery exhibiting Botanical Paintings and repeat the process. It can be an interesting journey of discovery.

A diagonal composition, avoiding painting from corner to corner by ending the composition before the corner is reached, and moving the elements just slightly to the left and right of the absolute diagonal.

There are a few rules, which can only be broken once they have been learned. Firstly, as previously mentioned, leave a good margin around the painting. This allows room for error and it provides space for additions to be made to a composition. It means too that a painting can be trimmed and a mount added, if required. Secondly try not to plonk the plant in the middle of the page. Sometimes it is precisely the right choice, but do not assume it is so. Tracing paper, or a lightbox, can help assess the correct position for the plant, or composition. Tracings of the drawing can be cut up and moved around on the paper before committing the final drawing to watercolour paper. Thirdly, avoid anything too contrived, for example strong diagonals from corner to corner. If drawn to a diagonal composition, consider moving the subject slightly to the left or right of the diagonal. It only needs to be a whisker either this way or that, but even a minute difference can make the overall effect more naturalistic. At the top and the base of the diagonal, consider changing the trajectory very slightly in the opposite direction to produce a very subtle curve; in effect an elongated 'S' shape. Alternatively ensure the diagonal is on a gentle gradient. Studying plants in their natural habitat can be of help when it comes to composition; plants have a way of arranging themselves sympathetically. However, do beware of malformations due to obstructions around the plant. These can present happy compositional accidents, but they can equally be ugly.

The use of thumbnails can be helpful in coming to decide upon a layout for a painting. In the sketchbook or on a rough sheet of paper, draw a number of boxes of varying shapes and sizes – square, rectangular, portrait and landscape. Taking the chosen subject, draw very simple basic outlines of the plant at a greatly reduced scale within the boxes. Arrange the proposed composition symmetrically, asymmetrically, with good margins or up to the edge, or even straying over the edge. Play around with any and every combination imaginable and allow the imagination to take over for a while. Consider the negative spaces, that is, the parts of the paper not occupied by the subject, looking at the proportions as well as the shapes formed. This can be done on a small scale by filling in the negative spaces with shading.

Do not think that a combined composition needs to be complicated. Of course it can be and many people enjoy the mental gymnastics of the operation, but it is not compulsory and prizes for complexity are rare. However, a combined composition should be well balanced. Well balanced does not necessarily mean evenly placed, but rather means the component parts should look comfortable. They can be individual components

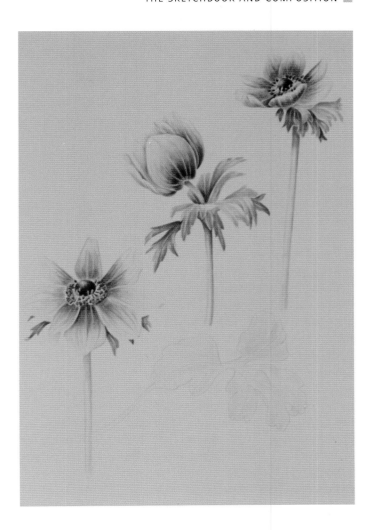

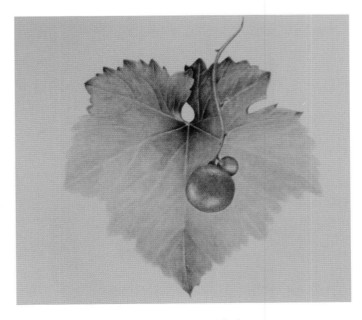

A layered composition with the grape positioned in front of the leaf.

on a theme as seen with the Amazonian seed pods (*see* page 130) or layered as in the vine leaf with grapes. In the case of the Amazonian seed pods, the larger and darker pod was placed below the smaller and paler-coloured pods. The overall composition was asymmetrical and the colours different, but nevertheless a sense of harmony was achieved. This was partly due to the positioning of the elements, but also achieved by using a series of harmonious washes over each of the pods. For example they all had a wash of Cobalt Blue to enhance the shine over the palest areas, as well as darkening further the darkest areas, which helped give a feeling of unity. Another wash applied was that of Rose Doré which had the effect of warming the brown pod, slightly dulling the yellowy green orchid pod, and warming the grey coating of the acorn type pod.

Harmonizing washes were used with the grape leaf composition. As the grapes were superimposed over the leaf, in order to give a feeling of distance between the two elements it was important to give the impression that light could pass between them. This was achieved by deliberately reducing the intensity of the detail behind the grape. This had the twofold effect of giving significance to the grape by making it appear to advance and, at the same time, giving the feeling of aerial perspective to the leaf by making it appear to recede. If the elements had been painted at the same intensity they could have appeared to be touching. This, of course, is perfectly acceptable, but the importance is to do anything through deliberate choice, not serendipity. However, one should never dismiss serendipity. It can be quite marvellous.

When undertaking a large composition there are a number of approaches to consider – each element can be completed fully before progressing to the next. Alternatively it can be useful to build up each element in a gentle, progressive sequence to avoid the problem of overworking one in particular, which could become a distraction from the whole. A further consideration is the effect of the directional light upon the whole composition. Therefore frequently the object to the far left of the composition could appear to be lighter as it is closer to the light source and the object on the far left would then appear darker. If this is a consideration it is often worth beginning the painting from the far right. This is by no means compulsory, but worth taking note of. It is more significant when considering a single, stand-alone specimen than when considering single elements as part of a composition. If an even distribution of light is required, each individual element can be built up separately; however if the subject requires numerous layers it is useful to work on more than one element at a time so as to allow for the layers of paint to dry thoroughly before the next is added.

The Golden Rectangle

The Golden Rectangle or Golden Ratio (1:1.618) are frequently mentioned when considering composition. The Golden Rectangle relates to the Fibonacci sequence as mentioned with the spiral in Chapter Two on drawing. In nature almost everything relates to this and as a result a feeling of harmony is created. When it comes to composition, the simplest way to understand the idea is to consider working in thirds. By dividing a page into thirds, both vertically and horizontally, the places where the lines cross relate to the Golden Section and these are

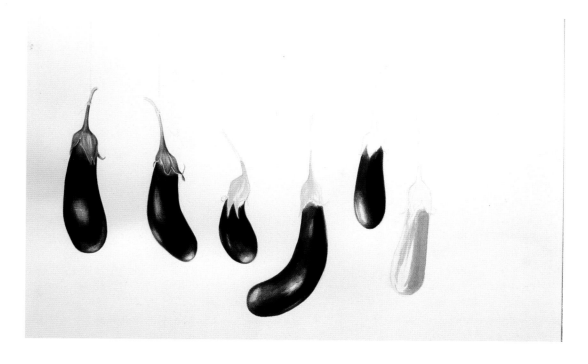

A composition of aubergines, using a variety of positions.

THE SKETCHBOOK AND COMPOSITION

good positions to consider an object of focus. Some artists can do this quite naturally without being conscious of the fact. If a composition does not come easily, bear in mind this very simple method to help with the positioning of various elements within a painting. The mathematics surrounding the Golden Section can seem overly complicated. To break it down into a straightforward and simple pattern can help understand the sequence. On a sheet of paper draw a 1in or 1cm square at the top left of the sheet. To the right of this square draw another 1in or 1cm square beside it. Label both these squares with the number 1. Directly below these squares draw a 2in or 2cm square and mark this square with the number 2. A rectangle has now been formed which forms the Golden Section. This progression can continue as follows. To the right of this rectangle draw a 3in or 3cm square, and mark this square with the number 3. Another rectangle has been created. Below this rectangle draw a 5in or 5cm square and mark this with the number 5. Yet another rectangle has been created. To the right of this rectangle draw an 8in or 8cm square and mark this with the number 8. Finally draw a 13in or 13cm square beneath this rectangle and mark with the number 13. This formula is endless. The size of each square is determined by the sum of the two previous squares.

To make a simple rectangle that relates to the Golden Section, draw for example a 6in or 6cm square. Mark the halfway point at 3in or 3cm, then draw another 6in or 6cm square, beginning from this halfway mark, superimposed over the first square. The result should be a rectangle, divided into three sections. Once the principle has been grasped, this method can be used to obtain a simple Golden Section as a guide for composition.

LABELLING PAINTINGS

It can be a matter of personal choice whether or not to include the name of the plant to accompany the painting. Careful consideration needs to be given to this. It is always useful to sign and date the painting on the reverse and also to add the name of the plant, if known. This in fact is to be highly recommended. If the decision is to label the plant next to the painting there are a few considerations to be taken into account.

The label should not dominate the painting, unless that is the intention. Whatever the intention, great care should be given to the position and lettering of the label. It should be in keeping with the size and scale of the painting. Generally it is the painting to which attention should be drawn, not the writing. It is advisable to draw a very faint pencil line or lines, as a guide for the lettering to help keep the label straight. Testing ideas in a sketchbook is useful.

One of the most obvious things to say about a label is that it is important to give the plant the correct name. It can be the full botanical name, or just its common name. The botanical name will ensure that the painting is universally understood, as Botanical Latin is an international language employed throughout the world for the classification of plants. Botanical Latin has strong foundations in Latin and Greek, combining both languages. Common names can be confusing as they vary from country to country, and even county to county, nevertheless they can be utterly charming. The choice of name is deeply personal and adds to the variety of presentations of paintings but whatever the choice, do not be tempted to invent. The less that is known about the plant the less information there should be. As mentioned, a common name can be quite sufficient and precisely what is required. It is equally acceptable to name the plant by its *genus* – that is its group name, such as Lily *(Lilium)*. If the *species* is known, that is the specific Lily (such as Martagon Lily) and the variety too, then include them. The classification of plants can be a complex and bewildering subject, but for the purposes of labelling there are a few rules which can be helpful. To give the Martagon Lily as an example:

FAMILY	Liliacea	Lily Family
GENUS	*Lilium*	Name
SPECIES	*Lilium martagon*	Type
VARIETY	*Lilium martagon* var. Alba	Variety
CULTIVAR	*Lilium martagon* 'Mahogany Bells'	Cultivated variety
COMMON NAME		Lily

The specific rule for writing the botanical name of a plant is called the system of binomial nomanclature, based on the work of the Swedish botanist Carl Linnaeus in the eighteenth century. Each plant is given two names. Its generic name, that of the genus, *Lilium* and then its specific name *martagon*. The genus always has a capital letter and the species always lower case. That is *Lilium martagon*. The names are either written in italics or if not italicized, underscored: Lilium martagon. The variety begins with a capital letter and is not in italics and a cultivar is contained within inverted commas and not in italics, but the first letter of each word is capitalized. This provides only a very rudimentary outline which should be useful as a guide.

When adding the name of a plant to a painting, to avoid the lettering dominating the composition, write the name in pencil and then trace over the pencil with a neutral tint in watercolour to match the colour of the graphite using a small paint brush: No. 1 or No. 0 are good choices. This will serve the dual purpose of sealing the graphite, so it doesn't smudge, and is soft yet visible. As it can be difficult to write using a paintbrush, by writing with a pencil and tracing the lines, the outline of the letters will be more secure. If in any doubt at all label the painting on the back.

Do sign the work but do not let this dominate either. Choose the signature to be used for signing paintings carefully and keep it constant. Try to be consistent in the placement of the signature too. Whatever choice is made, stick to it. Again, if in any doubt just sign the painting on the back and don't forget to put the date.

WHEN IS A PAINTING FINISHED?

This is always a very difficult question to answer. A few suggestions to help solve the problem might assist. Quite often the painting comes to an end because either the plant has completely died (as well as possibly interest in the subject) or time available has expired; there could be any number of other reasons. The death of a plant should not define the end of a painting, especially if adequate notes have been taken, but sometimes this signals a good point to stop.

If there is indecision as to the end, put the painting away in a safe place and do not look at it for at least forty-eight hours. When retrieved it can be examined with fresh eyes and, hopefully, a more critical assessment can be made. Another interesting and effective way is to hold the painting or drawing up to a mirror; the reflected image can reveal glaring errors, or elements that look 'uncomfortable' which cannot be spotted purely due to over-familiarity with the work and a tired eye. Any adjustments, if needed, can be made following this assessment.

Sometimes working on a number of paintings simultaneously can help as they all reach a particular state at the same time: this can work very well if working in a series. From bitter experience, try not to be tempted to fiddle with a painting just because an hour or so of useful painting time remains. Move on to something else to avoid clumsy mistakes if extra time is available. Placing a painting within a mount can change the overall look of the painting tremendously and this can be a useful means of establishing whether or not a picture is finished.

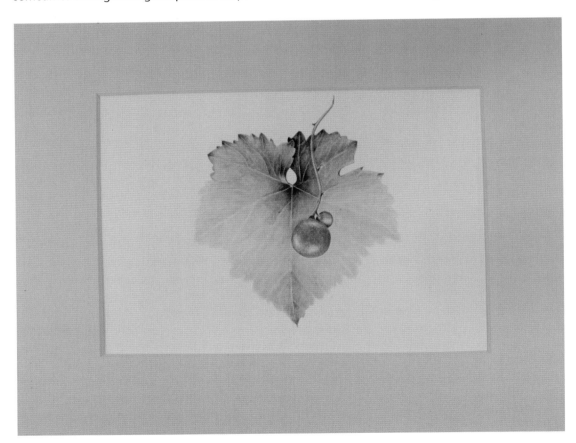

The completed painting (vine leaf with grape), mounted.

GLOSSARY

BASIC BOTANICAL TERMS

Actinomorphic – regular flower divisible into equal halves along many planes.

Anther (containing pollen grains) and filament – (stamens) male parts of the plant.

Bract – a scale-like leaf, as seen in the mop head of the hydrangea family.

Calyx – made of up sepals which protect the emerging flower.

Corolla – the petals.

Inflorescence – a flower cluster.

Inter-node – the part of the stem between nodes.

Locule – a chamber within an ovary.

Node – the point on the stem where the leaves emerge.

Pedicel – the stem.

Pistil – the female parts of the plant.

Raceme – a form of inflorescence with the flowers arranged on stalks or pedicels.

Receptacle – the top of the stem that holds the parts of the flower.

Sepal – a segment of the calyx.

Stamens – the male parts of the plant.

Stigma, style and ovary – (pistil) female parts of plant.

Stipule – a leaf-like growth at the base of a leaf stalk, seen especially in the pea family.

Temperate plant – of the temperate climatic zone, approximate latitude 40°–60°/70°.

Zygomorphic – irregular flower, divisible into equal halves along one plane only.

ACKNOWLEDGEMENTS

Along the way I have encountered great generosity and support which I would like to acknowledge. I would like to thank Anne-Marie Evans for her encouragement and infectious enthusiasm for Botanical Painting that proved to be such an inspiration. My gratitude extends to all at the English Gardening School and the numerous staff at West Dean College who give continued and enthusiastic support. Equally I owe a debt of gratitude to all the people that have attended my courses, many becoming friends along the way, who have helped make my work a complete joy.

My grateful thanks go to Harry Godman-Dorrington for his invaluable assistance with the photography. I also wish to thank Penny Summers for her practical help and guidance, and for keeping me to the point. And last, my understanding family, who seem resigned to this position, for their endless support and encouragement and who helped make this book a possibility.

USEFUL ADDRESSES

BOTANICAL PAINTING COURSES

The English Gardening School, Chelsea Wharf, 15 Lots Road, Chelsea, London, SW10 0QJ
www.egs.dircon.co.uk
The Short Course Programme, West Dean College, West Dean, Nr. Chichester, West Sussex, PO18
www.westdean.org

BOTANICAL ILLUSTRATION AND PAINTING SOCIETIES

The Chelsea Physic Garden Florilegium Society, Chelsea Physic Garden, 66 Royal Hospital Road, London, SW3 4HS
www.chelseaphysicgarden.co.uk/garden/florilegium
Hampton Court Palace Florilegium Society
www.florilegium-at-hamptoncourtpalace.co.uk
American Society of Botanical Artists, N.Y. Botanical Garden, 200th St & Kazimiroff Blvd, Bronx, NY 10458-5126
www.huntbot.andrew.cmu.edu/ASBA
The Society of Botanical Artists
www.soc-botanical-artists.org

BOTANICAL GARDENS

Chelsea Physic Garden, 66 Royal Hospital Road, London, SW3 4HS
www.chelseaphysicgarden.co.uk
Oxford Botanic Garden, Rose Lane, Oxford, OX1 4AZ
www.botanic-garden.ox.ac.uk
The Shirley Sherwood Gallery of Botanical Art, The Royal Botanic Gardens, Kew, Richmond, Surrey, TW9 3AE
www.rbgkew.org.uk
Eden Project, Bodelva, St. Austell, Cornwall, PL24 2SG
www.edenproject.com

The Royal Botanic Garden Edinburgh, 20A Inverleith Row, Edinburgh, EH3 5LR
www.rbge.org.uk
National Botanic Garden of Wales, Llanarthne, Carmarthenshire, SA32 8HG
www.gardenofwales.org.uk
Brooklyn Botanic Garden, 100 Washington Avenue, New York, NY11225
www.bbg.org
The New York Botanical Garden, 200th Street and Kazimiroff Blvd, Bronx, New York, NY 10458-5126

BOTANICAL LIBRARIES

The Lindley Library, Royal Horticultural Society, 80 Vincent Square, London, SW1 2PE
www.rhs.co.uk
The Hunt Institute for Botanical Documentation, Carnegie Mellon University, 5000 Forbes Ave, Pittsburgh, Pennsylvania, 15213-3890
www.huntbot.andrew.cmu.edu

ART MATERIALS

Green and Stone of Chelsea Art Materials, 259 Kings Road, London, SW3 5EL
www.greenandstone.com
L. Cornelissen and Son Art Materials, 105 Great Russell Street, London, WC1B 3RB
www.cornelissen.com
Pearl Paints, 308 Canal Street, New York, NY 10013, and 1250 S. La Cienega Blvd, Los Angeles, CA 90035
www.pearlpaint.com
New York Central Art Supplies, 62 Third Avenue, New York, NY 10003
www.nycentralart.com

FURTHER READING

Dunstan, Bernard *John Ruskin The Elements of Drawing, Illustrated Edition with Notes* (A&C Black Publishers Ltd, London 1991)

Heyward, V.H. *Flowering Plants of the World* (B.T. Batsford Ltd., London, 1993)

Hickey, Michael, and King, Clive *The Cambridge Illustrated Glossary of Botanical Terms* (Cambridge University Press, 2000)

Hickey, Michael, and King, Clive *Common Families of Flowering Plants* (Cambridge University Press, 1997)

Hyatt, Brenda Auriculas: *Their Care and Cultivation* (Cassell, London 1989)

Leech, Lizabeth *Botany for Artists* (The Crowood Press, 2011)

Page, Hilary *Hilary Page's Guide to Watercolor Paints* (Watson-Guptill Publications, New York, 1996)

Phillips, Roger, and Rix, Martyn *The Botanical Garden Volume I, Trees and Shrubs* (Macmillan Ltd., London, 2002)

Phillips, Roger, and Rix, Martyn *The Botanical Garden Volume II, Perennials and Annuals* (Macmillan Ltd., London, 2002)

Sherwood, Shirley *A New Flowering: 1,000 Years of Botanical Art* (Ashmolean Museum, University of Oxford, 2005)

Sherwood, Shirley, and Rix, Martyn *Treasures of Botanical Art* (Kew Publishing 2008)

Stern, William T. *The Art of Botanical Illustration* (The Antique Collectors' Club Ltd, 1994)

Wilcox, Michael *The Artist's Guide to Selecting Colours* (The Wilcox Trust, 1997)

Wilcox, Michael *The Wilcox Guide to the Finest Watercolour Paints* (The School of Colour Ltd, first published 1991, updated 2000)

INDEX